Freshwater FISH CARVING

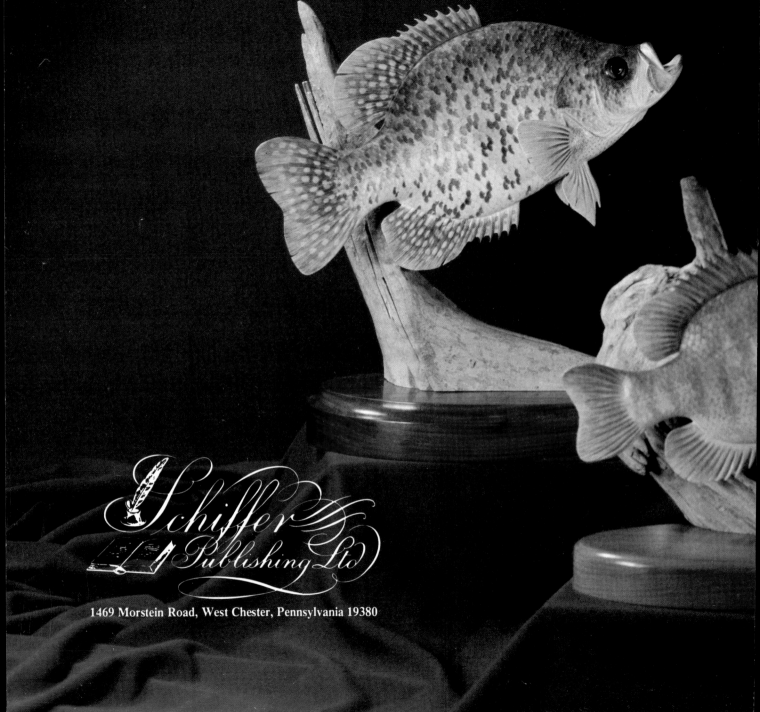

1469 Morstein Road, West Chester, Pennsylvania 19380

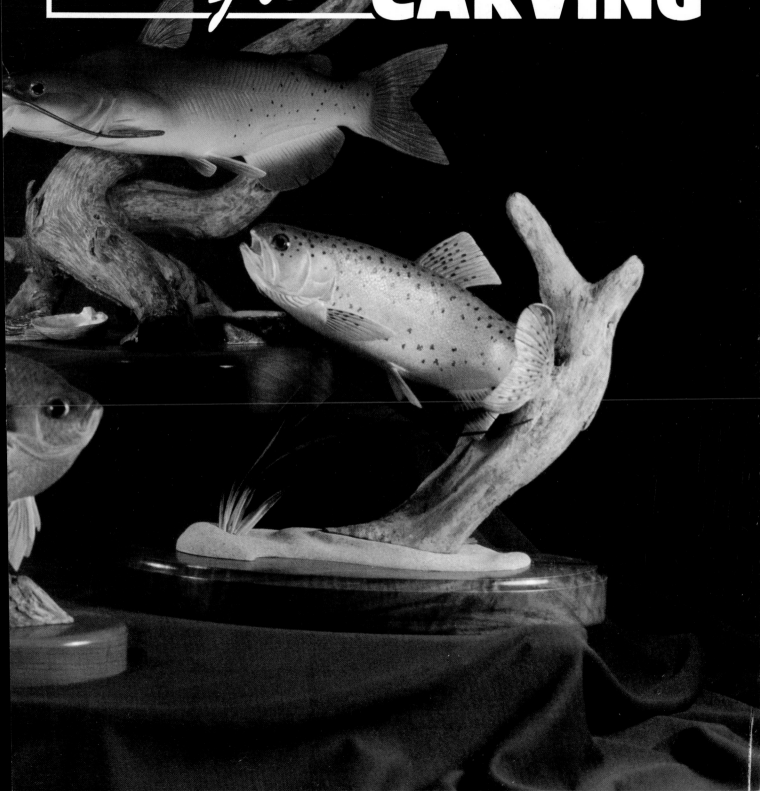

Freshwater FISH CARVING

Acknowledgments

My warmest thanks to my wife Jean and our daughter, Laura, for their support and patience during the hours I spent working on this book.

I would like to thank Bill Staley for his enthusiasm and expertise in the writing for this project.

For his generous assistance with the photography, a very special thanks goes to Randy Templeton.

My thanks to those members of the Central Flyway Decoy Carvers and Collectors Club for recognizing and promoting the art of fish carving.

My warmest thanks to Schiffer Publishing Ltd. for giving me the opportunity and assistance to complete this challenging project.

Jim Fliger

Printed in the United States of America.
ISBN: 0-88740-175-9

Published by Schiffer Publishing, Ltd.
1469 Morstein Road
West Chester, Pennsylvania 19380
Please write for a free catalog
This book may be purchased from the publisher.
Please include $2.00 postage.
Try your bookstore first.

PLEASE RETURN THIS TO
NICK CHRISTOLOVEON
561-2529

Contents

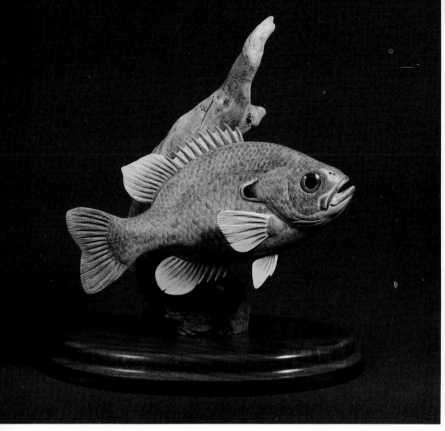

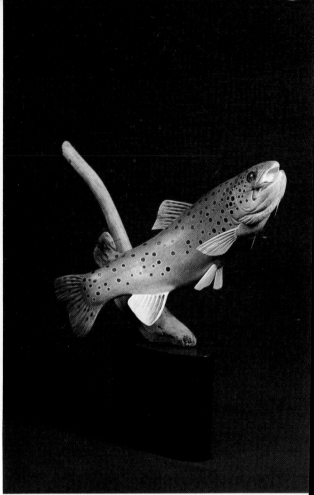

Orange-spotted Sunfish, from the collection of Mr. & Mrs. Joseph Tomich

Brown Trout, from a private collection

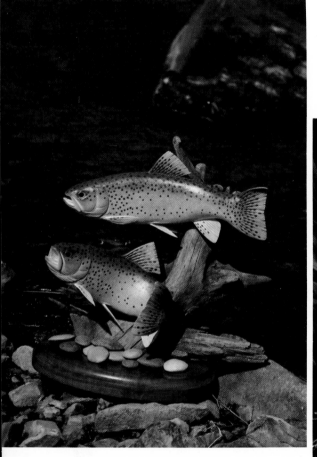

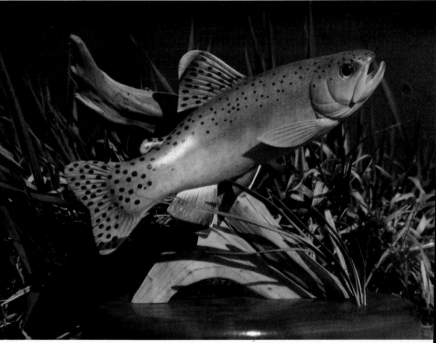

Rainbow Trout, from the collection of Mr. & Mrs. Thomas McGowan

Golden Trout, from the collection of Mr. & Mrs. Pat Jacobs

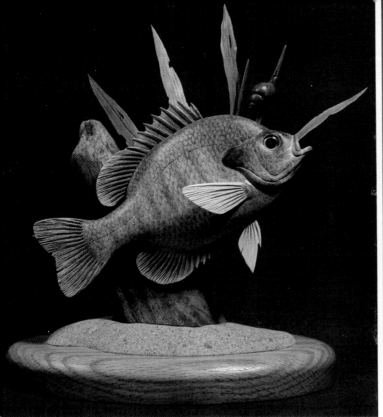

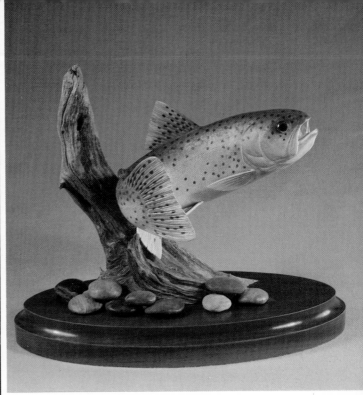

Bluegill Sunfish, from the collection of Dr. & Mrs. Chester Thompson

Rainbow Trout, from the collection of Mr. & Mrs. Robert Fliger

Black Crappie, from the collection of Mr. & Mrs. Francis Stejskal

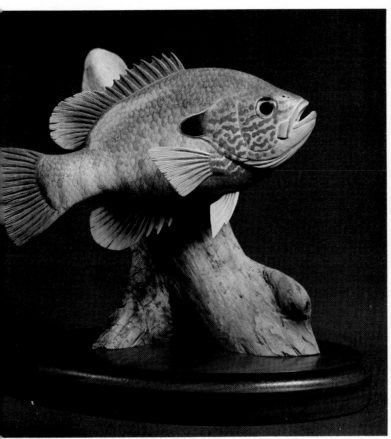

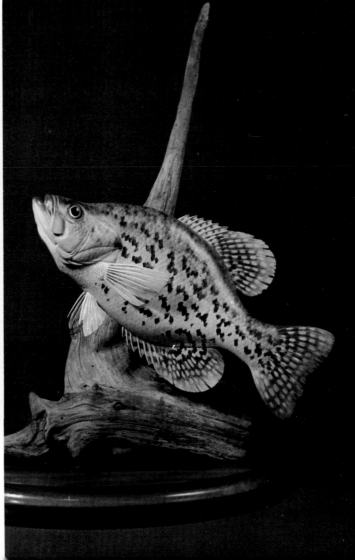

Red-breasted Sunfish, from the collection of Mr. & Mrs. Jack Gellatly

Reference

There are many sources of reference materials available to assist one in the research and study of most species of freshwater fish. Foremost would be to have the actual fish, whether just caught or frozen. I do not recommend the use of taxidermy mounts because the drying distorts some of the fish's features, especially in the head area.

With the numerous fishing magazines available through subscription or on newsstands, it does not take long to compile quite a few pieces of useful material. There are also several books in print that provide some excellent photos for study (FIG. 1). I use 11 by 14 inch film boxes (FIG. 2) to store my pictures, since they stack well and give me easy access. I spend considerable time in searching out and cataloging reference material.

One should always surround oneself with all the reference material possible for the particular project one is undertaking. Sometimes a photograph from a magazine or other source will show one small area of that fish one could not see in others.

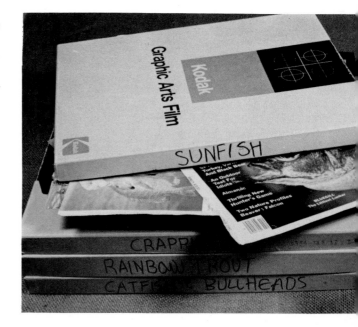

One reason to begin our projects in this book with the sunfish is that it allows us some artistic license when painting, while we are considerably more limited in painting the other three projects. The best rule is to pay very close attention to color detail at all times, using as many sources for that detail as possible.

As with birds, a good paint job can mask some slight imperfections in the carving, but we cannot let the carving slide while thinking the paint job will salvage the piece. I have a box full of half-carved fish I knew could not make the grade no matter how good my painting might be. Constant attention to reference materials and all aspects of each project can reduce adding to the contents of that box.

No carver or painter will ever claim having enough reference material.

8

BOOKS

THE AMERICAN SPORTSMAN, Ridge Press and American Broadcasting Co. Publication

COMPLETE BOOK OF BASS FISHING, by Grits Gresham

COMPLETE BOOK OF FRESHWATER FISHING, by P. Allen Parsons

THE FISH BOOK, Nebraska Game and Parks Commission, P. O. Box 30370, Lincoln, NE 68503

THE FISHES OF NEBRASKA, Nebraska Game and Parks Commission, P. O. Box 30370, Lincoln, NE 68503

THE FRESH AND SALTWATER FISHES OF THE WORLD, by Edward C. Migdalski and George S. Fichter

HUNTING AND FISHING LIBRARY, 5700 Green Circle Drive, Minnetonka, MN 55343

THE LORE OF SPORTFISHING by T.R.E. Tryckare and E. Cagner

McCLANE'S FIELD GUIDE TO FRESHWATER FISHES OF NORTH AMERICA, by A. J. McClane

NORTH AMERICAN GAME FISHES, by Francesca La Monte

WILDLIFE IN COLOR, by Roger Tory Peterson

MAGAZINES

IOWA CONSERVATIONIST, Department of Natural Resources, Wallace State Office Building, Des Moines, IA 50319

NEBRASKALAND, P. O. Box 30370, Lincoln, NE 68503

KANSAS WILDLIFE AND PARKS, Kansas Department of Wildlife and Parks, R. R. 2, Box 54A, Pratt, KS 67124

NATURAL HISTORY, American Museum of Natural History, Central Park West at 79th Street, New York, NY 10024

THE IN-FISHERMAN, P. O. Box 999, 651 Edgewood Drive, Brainerd, MN 56401

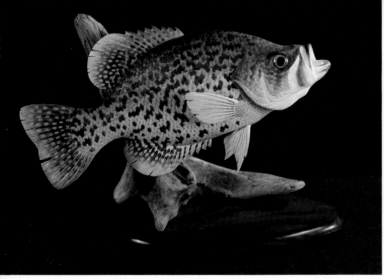

Black Crappie, from the collection of Mr. & Mrs. Lee Weyh Largemouth Bass, from the collection of Mr. Dale Kuker

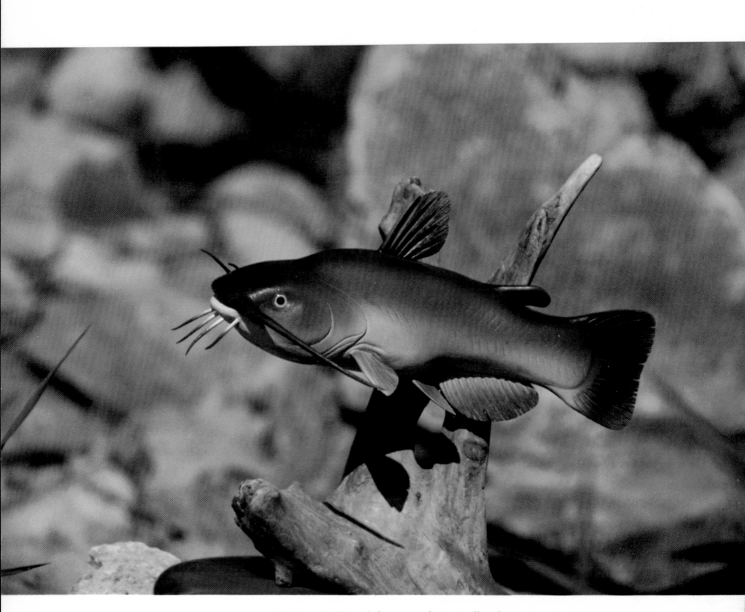

Yellow Bullhead, from a private collection

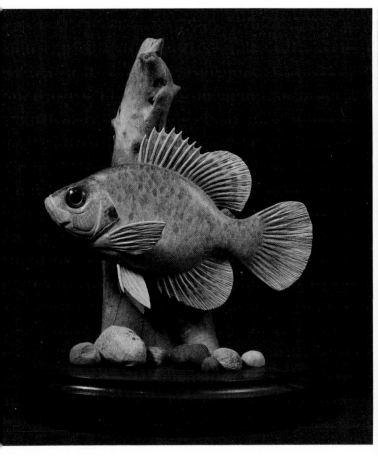

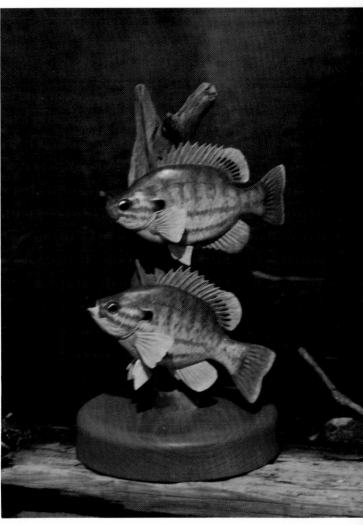

Blue-spotted sunfish from the Collection of Miss Laura Fliger.

Rainbow Trout, from the collection of Mr. & Mrs. Alan Hafemann

Pumpkinseed Sunfish, from the collection of Mrs. James Fliger

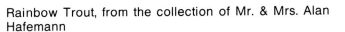

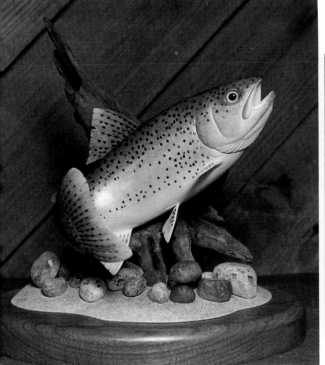

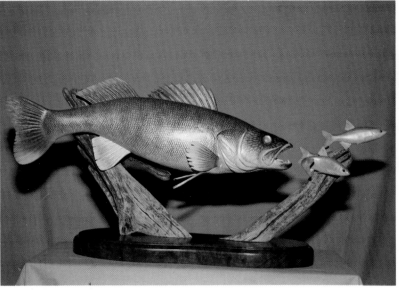

Walleye, from the collection of Mr. & Mrs. Gordon Coon

Dedication

I wish to dedicate this book to the memory of my parents, Louis and Erna Fliger, Jr. They spent countless hours with their children observing the natural world about us. Through this interest in and appreciation of nature this book is possible.

Foreword

If you can visualize a terrified frog about to be consumed by a largemouth bass, minnows scurrying to avoid a crappie, or a catfish eyeing a crawdad for an easy meal, then you can imagine what Jim Fliger achieves through his wildlife sculptures. Each of these scenes conjures visions in all of us who have ever fished or had an interest in nature. The thought of emulating nature with predator and prey can excite the imagination to create with wood and paint those special moments. Jim, in a most unique way, has brought each of these scenes to life through his painstaking ability to reenact nature's wonders.

Jim is that special person who will make ichthyologists take a second glance to know that what they see is not a taxidermy mount, but rather a work of art, sculpted wood taking on a very animated pose. These impostors from ponds and streams are visually attractive and artistically sculpted fish depicted in their natural surroundings. Many of these art forms have won awards at show and have been enjoyed by thousands of spectators.

My association with Jim Fliger these past years has made me envious of his talent to add life to wood and realistically paint, thus emulating scales, fins, vent lines and gills that only fall short of breathing.

In *Freshwater Fish Carving* Jim unveils special secrets, helpful hints and suggestions to assist its readers on a voyage to modeling their own vertebra of our waters. I have always viewed Jim as a personal friend and a friend of all wildlife. His fondness of nature and its creatures can be seen in his art as he takes you step by step to the completion of a lightening fast crappie or a trout. The book will provide you an opportunity to learn from the best and you will.

Cliff Hollestelle

Introduction

This book has a single purpose: to introduce you to a newly developing art form—freshwater fish carving.

In order to accomplish this I wish to share with you some insight and hints for composition, detailed illustrations and step-by-step carving and painting instructions.

The four projects selected not only represent those fishes we are familiar with, whether as fishermen or observers of nature, but those with differing anatomical characteristics requiring a wide range of techniques and some "engineering" skills. For this reason I would suggest reading through all of the chapters before starting your decorative fish carving project.

My approach to creating an artistic carving relies on three basic elements—composition, carving and color.

My belief is that a bird, fish or animal carving should be more than anatomically accurate. They must also stand up creatively in composition and color.

In my carvings you will find the composition broken down abstractly into a series of elliptical or oval shapes. The square, rectangle and circle are too regimental for my taste, whereas the ellipse demonstrates a feeling of freedom, movement and emotion. As you proceed through the following chapters I think you will discern those same feelings.

Wildlife art shows have for some time recognized that carving fish is a viable art form, but only in the past few years have wildlife carving competitions opened their doors to decorative fish carvings.

Whether you wish to participate in shows and competitions, or carve just for the pleasure it provides, it is my hope that this book will provide a spark or fan the fires of your imagination and creative abilities.

1988 Best of Show—Fish at the Ducks Unlimited National Wildlife Show in Overland Park, Kansas

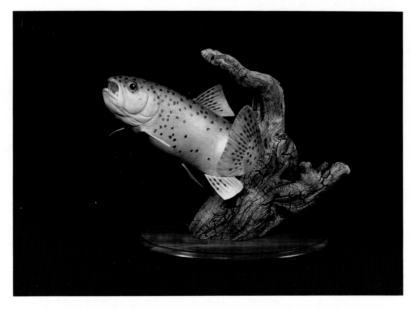

From the collection of Mr. and Mrs. Dan Teich

The following represent the species I will be carving and painting.

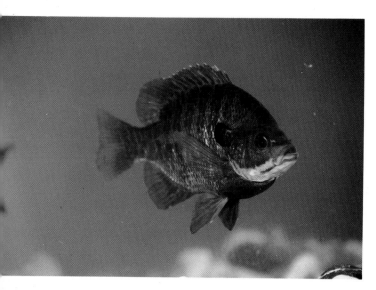

Bluegill Sunfish

Black Crappie

Rainbow Trout

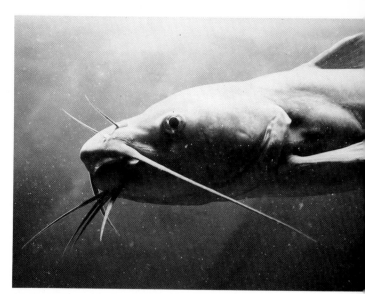

Channel Catfish

Photos provided through the courtesy of the
Nebraska Game and Parks Commission

15

Glossary

ADIPOSE FIN A small fleshy fin between the dorsal fin and caudal (tail).

ANAL FIN Single fin on the ventral (bottom) located between the pelvic fins and the tail.

BARBEL A threadlike structure or "whisker" on the head near the mouth.

CAUDAL FIN The tail fin or tail.

DORSAL FIN The single or two part fin (sometimes contains both spiny and soft rays) on the back.

ISTHMUS The throat or fleshy area that separates the gill chambers.

LATERAL LINE Pored scales extending from the head along the side of the body usually to the base of the tail fin.

MANDIBLE The lower jaw.

MAXILLARY The upper jaw.

NARES The nostrils.

OPERCLE The large bone covering the gills, also called the Gill Covers.

ORBIT The eye socket.

PECTORAL FINS The paired fins on the sides just behind the gill openings.

PECTORAL GIRDLE A series of bones to which the pectoral fins are attached.

PELVIC FINS The paired fins on the bottom (ventral) side of the body.

PELVIC GIRDLE A series of bones to which the pelvic fins are attached.

SCLEROTIC CAPSULE The eyeball in which the cornea is located.

SPINE The stiff but sometimes flexible rod that acts as a supporting structure in the fins.

SOURCES OF SUPPLIES

TOOLS:
Everett and Vera Cutsinger
3910 Humboldt Street
Topeka, KS 66609

Harmon Co., Inc.
34 Parkway
Little Falls, NJ 07424

Midwest Woodworkers Supply
13209 "I" Street
Omaha, NE 68137

CLEAN-AIR MACHINE:
Carver's World
3305 S. 107th Street
Omaha, NE 68124

GLASS EYES:
Tohickon Glass Eyes
P.O. Box 15
Erwinna, PA 18920

J. W. Elwood Supply Co.
Box 3507
Omaha, NE 68103

Van Dyke Supply Co.
Woon Socket, SD 57385

Anatomy

MORPHOLOGY OF BONY FISHES

SPINY-RAYED FISH

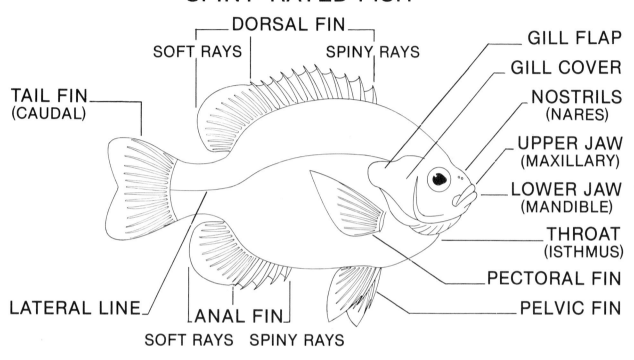

DORSAL FIN

SOFT RAYS SPINY RAYS

GILL FLAP

GILL COVER

NOSTRILS
(NARES)

TAIL FIN
(CAUDAL)

UPPER JAW
(MAXILLARY)

LOWER JAW
(MANDIBLE)

THROAT
(ISTHMUS)

PECTORAL FIN

PELVIC FIN

LATERAL LINE

ANAL FIN

SOFT RAYS SPINY RAYS

SOFT-RAYED FISH

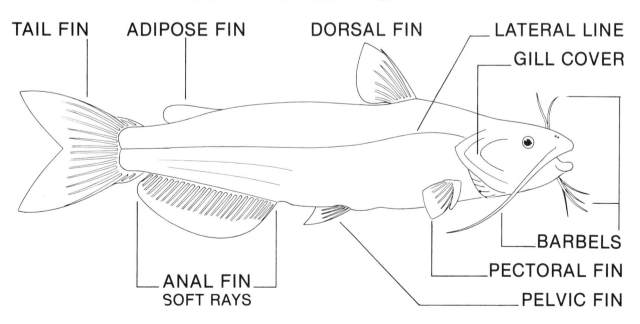

TAIL FIN ADIPOSE FIN DORSAL FIN LATERAL LINE

GILL COVER

BARBELS

PECTORAL FIN

PELVIC FIN

ANAL FIN
SOFT RAYS

Patterns

I begin drawing a pattern from measurements of my frozen specimens with help from my reference files. Unlike songbirds or waterfowl, you are not locked into any definite size. Fish can vary in size without too many anatomical changes. The desired size is not important at this time; rather, the patterns show the anatomy as accurately as possible.

With the use of film grid patterns I can proportionately increase or decrease my pattern in a short time and with little effort. For example, the bluegill pattern (FIG. 1) was six inches long. In order to increase the size to seven inches I first place a 7/16 inch positive over the smaller drawing, then with a 1/2 inch grid pattern and a piece of tracing paper over the positive I plot the outline of my new drawing (FIG. 2).

Several drawings of different sizes can be made rather quickly using any grid pattern you wish. These drawings are then transferred to chipboard and cut out (FIG. 3).

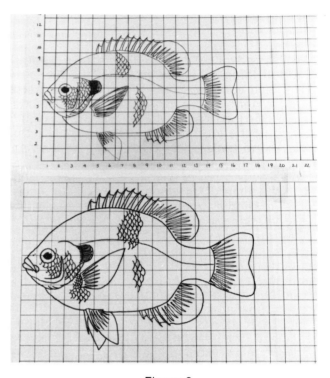

Figure 2

Figure 3

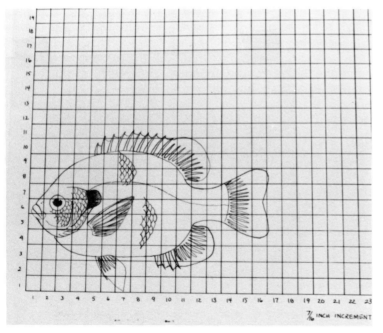

Figure 1

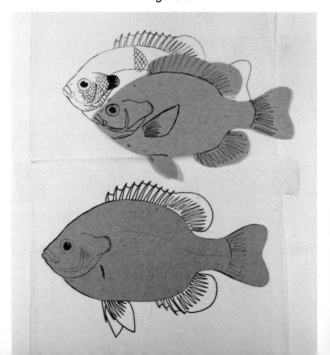

Carving Basics

TOOLS:

I will not advocate the use of one tool or other. The important thing is that whether a hand tool or power tool is used, you use it safely and only for the task it is meant to perform. I readily go to the tool that does the specific job intended so, as you go through the carving of the four projects, you will notice that I prefer hand tools. I like the feeling I get when a gouge or knife removes the wood into piles of wood chips. Power tools evaporate that feeling but they can save time. This is particularly true when it comes to sanding your carving to a smooth surface in preparation for painting.

Dust creates several problems. Lately much has been written about the hazards of inhaling large amounts of wood dust. Every precaution should be taken to prevent the breathing in of any dust. Dust collectors are best but masks and goggles do prevent inhaling most of the dust.

Figure 1 shows various knives on a piece of basswood. The knife on the extreme left is an X-acto handle with a homemade blade for downward cuts. The next three, also X-acto, perform very well for numerous cutting jobs, but mostly for detail work. The last two carving knives make roughing out your carving an easy task. I have several handy so I can carve for a longer time without stopping to hone a sharp edge on the blade.

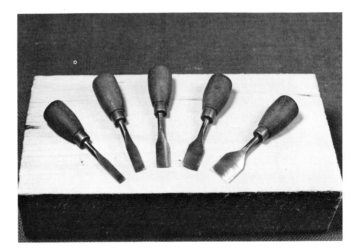

Figure 2

The flat gouges shown in Figure 2 were fashioned from wood bits and range in size from three-eighths to one inch. They have very good steel and keep a sharp edge for a considerable length of time.

The first two gouges shown in Figure 3 are from a set made by Harmon Tools. The other four, smaller gouges are also from a Harmon set. These sets are very good starter sets, are reasonably priced and excellent for fine detail. The two X-acto U-gouges are 1/16 inch and 1/8 inch. All these tools will maintain a good cutting edge but must be kept sharp to provide the best results (FIG. 4).

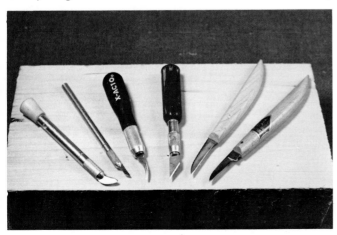

Figure 1

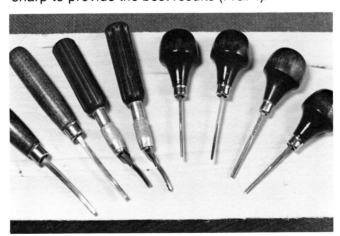

Figure 3

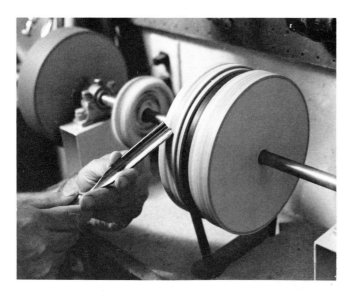

Figure 4

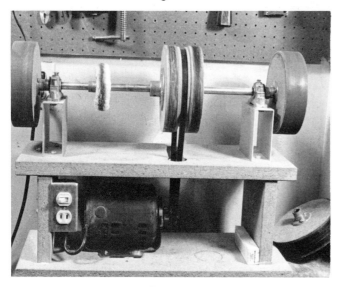

Figure 5

For my time and money, a sharpening machine is invaluable. The one I use (FIG. 5) has two wheels with 120 grit crocus cloth and 240 grit crocus cloth, a leather stropping wheel and a buffing wheel. This machine is the fine work of a fellow carver in Omaha, Ferd Nordrum. As you can see, this machine is very well built and no doubt will serve me loyally throughout my carving career.

Other tools and equipment will be shown as we proceed with the carving and painting of the four projects.

WOOD:

The type of wood you use depends mainly on availability and how it carves. My preference is basswood, not only for its clear, fine grain, making it easy to carve, but for its strength. I especially like it when I am able to carve a fin almost as thin as a real one.

Other popular carving woods, although not as readily available, are jelutong, sugar pine and

tupelo (water gum). Whatever the wood used, ease of carving depends, of course, on the tools you use.

GLASS EYES:

After choosing a subject for your carving you need to consider the eyes. Glass eyes can be purchased from any taxidermy or wood carving supply company. Tohickon, Van Dyke and J. W. Elwood Taxidermy Supply have excellent painted and unpainted eyes for all species of freshwater fish. When painting my own I choose the black pupil on wire for ease in holding while I paint them with Testor's enamel. The size, of course, depends on the species and size of the fish. The circle template aids in marking the eye socket as you will see later in the carving segments (FIG. 6).

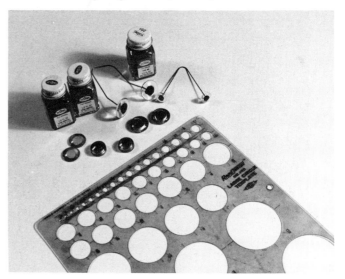

Figure 6

FINISHED WOOD BASES:

Some people, of course, make their own display bases. I prefer to purchase mine because it saves me much time and trouble.

Joe Hinman is a quality woodworker. His knowledge of woods and his ability to work with them have contributed greatly to enhancing my compositions. We have a matching numbered set of elliptical patterns, as well as some teardrop shapes. As soon as I determine the base I shall need, I call him, give him the pattern number, type of wood and edging desired, and he makes the finished base while I am completing the painting of my piece. I use rough cut-outs of the bases for planning and doing the preliminary mounting of the driftwood to which my carvings will be attached.

The sizes of the bases for the four projects discussed in this book are as follows:

Sunfish: 5 X 8-3/4 inches
Crappie: 6 X 11-1/2 inches
Rainbow: 6-1/4 X 12 inches
Catfish: 9-1/2 X 11-3/4 inches

Bluegill Sunfish

Lepomis macrochirus

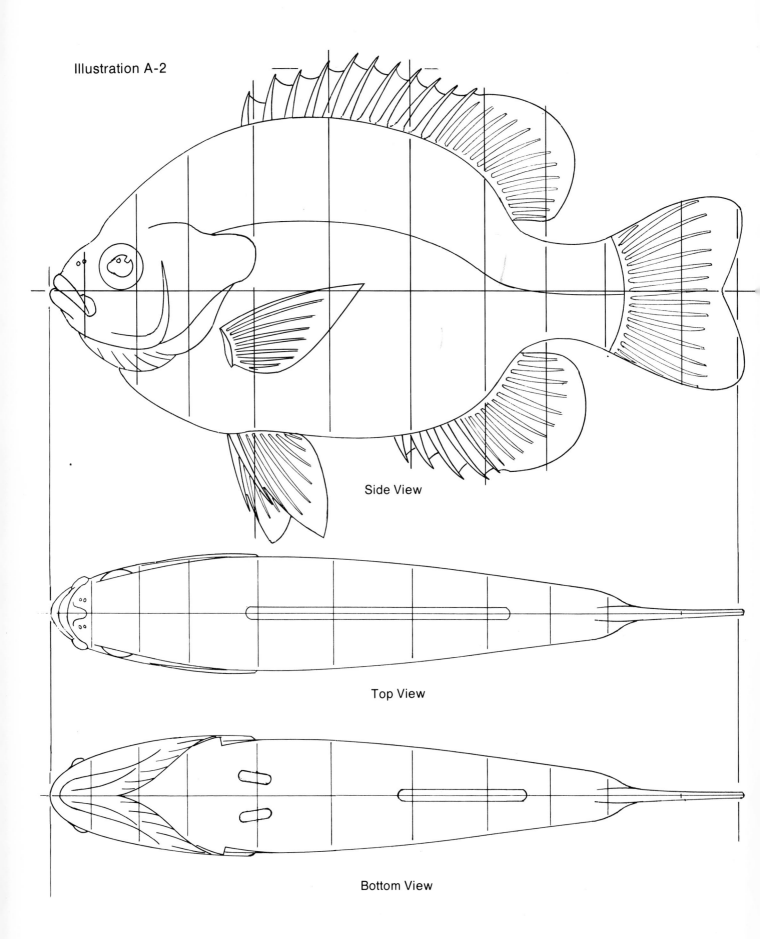

Illustration A-2

Side View

Top View

Bottom View

(1) Dorsal Fin

(3) Anal Fin

(4) Pectoral Fin

Top View

(2) Pelvic Fin

Bottom View

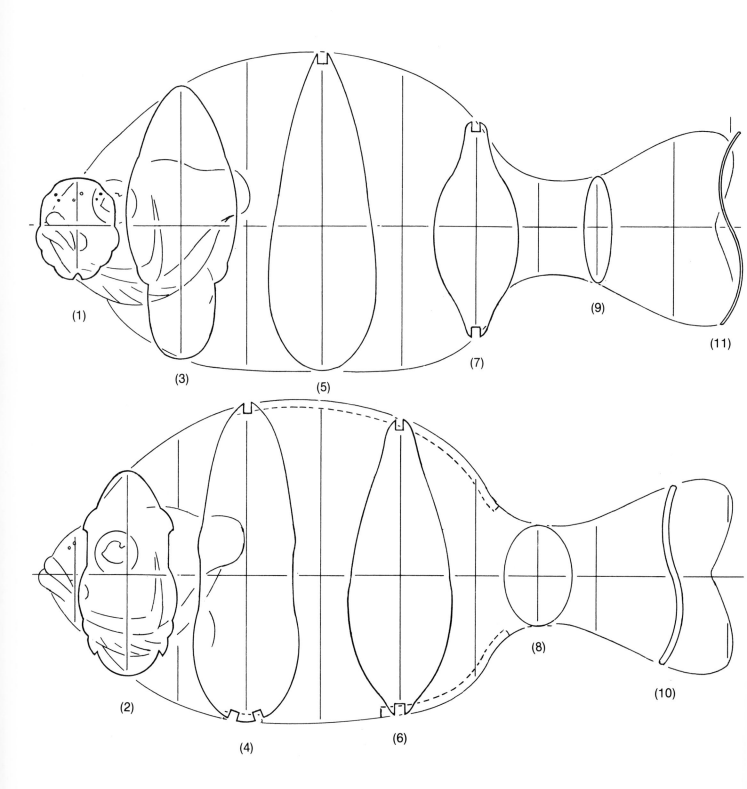

(1)

(3)

(5)

(7)

(9)

(11)

(2)

(4)

(6)

(8)

(10)

Cross Sections

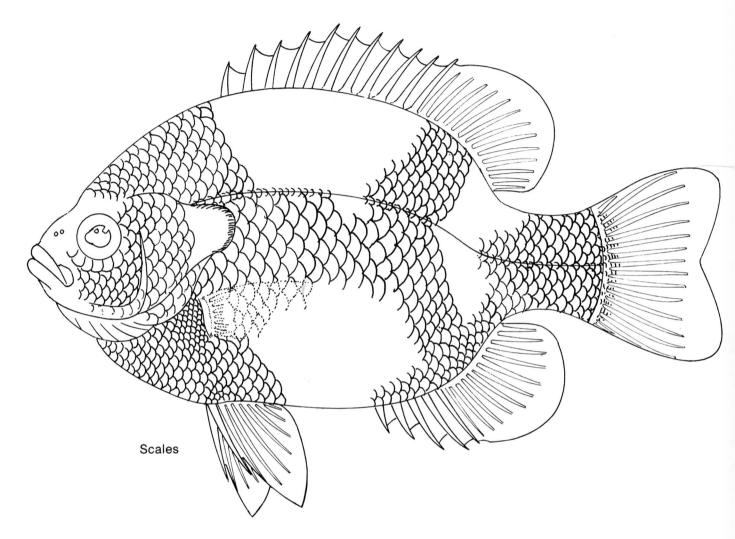

Scales

BLUEGILL SUNFISH

The sunfish family consists of over thirty species The bass, crappies and sunfish, genus Lepomis, make up this family of colorful freshwater gamefish. This most popular panfish is regionally known by many names but here in the Midwest they are called bluegills. In fact, bluegill has become the generic name for many similar members of the sunfish family. The flap on the gill cover, being blue-black in color right out to the edge, is the most useful key for identifying this abundant fish.

Sunfish provide many hours of fishing enjoyment for all ages and skill levels of the angler. Not only are sunfish good eating, they bite on a wide range of bait all year long under varying weather conditions. The bluegill sunfish is known as a spiny-rayed fish for having spines in both the dorsal and anal fins.

I have chosen the bluegill for my first carving project because of its popularity. Many times at shows I have heard the comments, "That's a bluegill, like we caught last summer," or "We used to catch them just that size when I was a kid."

Illustration A-6
Carving the pectoral fin muscle

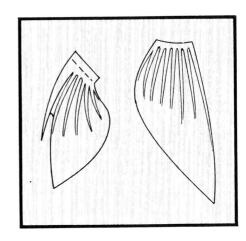

Illustration A-7
Pelvic and pectoral fin—wood-grain direction

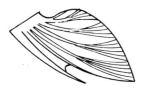

Illustration A-8
Pelvic fin—wood burned rays

Illustration A-9
Pectoral fin—wood burned

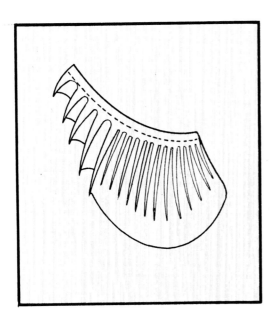

Illustration A-10
Anal fin—wood grain direction

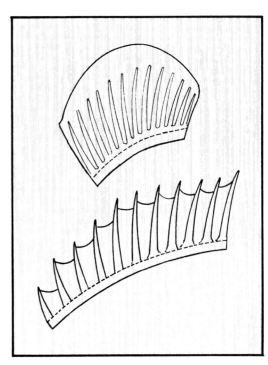

Illustration A-11
Dorsal fin—wood grain direction

CARVING THE BLUEGILL SUNFISH

The following use of patterns will show how important they are in creating a well-planned, artistic piece. Figure 1 shows the rough base for the bluegill we are to carve and the pattern from which the base was cut. This oval base, made from cherrywood to enhance the colors on the belly of the fish, measures 5 inches by 8-3/4 inches by 1 inch.

The bottom of the driftwood selected to best display our sunfish is sawed flat and sanded to fit on the base (FIG. 2). Use the sunfish pattern to approximate where on the base the driftwood will best exhibit the finished work. When the position of the driftwood is determined, two small (1/16 inch) holes are then drilled approximately 1/2 inch deep into the driftwood (FIG. 3). Then we insert two small nails cut to a length of 1/16 inch more than the depth of the holes, position the driftwood on the base pattern where we want it to be attached, and push to mark the pattern with the inserted nails.

Figure 2

Figure 1

Figure 3

Figure 4

Figure 6

Figure 5

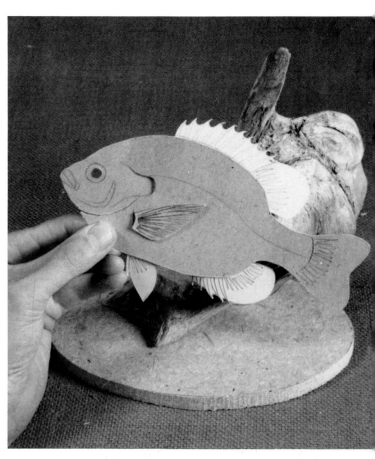

Figure 7

Using the marked base pattern, mark the rough base with a pencil (FIG. 4), drill the mounting holes to the proper size (FIG. 5), and mount the driftwood to the rough base with 1-1/2 inch wood screws (FIG. 6). We can now use the sunfish pattern to again get an idea how the finished bluegill will look when mounted (FIG. 7).

Now we are ready to prepare the basswood for carving. Using the pattern we cut out before, transfer the top view shape to a block of basswood measuring 7-1/2 by 3-1/2 by 2-1/4 inches (FIG. 8) and cut out the shape on a band saw (FIG. 9), saving the scraps for later use. After tracing the side view pattern onto the wood (FIG. 10), cut out the side view shape (FIG. 11), remembering to allow for the curvature of the pattern so as not to distort the cut-out shape.

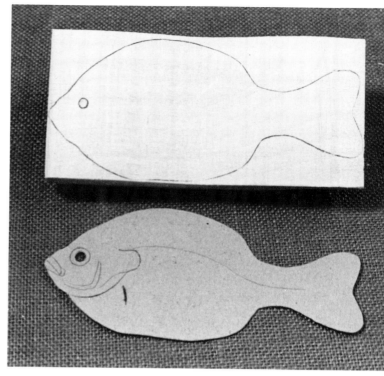

Figure 10

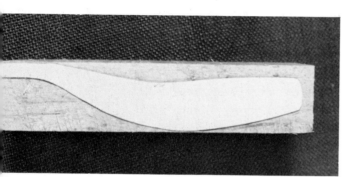

Figure 8

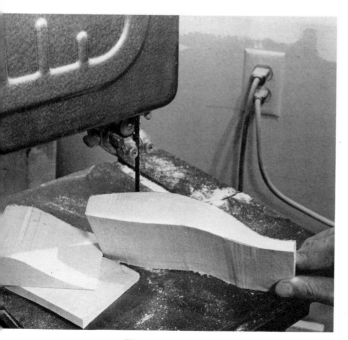

Figure 9

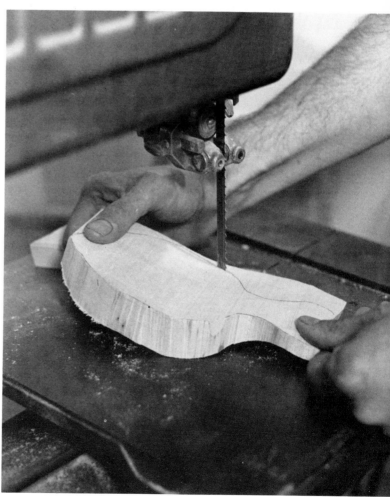

Figure 11

29

Now we draw the center line on the top view, indicating the area of the dorsal fin (FIG. 12), and on the ventral or bottom view, marking the location of the anal fin (FIG. 13). These lines will remain important to retain the shape of the pattern as we carve.

Using the side view pattern, mark and drill the eyes 1/2 inch deep with a 1/4 inch drill bit (FIG. 14). The eye will actually be larger but for the time being this will mark its location so it can be used as a reference when we carve the head. With the eye as a reference, use the gill pattern to draw the gill outline (FIG. 15). After marking the location of the pectoral fin muscle (FIG. 16), with a curved blade cut 1/16 inch from the edge of the gill cover outline to a depth of 1/16 to 3/32 inch (FIG. 17). This line can be altered later but now kept for reference and future use. As we did with the gill outline, we now cut down on the pectoral muscle (FIG. 18).

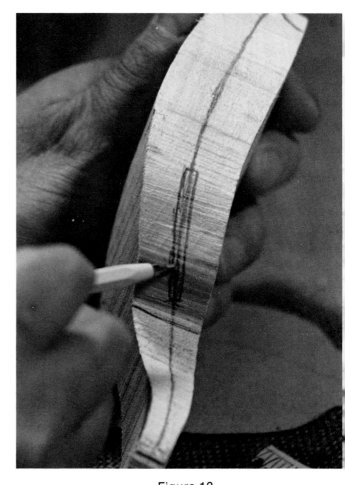

Figure 13

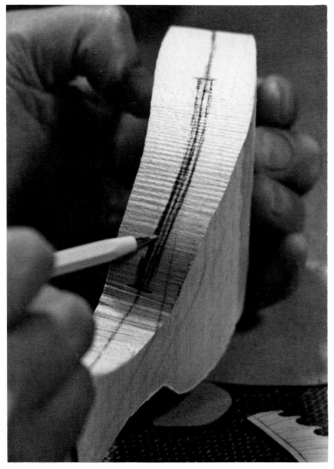

Figure 12

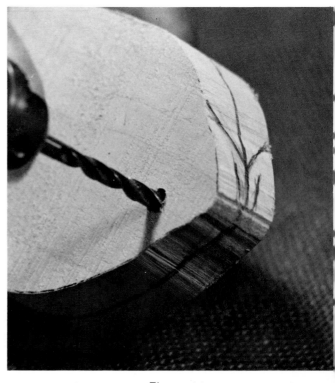

Figure 14

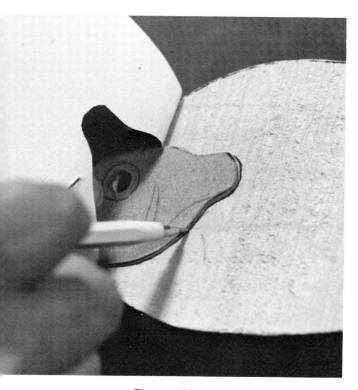

Figure 15

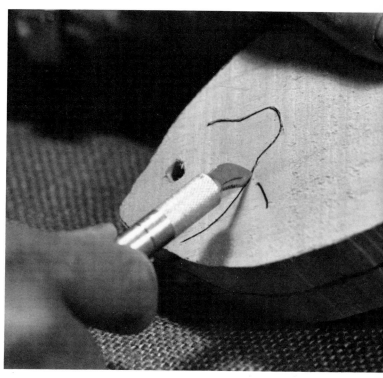

Figure 17

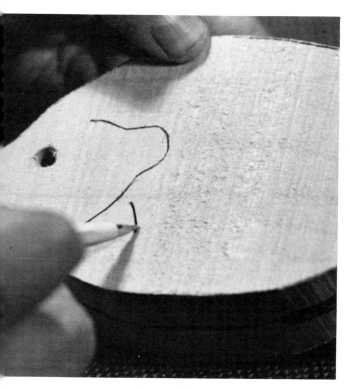

Figure 16

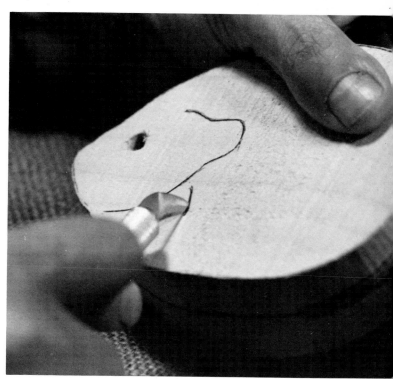

Figure 18

While referring as often as needed to Illustration A-4, showing the cross-sections, to maintain the correct proportions, we now begin to rough out the body of the sunfish (FIG. 19). I use a Murphy knife. With a fairly large gouge, a 14 mm with a No.7 sweep, we rough out the tail (FIG. 20), then refine it with a smaller, one-half inch gouge (FIG. 21). In shaping the tail be sure to form the wave or ripple (FIG. 22) to give the fish movement and life.

Always keeping the center line in perspective, continue carving the body toward the head (FIG. 23), rounding the body to the center lines (FIG. 24). At this point we can really see the sunfish taking shape. I carve the body first, leaving the head to be carved after the body is sanded.

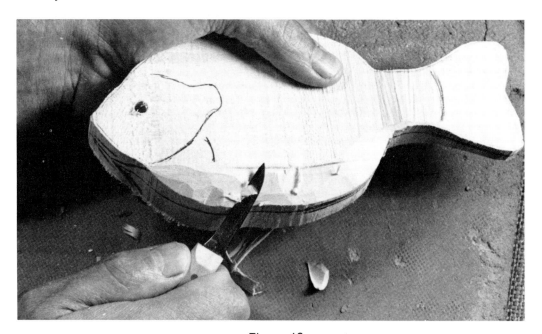

Figure 19

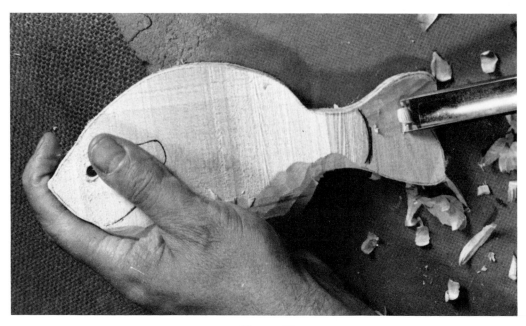

Figure 20

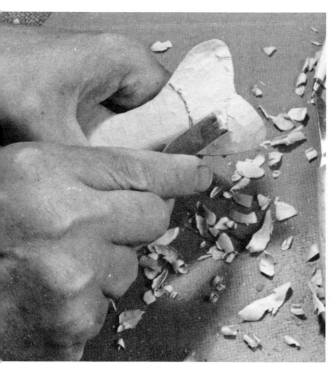

Figure 21

Figure 23

Figure 22

Figure 24

Not worrying too much about carving the head at this time, we next cut the relief around the gills and the head, using a 1/2 inch chisel, knife and stop cuts (FIG. 25, 26, 27). Again using the 1/2 inch gouge, I now put in the pectoral fin muscle (FIG. 28), and refine the area around it with a knife (FIG. 29 and Illustration A-6).

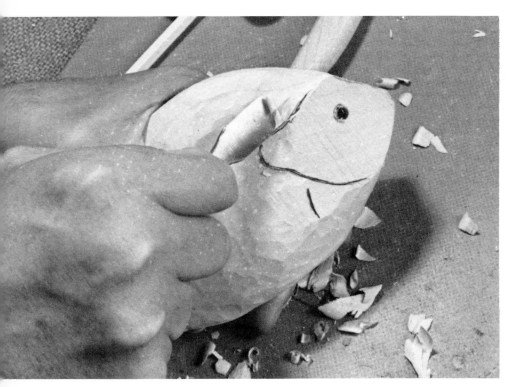

Figure 25

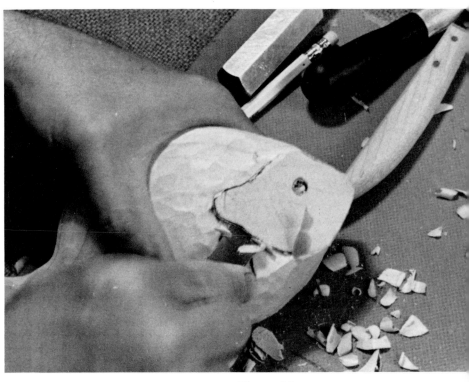

Figure 27

Figure 26

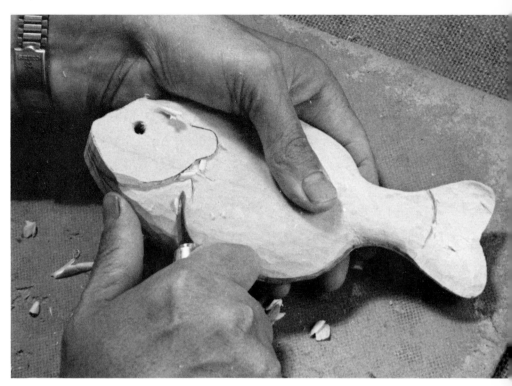

Figure 29

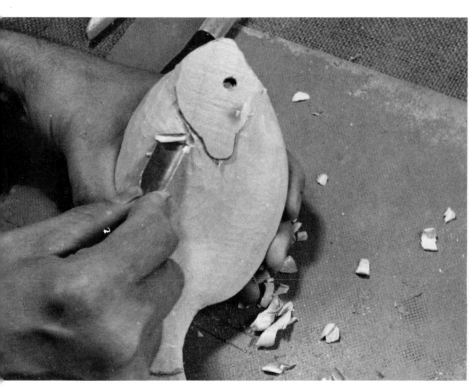

Figure 28

Now we refine the rough carving of the body (FIG. 30), the area of the anal fin muscle (FIG. 31), and the area of the dorsal fin muscle (FIG. 32), after which we are prepared to sand the body. I use a Foredom tool with tootsie roll and drum sanders (FIG. 33) to sand the carved fish to a smooth finish.

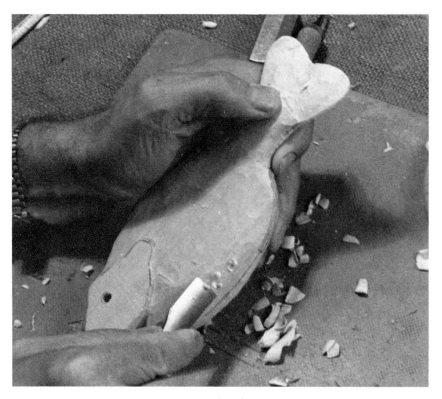

Figure 30

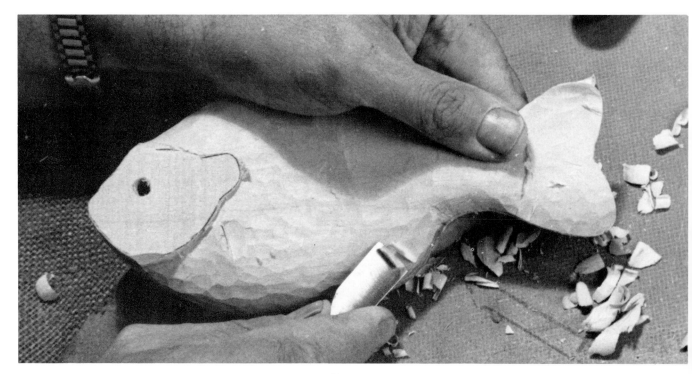

Figure 31

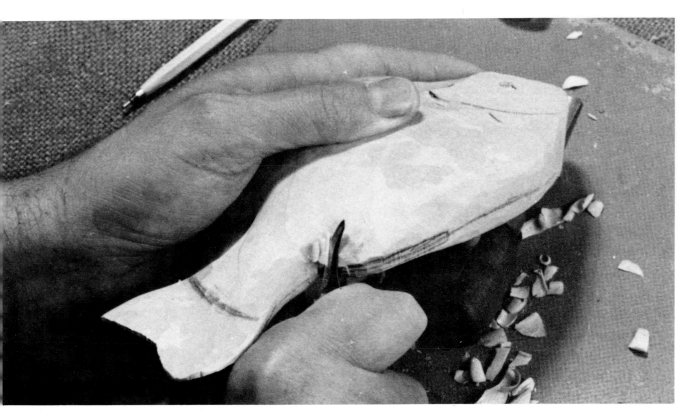

Figure 32

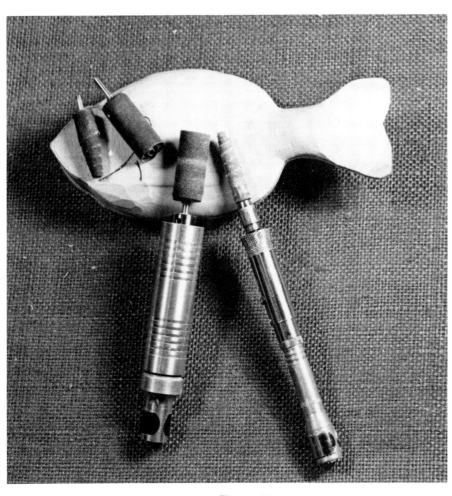

Figure 33

Sand the tail areas first with the drum sander (FIG. 35) and then the tail ripple or wave with the tootsie roll sander (FIG. 36), followed by the area around the anal fin (FIG. 37). After sanding the body with the large drum sander (FIG. 38), it is time for hand sanding with 240 grit crocus cloth or sandpaper to remove all marks left by the drum sander (FIG. 39, 40).

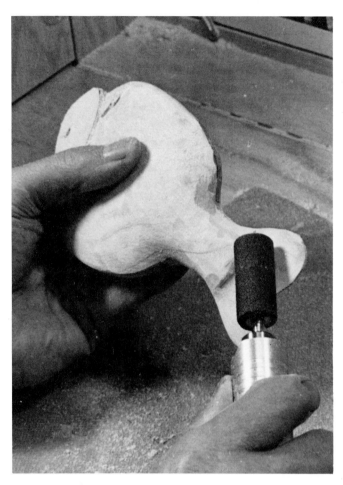

Figure 35

Figure 36

Figure 37

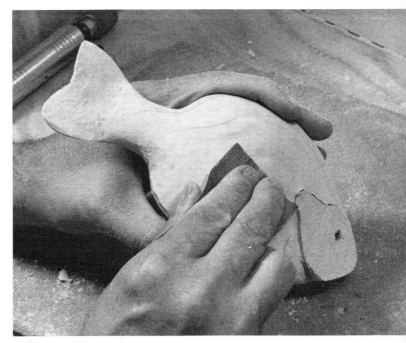

Figure 39

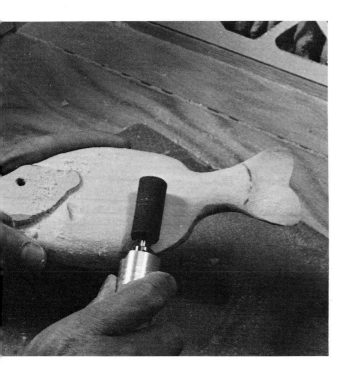

Figure 38

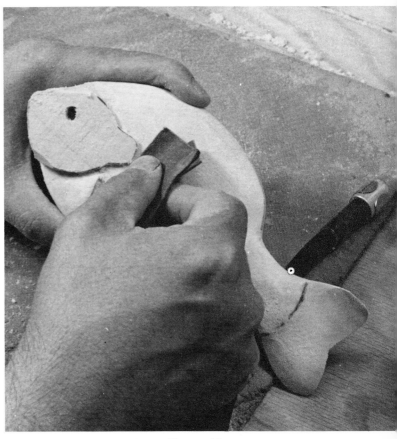

Figure 40

Using the pattern with the head detail and a pin to mark the detail on the wood (FIG. 41), transfer the pattern detail to the wood by connecting the pin marks with a pencil (FIG. 42).

Before we start the final stages of carving the fish, it is a good idea to fit the sunfish to the position it will occupy on the driftwood. We need to sand the driftwood at the point where the sunfish is to be mounted (FIG. 43), and position the sunfish where it will be attached to the driftwood (FIG. 44), checking to see the fish fits properly and gives the composition its best look (FIG. 45). Notice how the driftwood is sanded to conform to the shape of the fish at the point it is to be mounted (FIG. 44, 46).

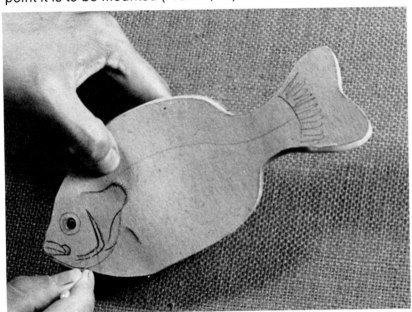

Figure 41

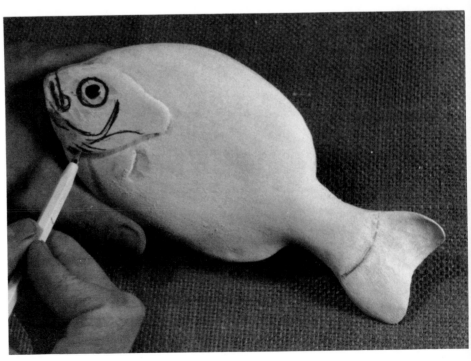

Figure 42

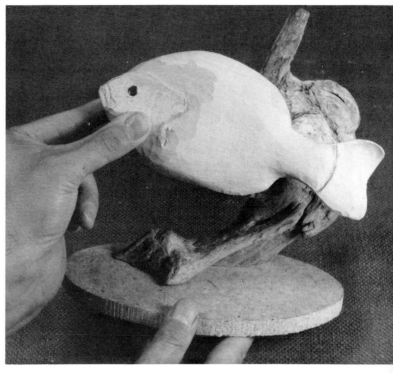

Figure 43

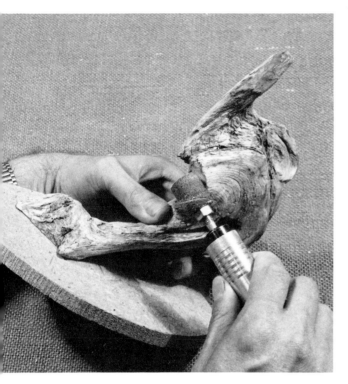

Figure 45

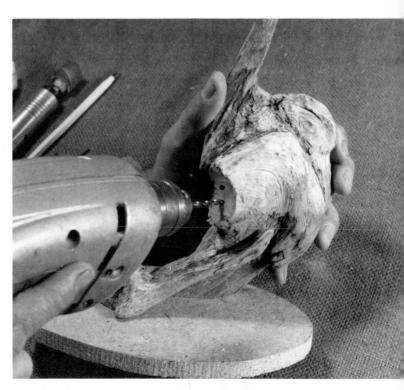

Figure 44

Figure 46

41

When the sunfish fits just right, drill two 1/8 inch holes in the driftwood. To mark the holes on the sunfish, use a piece of acetate (a folder divider) cut out from the sunfish pattern, position it on the driftwood, and mark the holes with a pencil (FIG. 47). Be sure to reverse it to mark the holes on the sunfish itself (FIG. 48), and drill the 1/8 inch holes (FIG. 49). Metal pins cut from welding rods or nails are used to attach the sunfish to the driftwood, inserting the pins in the driftwood first (FIG. 50). Figures 51 and 52 show the unfinished sunfish attached to the driftwood and base.

Figure 53 shows the sunfish with the cross-section lines corresponding to the cross-sections in Illustration A-4, along with calipers useful in maintaining proper positions and proportions. The cross-section lines (FIG. 54) will be used to accurately place the fish's fins.

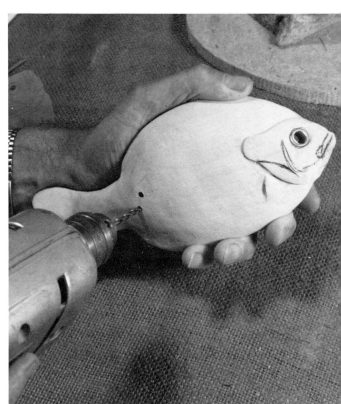

Figure 49

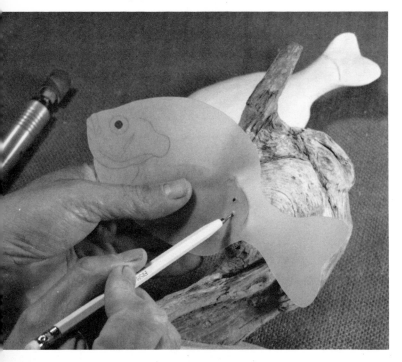

Figure 47

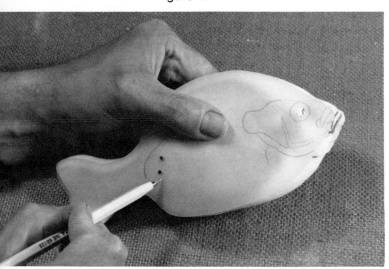

Figure 48

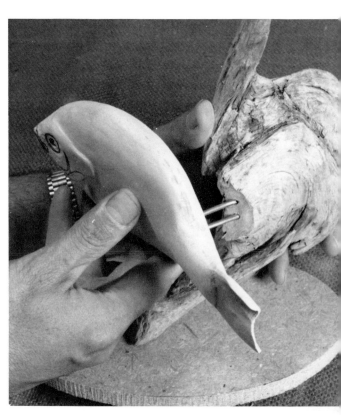

Figure 50

42

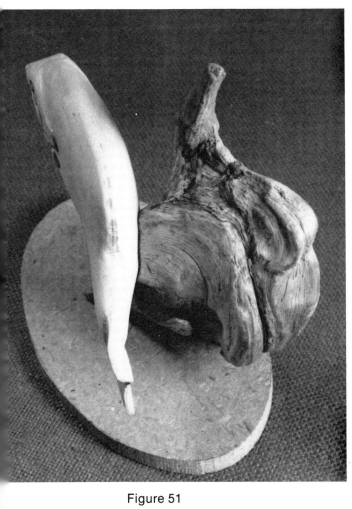

Figure 51

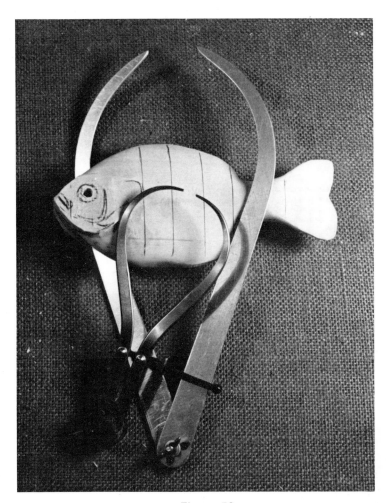

Figure 53

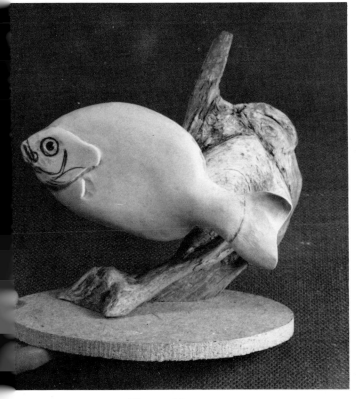

Figure 52

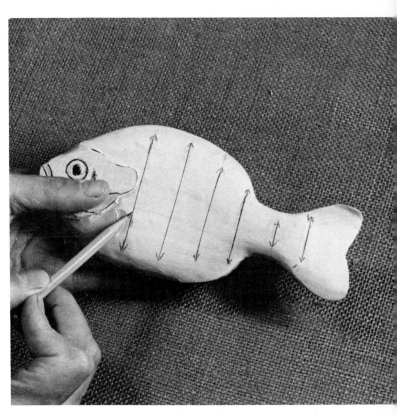

Figure 54

Since we have already drawn the detail lines on the sunfish's head and have sanded the body, we can now begin carving the head by cutting out the upper jaw with a curved knife (FIG. 55). I then rough out the head with my Murphy knife (FIG. 56), refining and putting in the detail with a small blade X-acto knife (FIG. 57). When the head is carved, it should be sanded with 120 grit crocus cloth or sandpaper to smooth out the rough surfaces (FIG. 58).

With a pencil mark the gill lines (FIG. 59) before cutting them with a small V-gouge (FIG. 60). I use a dental pick, a very useful tool, to put in the nostrils, as shown in Figure 61. Again using the dental pick, press in the detail on the gill flap as shown in Figure 62.

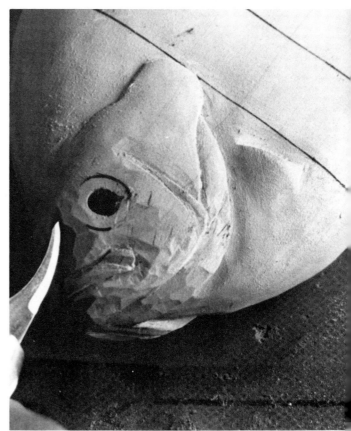

Figure 57

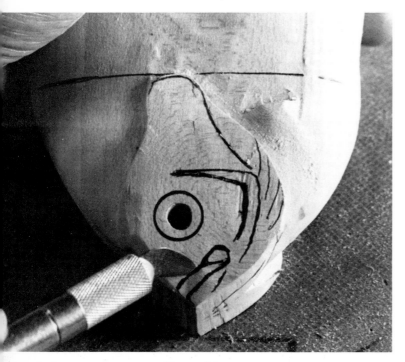

Figure 55

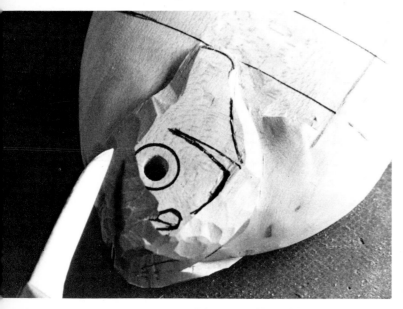

Figure 56

Figure 58

Figure 59

Figure 60

Figure 61

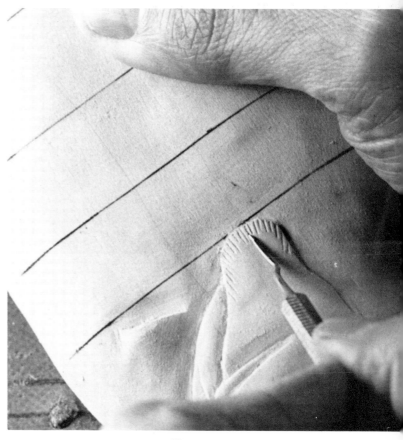

Figure 62

I use a circle template to insure the eye holes are the right size to hold the eyes (FIG. 63). In this case the eyes are 14mm. I use the template to mark the eye size where the holes were drilled before (FIG. 64) and carefully cut the eye cavity about 1/4 inch deep with a ruby cutter on the Foredom (FIG. 65), constantly checking that the hole is the correct size for the eye.

Since the head has been carved, redraw the cross-section lines from the cross-section illustrations (FIG. 66) on the head and check the anatomy with Illustration A-4.

To guarantee accuracy, pencil in the rays of the tail fin (FIG. 67) before carving them with a small (1/16 inch) U-gouge (FIG. 68). With a piece of 240 grit crocus cloth or sandpaper, form the roundness to the rays (FIG. 69).

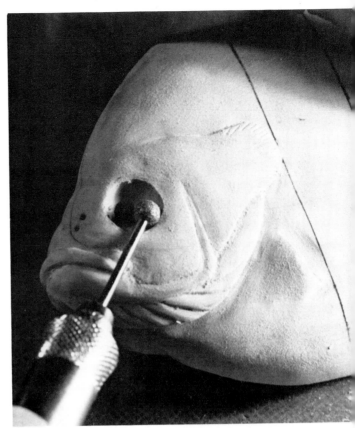

Figure 65

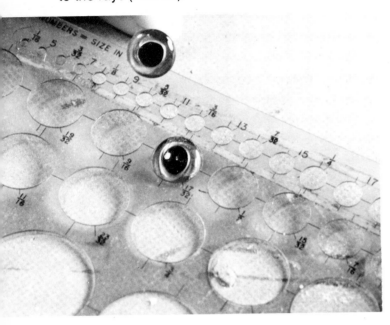

Figure 63

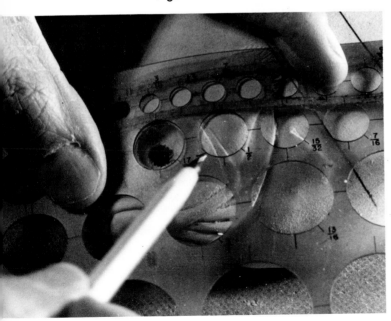

Figure 64

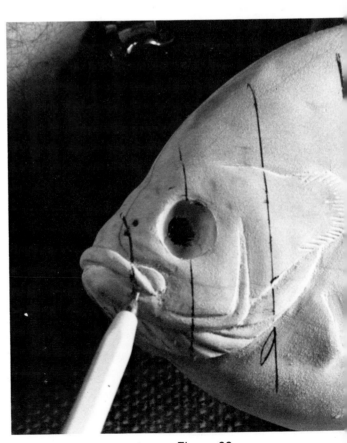

Figure 66

46

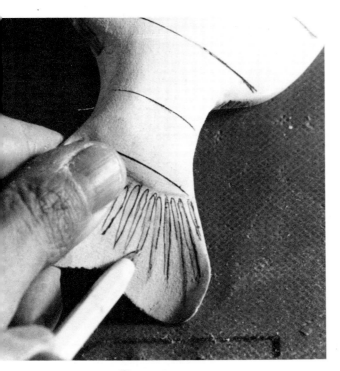

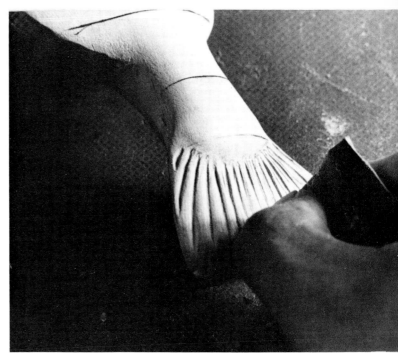

Figure 67

Figure 69

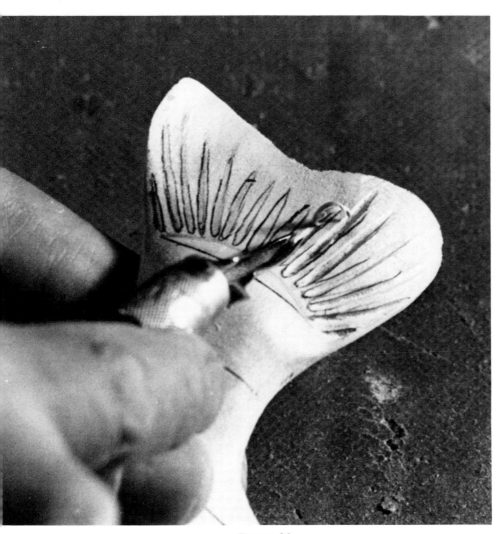

Figure 68

Refer to Illustration A-7 for the grain direction for the pelvic and pectoral fins. Using the cardboard fin cut-outs, made from the patterns shown in Illustration A-3, draw the fin patterns onto the wood scraps cut into 1/8 to 1/4 inch thick pieces (FIG. 70, 71), and carefully cut them out on a bandsaw (FIG. 72), with the grain running from the bases of the fins toward the ends of the rays or fans. With a #7 sweep gouge cut a slight curvature in the pelvic fin (FIG. 73). Figure 74 shows the curvature carved in the fin on the left and the uncarved fin with a line drawn to mark the edge of the curve.

Figure 72

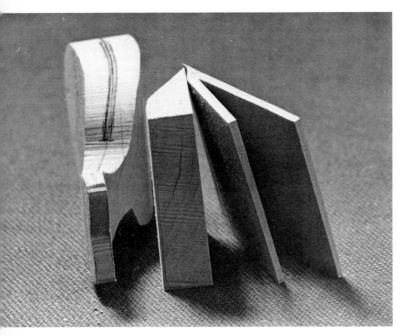

Figure 70

Figure 71

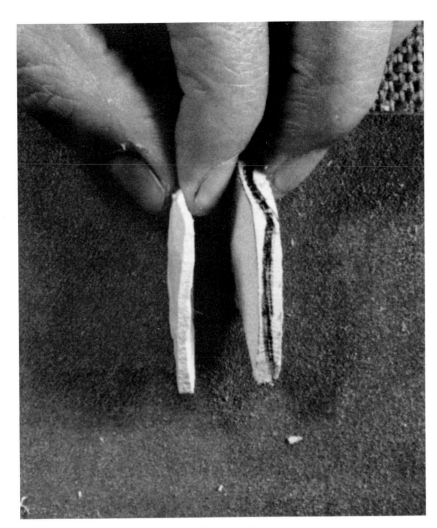

Figure 74

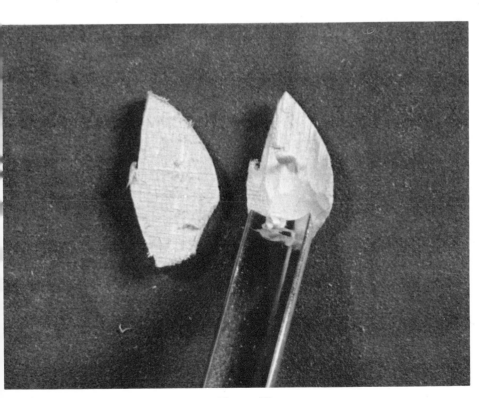

Figure 73

49

Now we mark and carve out the pelvic fin spine with a small gouge (FIG. 75), in effect making a groove along both sides of the spine so a larger U-gouge can then be used to taper the area from the fin's soft rays into the gouge line along the spine (FIG. 76). Be patient and careful not to apply too much pressure so the fin cracks or breaks. A 3/8 inch gouge is then used to remove the wood from the soft rays to obtain the proper thickness of the fin (FIG. 77).

Before drawing the lines for the soft rays of the fins (FIG. 79), sand the fin with a small piece of 240 grit crocus cloth or sandpaper (FIG. 78). After drawing the lines, carve in the soft rays with a small (1/16 inch) U-gouge (FIG. 80), again being careful not to break the now rather thin fins, and sand the rays somewhat rounded, again with 240 grit crocus cloth or sandpaper (FIG. 81). The soft rays' detail is then burned in with a fine-edge tip wood burner (FIG. 82), as is the detail of the pelvic spine (FIG. 83). Illustration A-8 shows the rays to be woodburned into the finished fins. All the fins are sealed with Deft or Krylon acrylic spray. Figure 84 shows the pelvic fins finished and ready to paint.

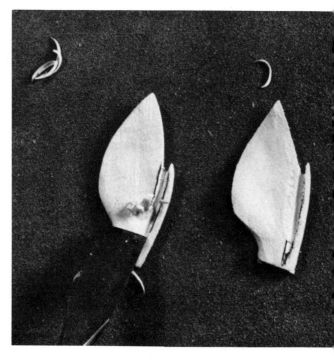

Figure 77

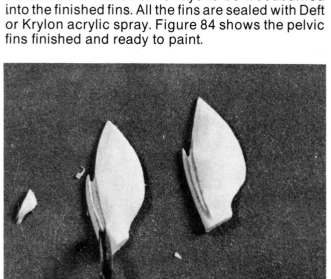

Figure 75

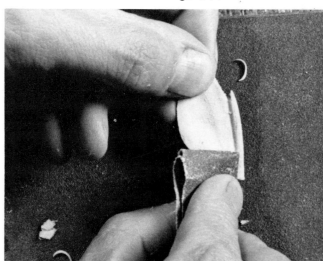

Figure 78

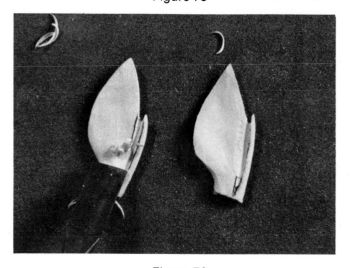

Figure 76

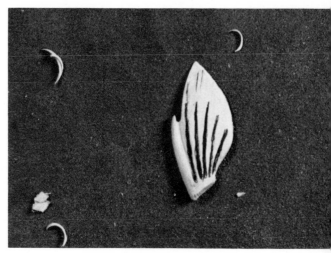

Figure 79

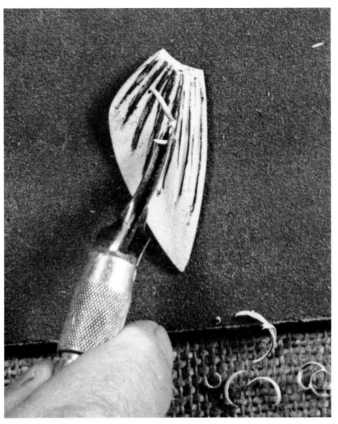

Figure 87

Figure 88

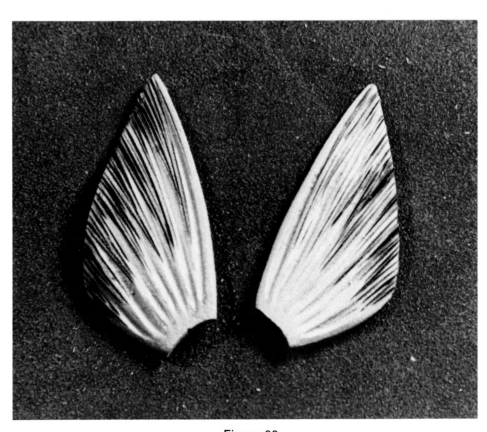

Figure 89

53

On a 3/16 inch thick piece of basswood draw the patterns of the dorsal and anal fins (FIG. 90), and rough them out on a bandsaw (FIG. 91). To cut out the pronounced spines (FIG. 93) on the dorsal and anal fins, use a coping saw (FIG. 92) so as not to cut too far (Illustrations A-10 and A-11).

Figure 90

Figure 91

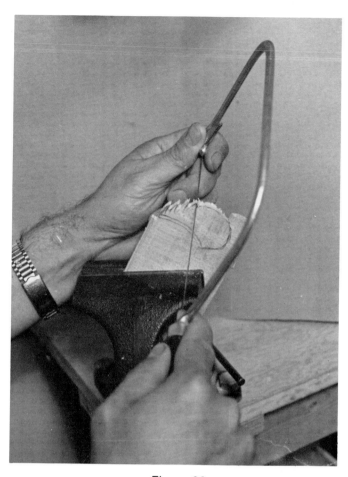

Figure 92

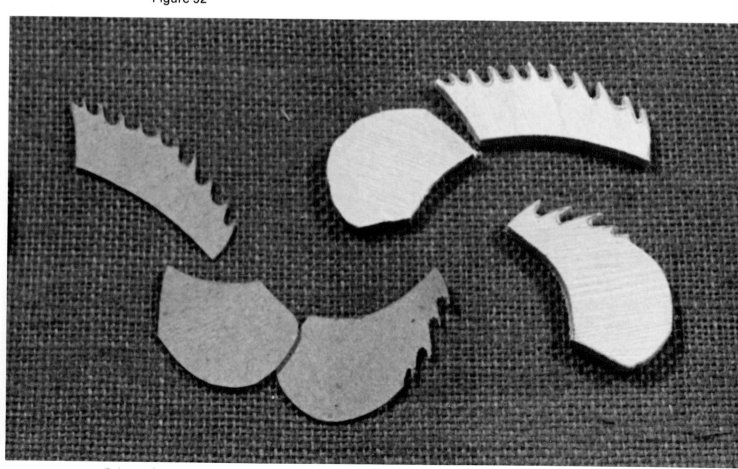

Figure 93

55

Using a 14 mm, No. 7 straight gouge, carve the ripple effect to the soft ray portion of the dorsal fins (FIG. 94), draw in the soft rays (FIG. 95), and carve the rays with a 1/16 inch U-gouge (FIG. 96). Use a small (Harmon) V-tool to create the splits at the ends of the rays (FIG. 97) and a woodburner for the smaller splits and to accentuate the rays themselves (FIG. 98).

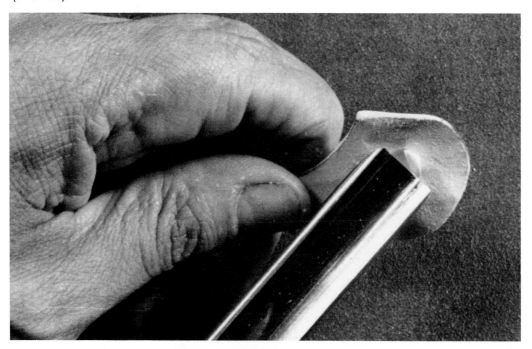

Figure 94

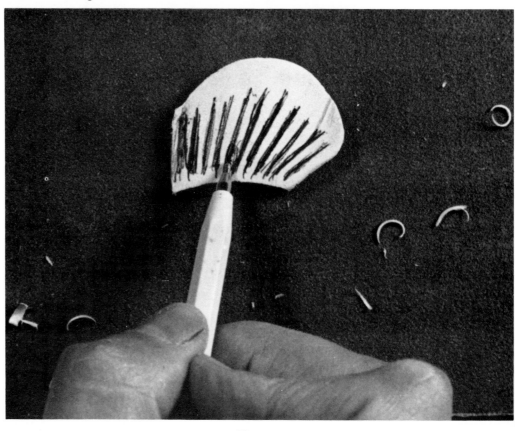

Figure 95

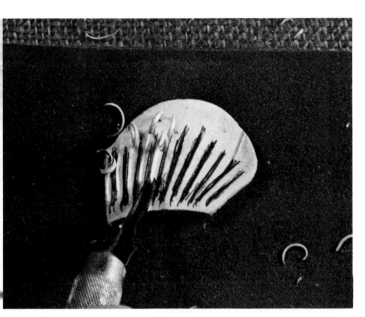

Figure 96

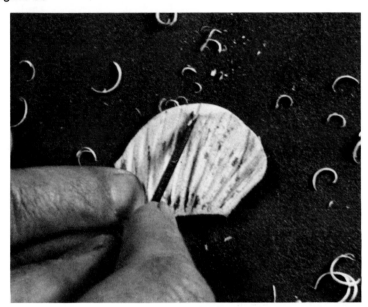

Figure 97

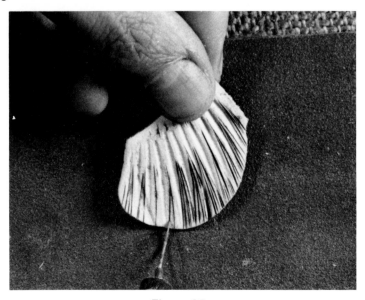

Figure 98

57

Define the spines of the dorsal fin with a piece of sandpaper (FIG. 99) and with a small V-gouge carve along the previously drawn lines of each spine (FIG. 100), defining them by removing wood between the spines with a 1/8 inch U-gouge (FIG. 101) and again with the small V-tool (FIG. 102). After gently sanding the spines round with 240 grit crocus cloth or sandpaper (FIG. 103), put Super Glue on the tips of the spines to strengthen them (FIG. 104). The carved dorsal fins (FIG. 105), now ready for sealing and painting, should be set aside with the other finished fins.

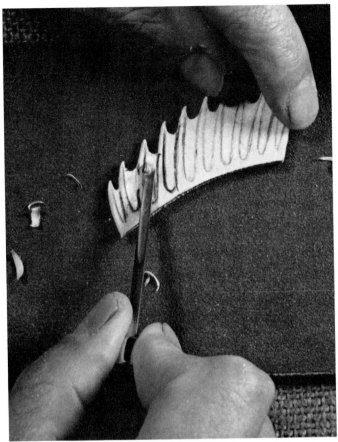

Figure 100

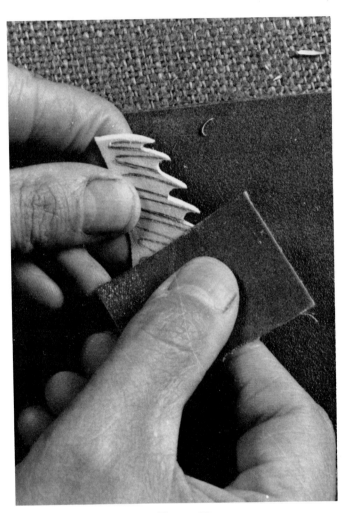

Figure 99

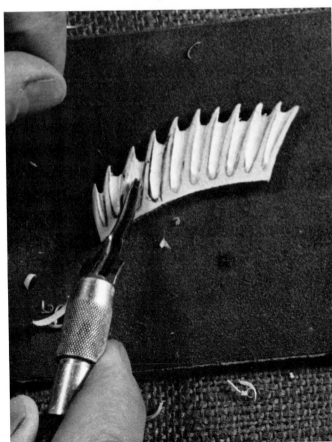

Figure 101

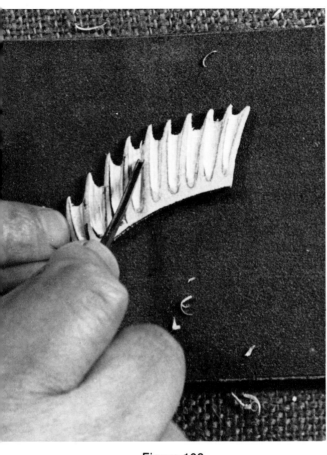

Figure 102

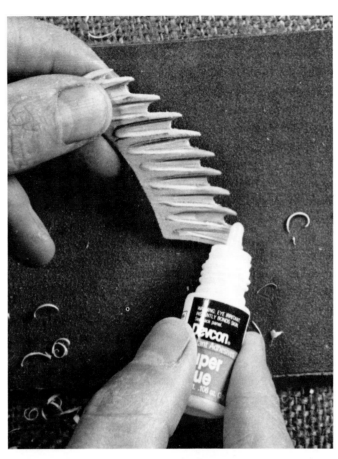

Figure 104

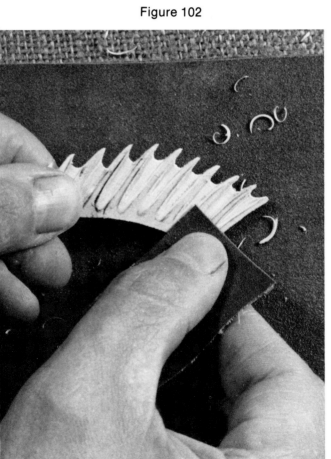

Figure 103

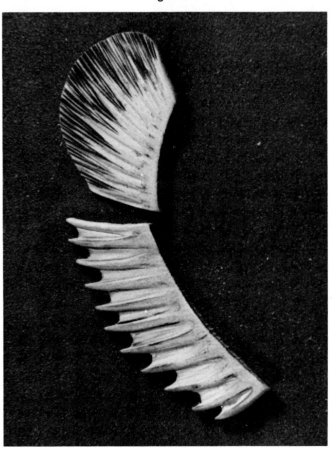

Figure 105

59

Since the anal fin curves as the sunfish turns, we must carve a slight curve to the anal fin corresponding to the curve of the sunfish we are carving (FIG. 106). Be sure the curve also corresponds to the spines of the sunfish, which curve toward the back of the fish. The procedure for carving the spines of the anal fin is the same as that followed for the dorsal fins. First sand the tips of the spines (FIG. 107), which were cut out with a coping saw. Then carve the spines with a small U-gouge (FIG. 108). Follow the same steps as shown in Figures 100 through 105 to achieve the finished anal fin (FIG. 109).

To mount the anal fin, first hold it in place and outline with a pencil the area where it is to be inserted (FIG. 110). Using a knife with a sharply pointed blade, cut down 1/8 inch along the lines just drawn (FIG. 111). I use a 1/8 inch U-gouge to make the cuts at each end of the groove, and along with a small V-gouge to clear and square up inside the groove where the fin is to be inserted (FIG. 112). Making adjustments as needed, fit the anal fin into the slot (FIG. 113).

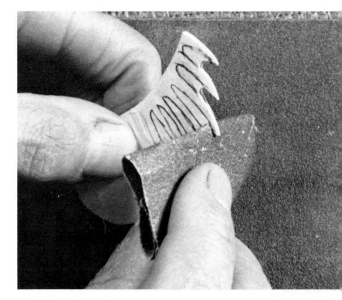

Figure 107

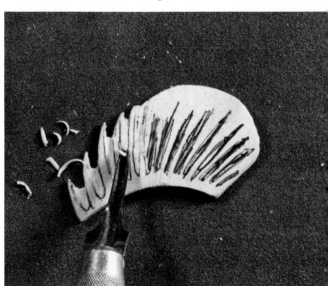

Figure 108

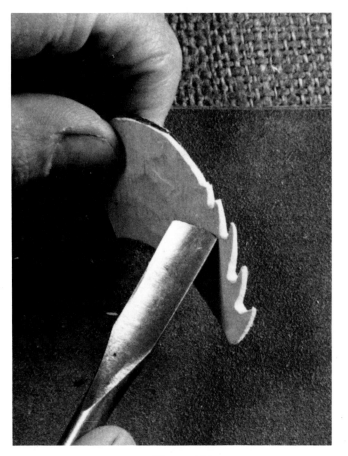

Figure 106

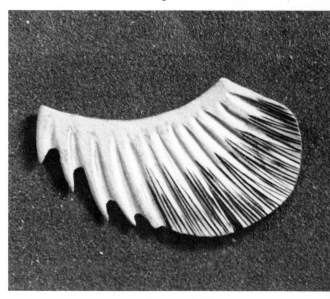

Figure 109

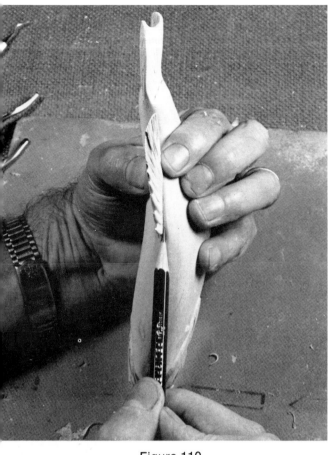

Figure 110

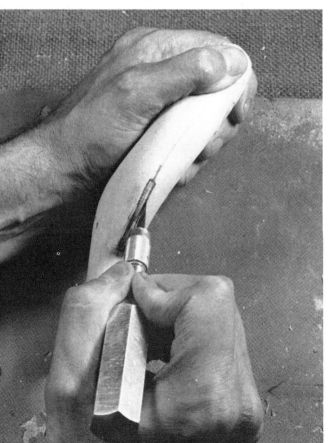

Figure 111

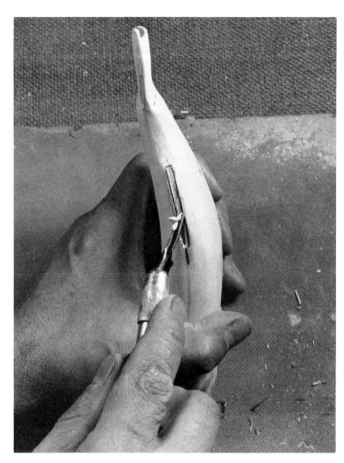

Figure 112

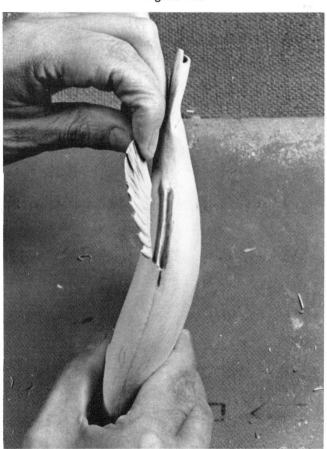

Figure 113

Follow exactly the same procedure to mount the spiny ray dorsal fin and the soft ray dorsal fin (FIG. 114, 115). Again, continually check the fit of the fins into the grooves and make adjustments as required (FIG. 116).

Refer to illustration A-3 on page 23 for the approximate location for the two pelvic fins. Mark the locations and use a U-gouge to open the slots for insertion of the pelvic fins later (FIG. 118). We will not insert them until the fish is painted to minimize the chance of breaking, but do check their fit at this time (FIG. 119).

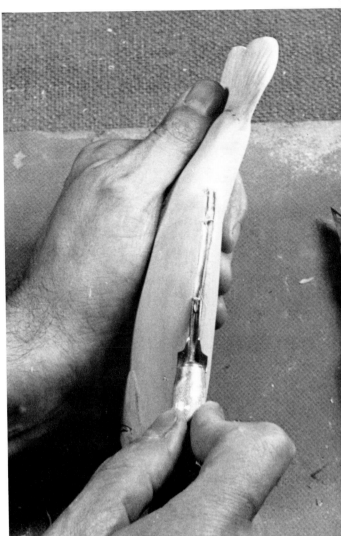

Figure 115

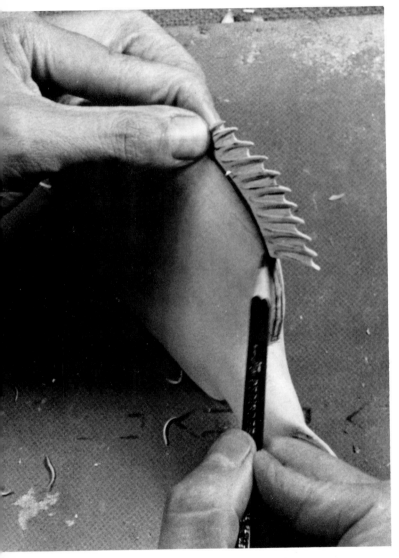

Figure 114

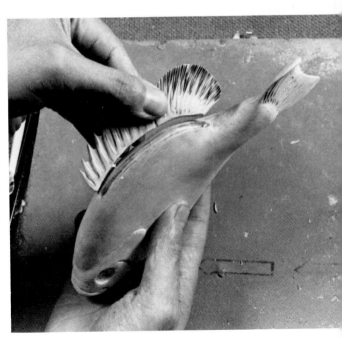

Figure 116

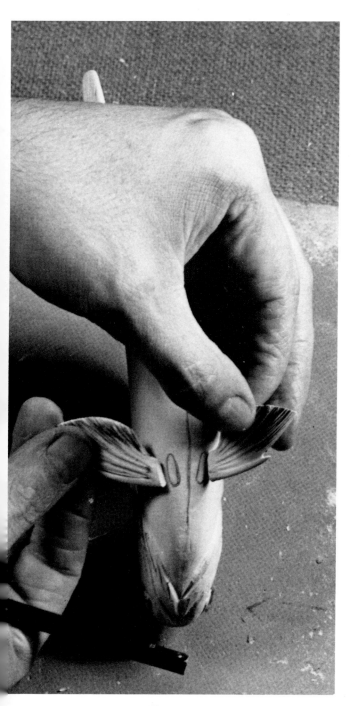

Figure 117

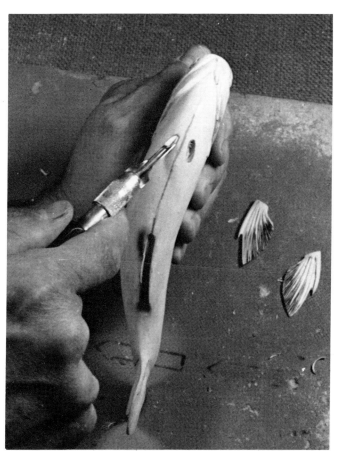

Figure 118

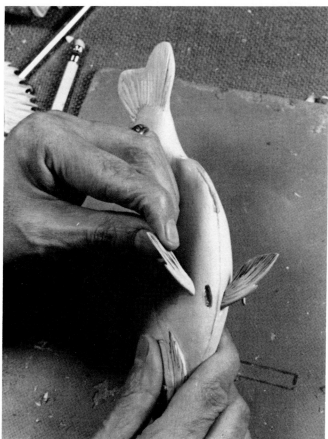

Figure 119

63

I always wait until the fins are carved and ready for insertion before I carve and burn in the rays and splits of the tail fin (FIG. 120, 121). Because the fish body is handled so much when preparing the other fins for mounting, carving the tail fin earlier would make it much too easy to break.

Now it is time to insert the fins, all except the pectoral and pelvic fins, which we will mount later. A water-based white glue works really fine for me (FIG. 122). Put a bead of glue on the edge of the spiny ray dorsal fin (FIG. 123). It is usually not necessary to put any glue in the slot, but if it makes you more confident to do so, use a very small amount. If glue squeezes up when you insert the fins, quickly wipe it away with a damp paper towel. Failing to do so will affect the sealing and painting later on.

When gluing the soft ray or rear portion of the dorsal fin into place, match it up against the front, spiny portion of the fin (FIG. 124). A small amount of glue may be used where the fin sections meet to form a stronger bond. Follow the same procedure for gluing and inserting the anal fin (FIG. 125, 126).

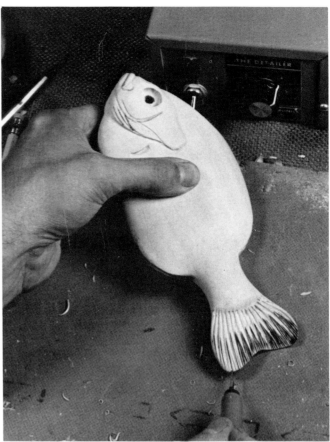

Figure 121

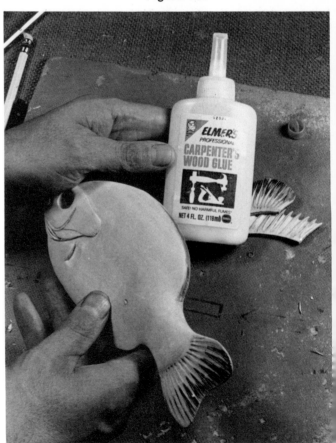

Figure 122

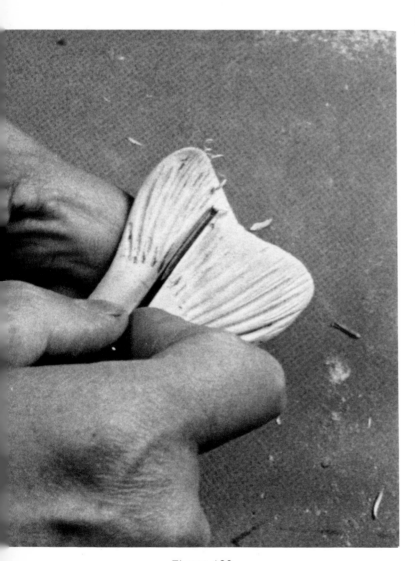

Figure 120

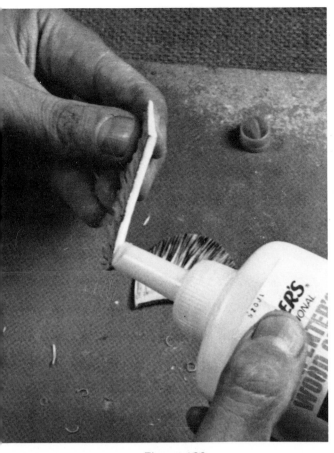

Figure 123

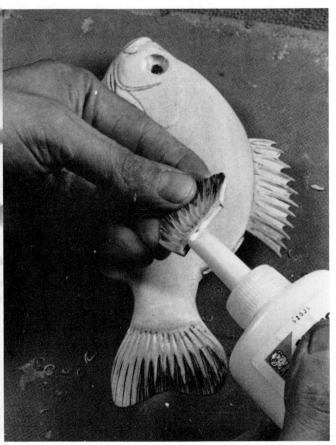

Figure 124

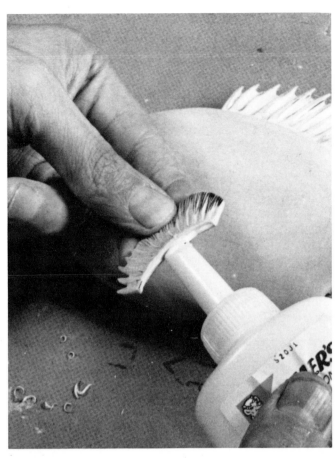

Figure 125

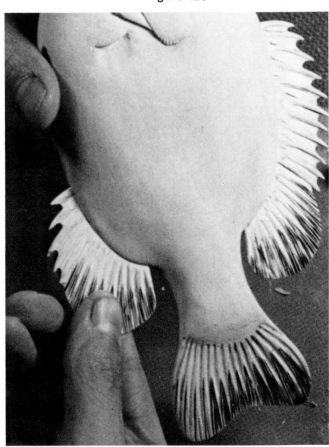

Figure 126

Although other products may work as well or better, I prefer Elmer's Carpenter's Wood Filler for inserting the eyes and any necessary patch work (FIG. 127). Not only is it water soluble, but after it dries it has the same properties as the basswood, seals well and takes paint very nicely.

To prepare for inserting the eye, with a small brush first wet the area in and around the eye socket so the wood filler can penetrate the wood and adhere better (FIG. 128). With a palate knife fill in the eye socket with the wood filler to about 3/4 full (FIG. 129). Position the eye in the socket, squeezing out the excess wood filler around the eye (FIG. 130). This excess filler will be used to form the sclerotic membrane, which is shaped by using a small brush kept wet (FIG. 131). Build up the membrane, but remove any excess if possible so you do not waste time later having to use a knife and sandpaper to remove it (FIG. 132). When the sclerotic membrane is almost completed (FIG. 133) allow the wood filler to dry overnight.

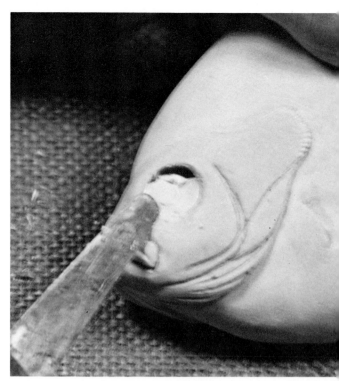

Figure 129

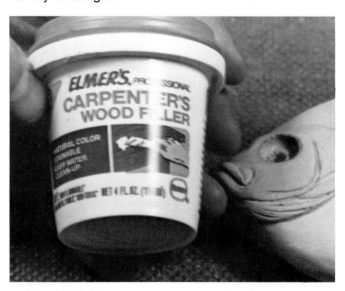

Figure 127

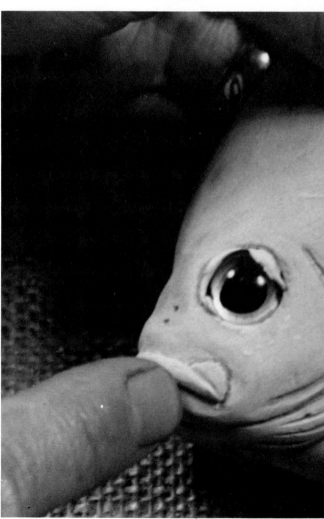

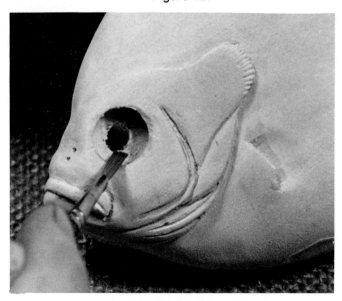

Figure 128

Figure 130

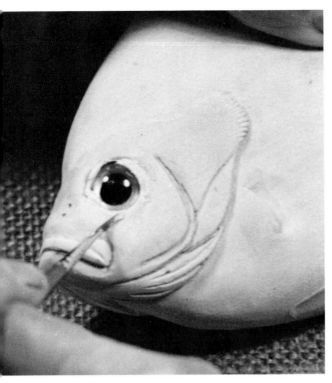

Figure 131

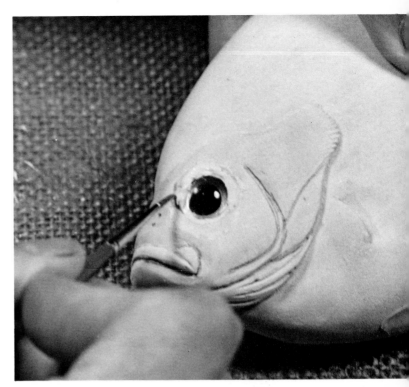

Figure 132

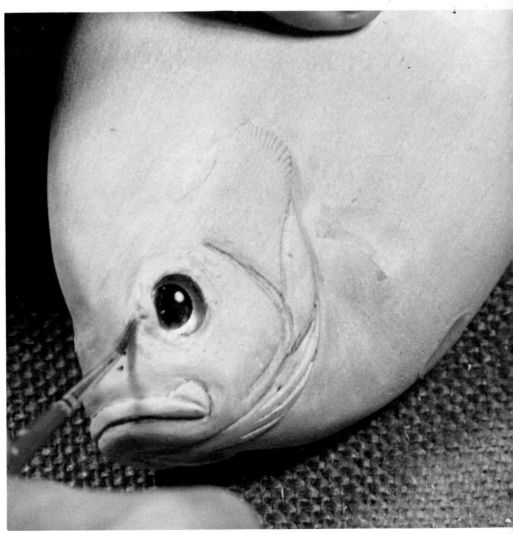

Figure 133

While you have the wood filler handy, now is a good time to fill in any gaps around the dorsal and anal fins (FIG. 134).

After the wood filler has dried I use an X-acto knife with a number 16 blade to trim away any excess wood filler and to complete the shaping of the membrane (FIG. 135, 136), before I very carefully smooth the entire area around the eye with 240 grit sandpaper, being extremely careful not to scratch the glass eye (FIG. 137).

Before sealing the sunfish in preparation for painting, I apply small pieces of masking tape to cover the areas of the pectoral and pelvic fins (FIG. 138) to prevent sealing these areas so the glue and wood filler used later will adhere better.

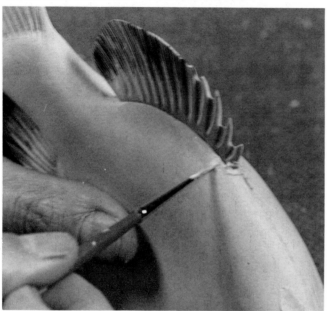

Figure 134

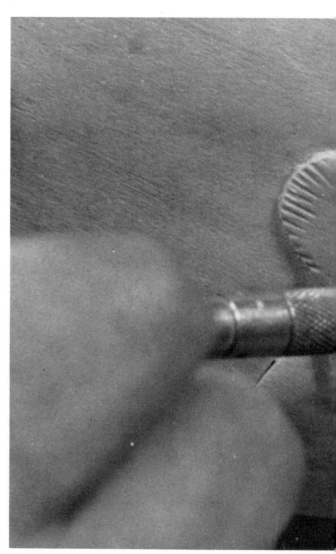

Figure 136

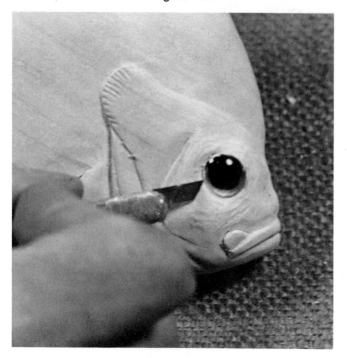

Figure 135

68

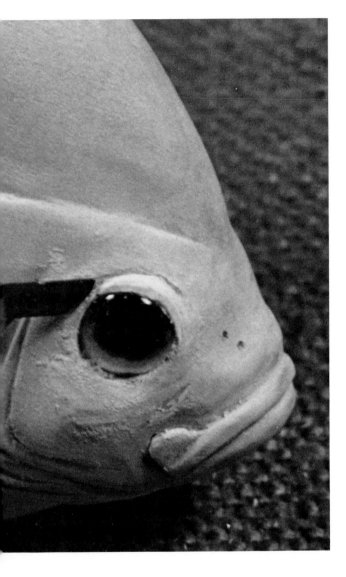

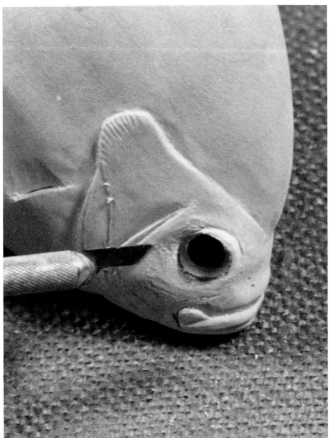

Figure 137

Figure 138

69

To seal the wood use an acrylic spray (I prefer Deft clear spray or Krylon 1301) (FIG. 139). I remove any "fuzzies" appearing with 240 grit crocus cloth or sandpaper. Sometimes I will lightly sand the entire fish. Now the sunfish is ready for the first of two coats of gesso (FIG. 140), which is applied with a one-half inch sable brush (FIG. 141). Be careful not to apply the gesso to the areas of the pectoral and pelvic fins, and sand any rough areas which may appear, since a very smooth surface is critical.

After the sealing coats have dried, with a fine-pointed knife carefully clean the sealants from the glass eyes so as not to scratch them (FIG. 142).

Figure 139

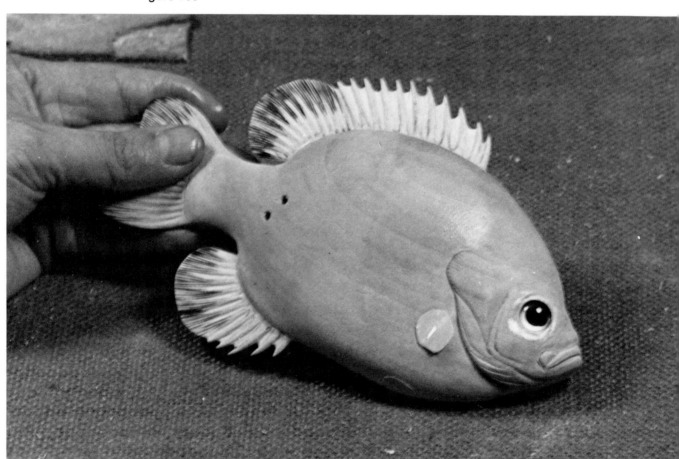

Figure 140

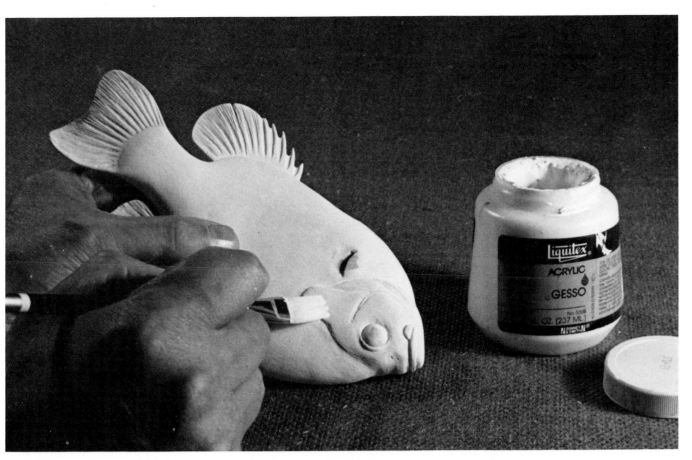

Figure 141

Figure 142

71

Using Illustration A-5, draw the lateral line (FIG. 144). Figure 143 shows regular pencils on the left and a mechanical lead holder with 8H or 9H leads on the right, which require a lead sharpener shown above. Using regular pencils with 8H or 9H leads, begin drawing the scales (FIG. 144, 145) on the head and body of the fish in conformity with Illustration A-5 (FIG. 145, 146). After the scales are drawn on both sides of the fish, we are ready to paint.

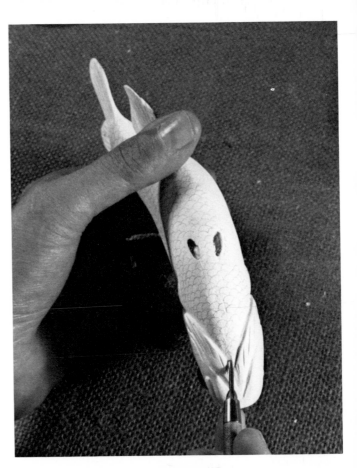

Figure 145

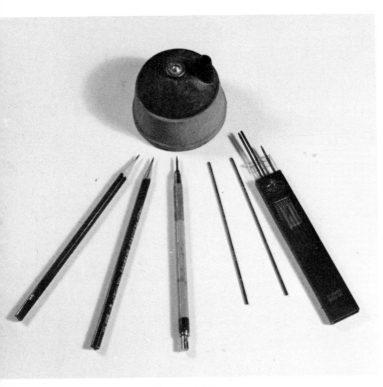

Figure 143

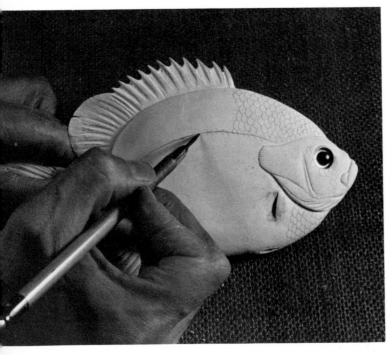

Figure 144

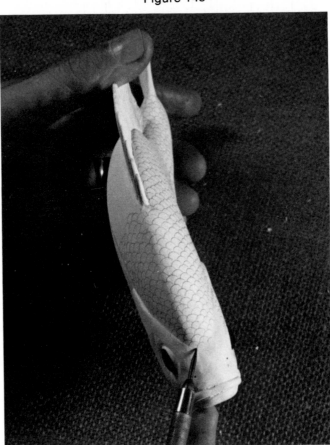

Figure 146

Black Crappie
Pomoxis nigromaculatus

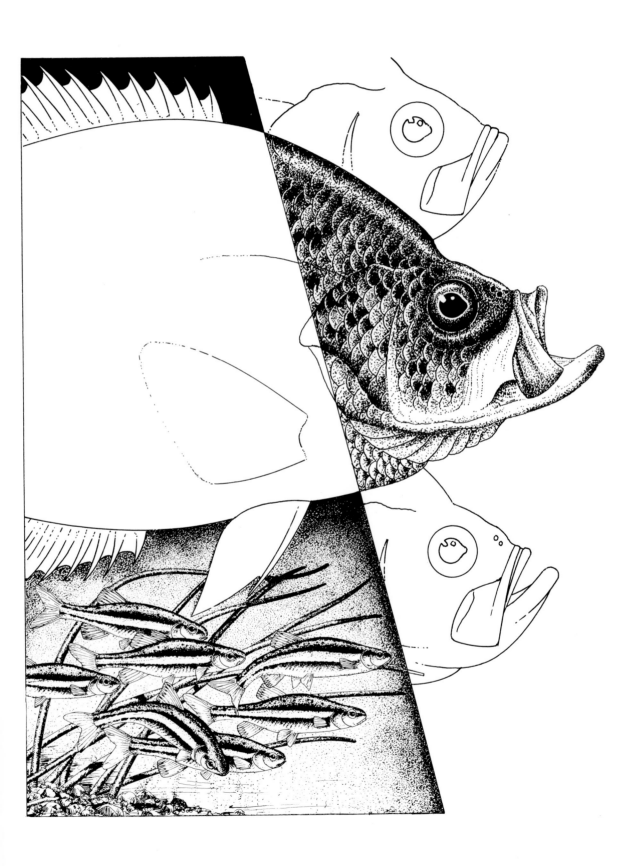

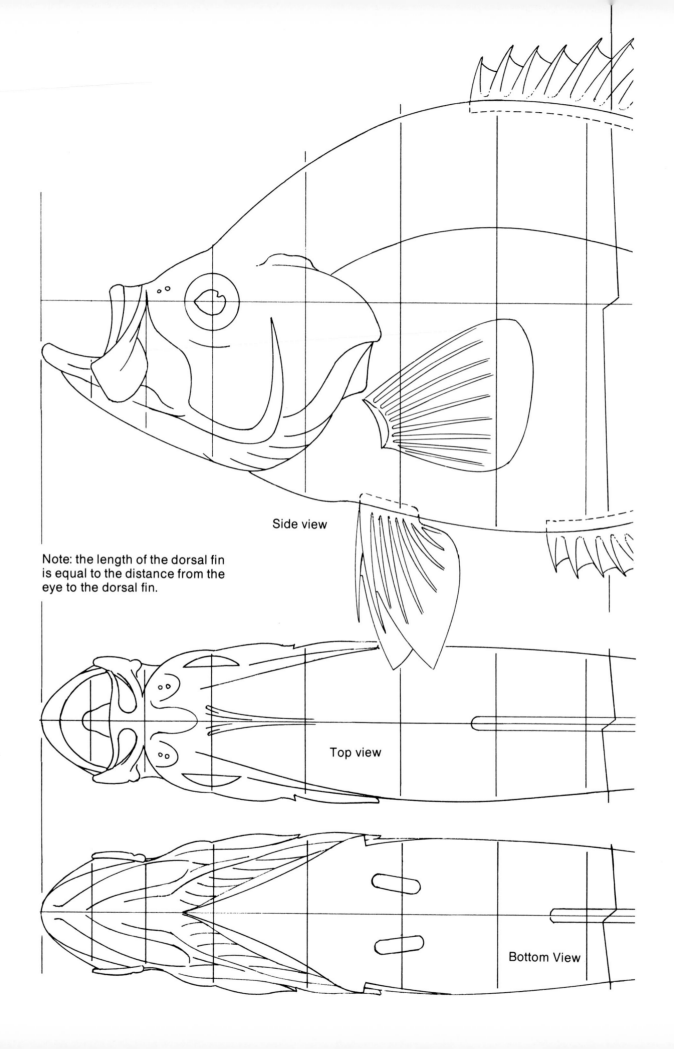

Side view

Note: the length of the dorsal fin
is equal to the distance from the
eye to the dorsal fin.

Top view

Bottom View

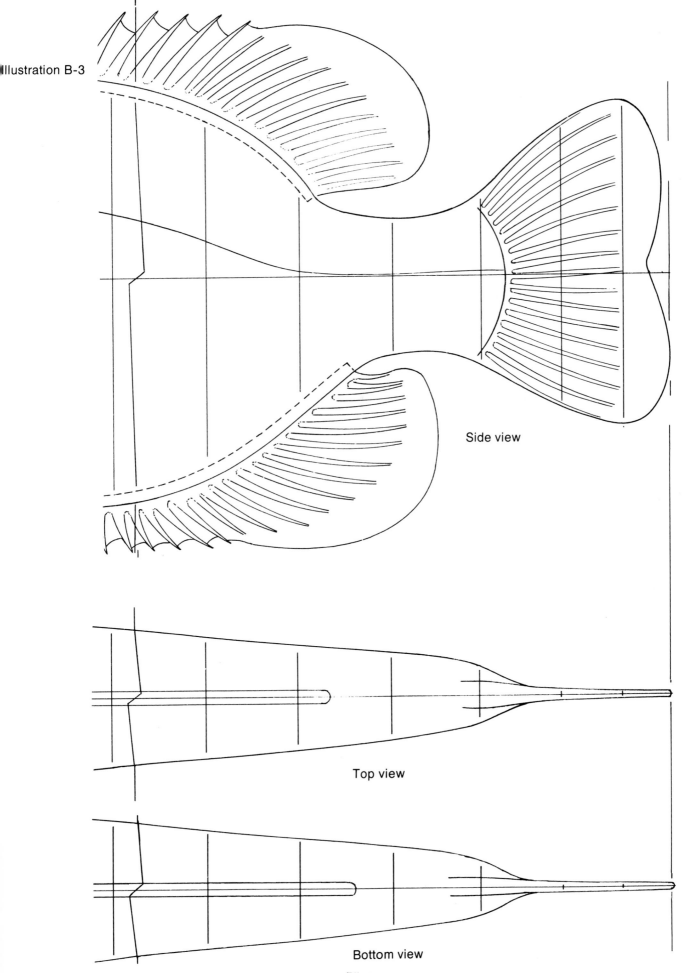

Side view

Top view

Bottom view

Illustration B-4

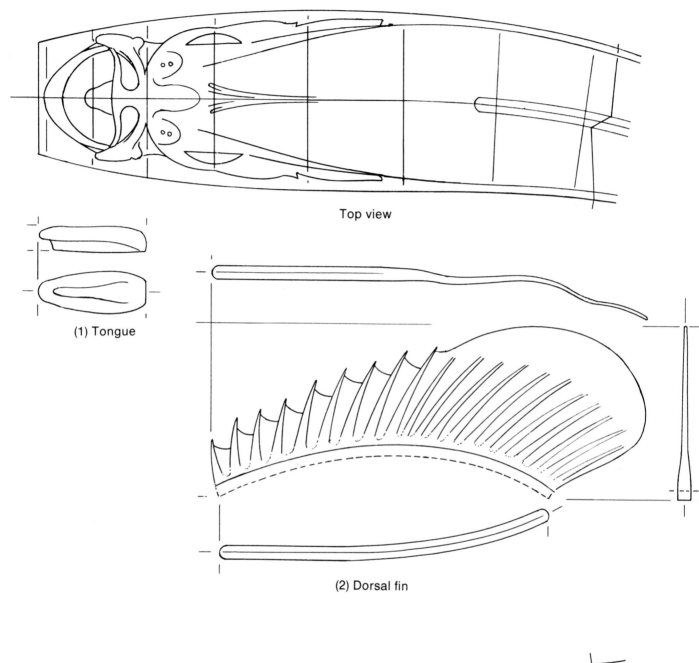

Top view

(1) Tongue

(2) Dorsal fin

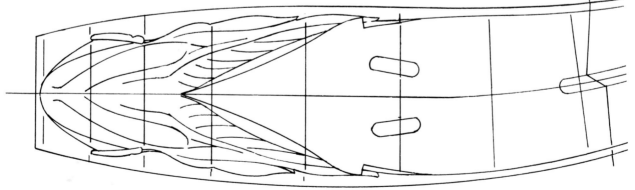

Bottom view

Illustration B-5

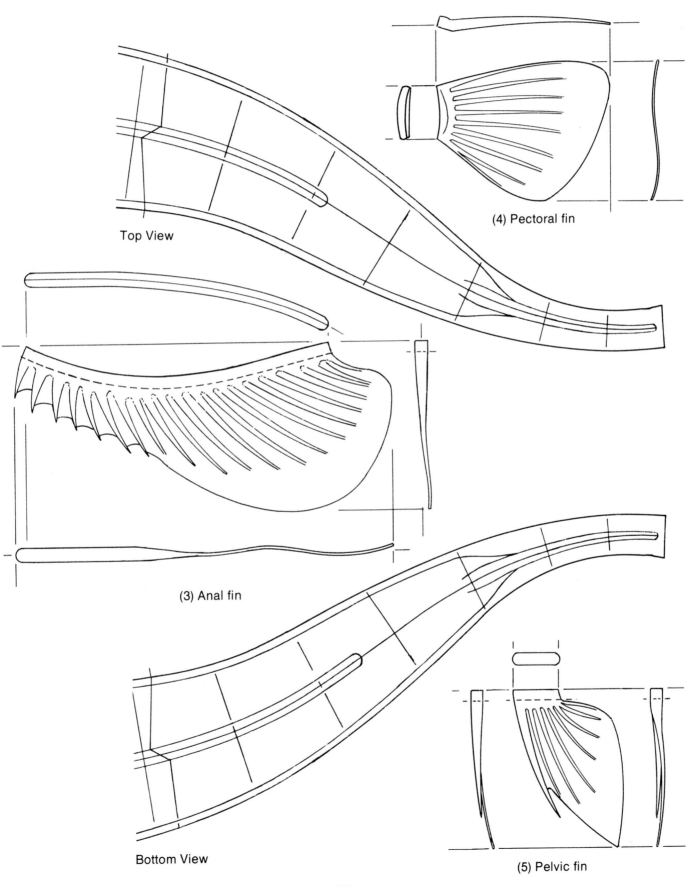

Top View

(4) Pectoral fin

(3) Anal fin

Bottom View

(5) Pelvic fin


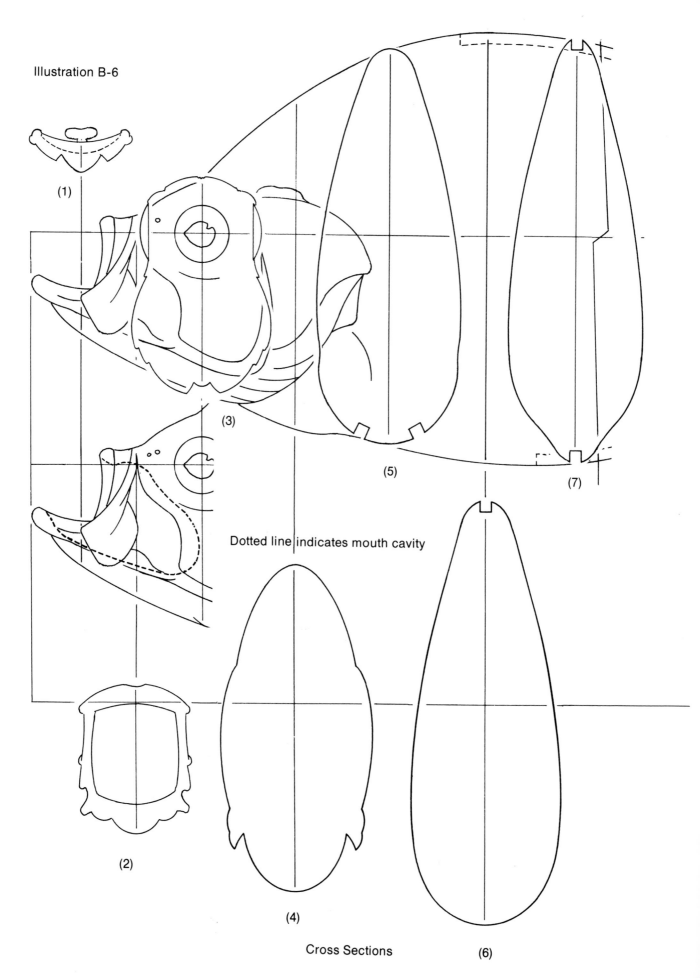

Illustration B-6

(1)

(3)

(5)

(7)

Dotted line indicates mouth cavity

(2)

(4)

(6)

Cross Sections

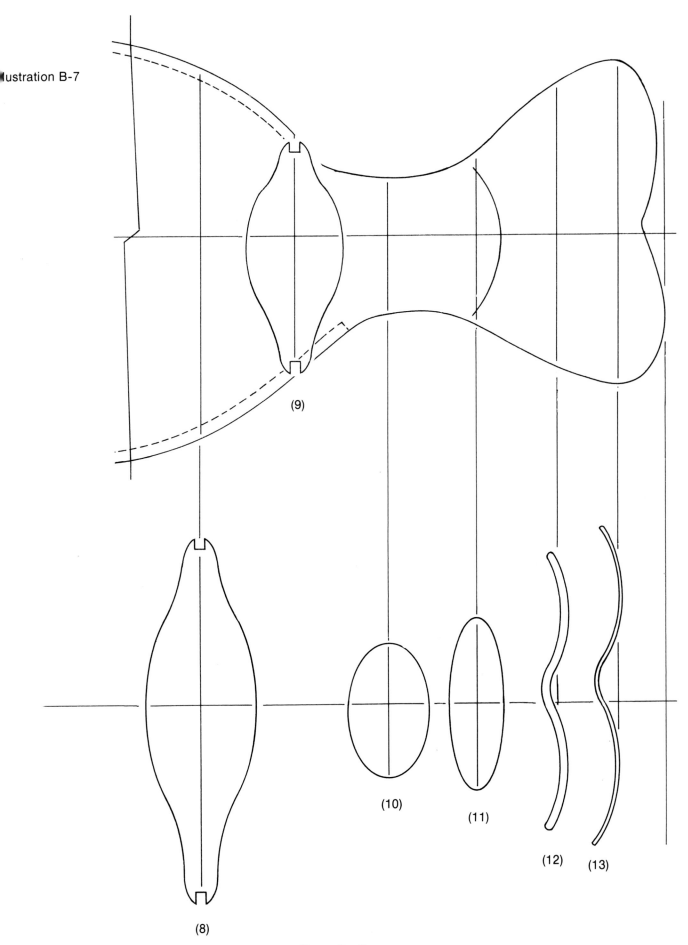

(9)

(8)

(10)

(11)

(12)

(13)

Cross Sections

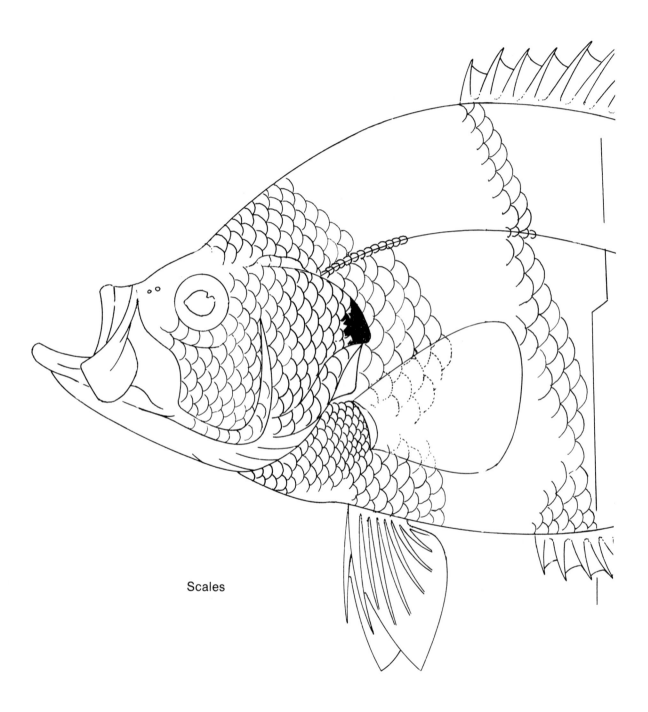

Scales

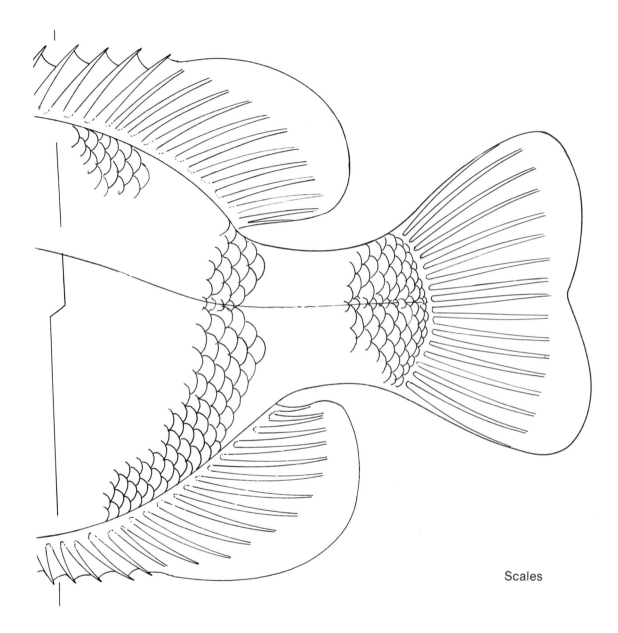

Scales

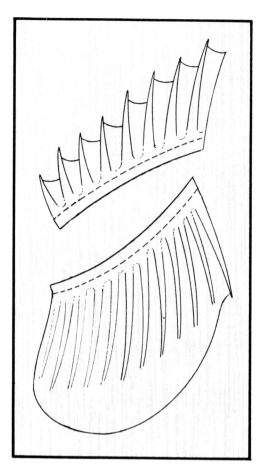

Illustration B-10
Dorsal fin -Grain direction

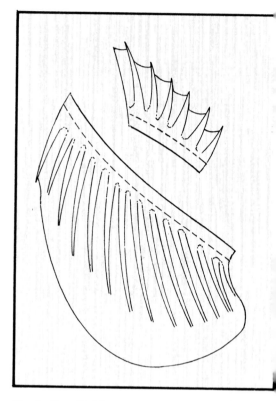

Illustration B-11
Anal fin—Grain direction

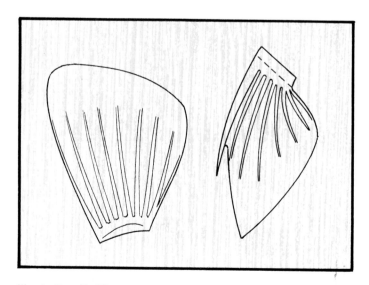

Illustration B-12
Pectoral & Pelvic fin—Grain direction

BLACK CRAPPIE

The black crappie is one of two members of the genus Pomoxis, the other being the white crappie. In my estimation both are beautiful fish for their large fins and black speckled markings. They possess a "tropical fish" appearance and are my favorite fish subjects to carve. There are a few minor differences between the two. The black crappie has random black speckles while the white crappie's dark speckles occur in vertical bars. The dorsal fin of the black crappie has seven or eight spines while the white crappie generally has six spines.

The black crappies range more in the northern parts of the country and white crappies are more abundant in the south. White crappies have adapted to the more turbulent waters of rivers and streams, while black crappies find clear lakes and ponds more to their liking.

Although crappies lack leaping ability and are not particularly powerful fighters, they are fun to catch and delicious eating. This fish is also known as spiny-rayed fish for having spines in both the dorsal and anal fins.

CARVING THE BLACK CRAPPIE

The procedure for planning and carving the black crappie is basically the same as that followed for the sunfish project just completed. We will be working from illustrations and patterns, beginning with the pattern and the rough cutout of the base, in this case a walnut teardrop shape measuring 11-1/2 inches by 6 inches (FIG. 1).

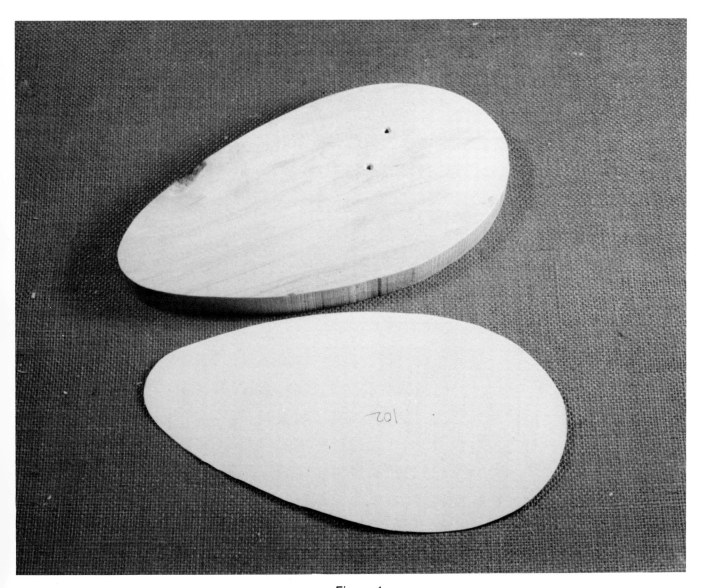

Figure 1

Next find the position of the driftwood which best exhibits the composition and cut the driftwood flat at the point where it will rest on the base (FIG. 2). Drill the holes in the driftwood, insert the pins for marking the base pattern (FIG. 3), use the holes in the base pattern to mark their location on the base itself (FIG. 4), drill the holes in the base (FIG. 5), and attach the driftwood to the base with wood screws (FIG. 6). Notice the extra hole in the rough base. That is from using the same rough base for a previous project, which I often do with or without modifications.

Figure 3

Figure 2

Figure 4

Figure 5

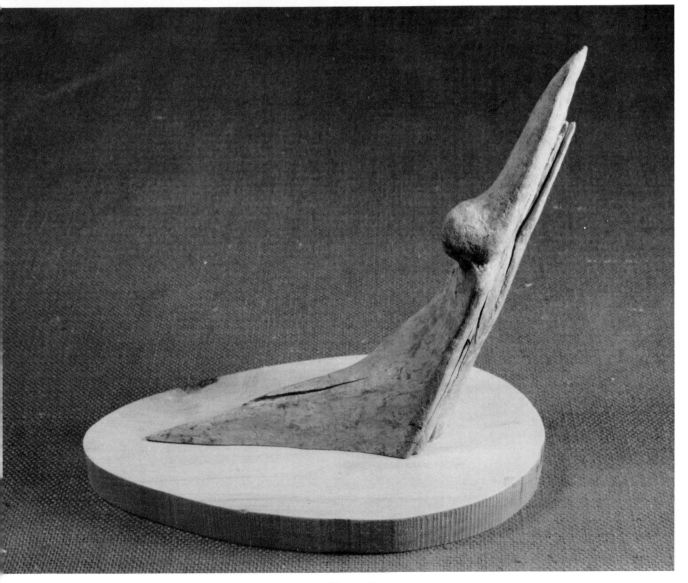

Figure 6

Use the crappie pattern to get an idea how the completed carving will look when mounted (FIG. 7). It sometimes helps to keep the intended composition in mind during the carving of the fish, if for nothing else than motivation.

Next we trace the top view pattern onto our block of basswood measuring 11-1/2 by 4-3/4 by 3-1/2 inches and cut the shape on the bandsaw (FIG. 8). Using the side view pattern, we then cut out the side view, draw the reference lines of the gill, tail and point of attachment for the pectoral fin. At this time the location for the pectoral fin can be marked with a stop cut and the eye can be drilled with a 1/4 inch bit (FIG. 9).

Now draw the center line on the dorsal (top) side of the crappie, also indicating the location of the dorsal fin (FIG. 10), followed by the center line on the ventral (bottom) view, the lines for the gill area and the anal fin (FIG. 11).

Figure 8

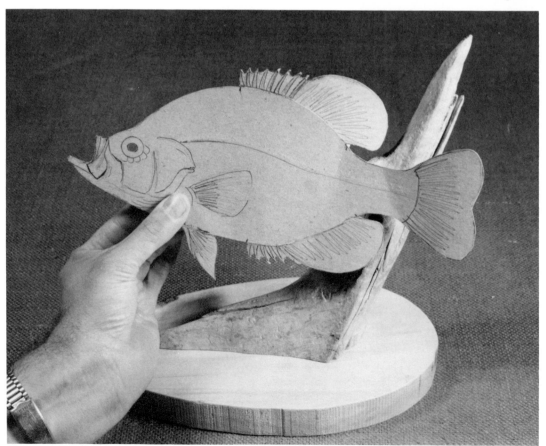

Figure 7

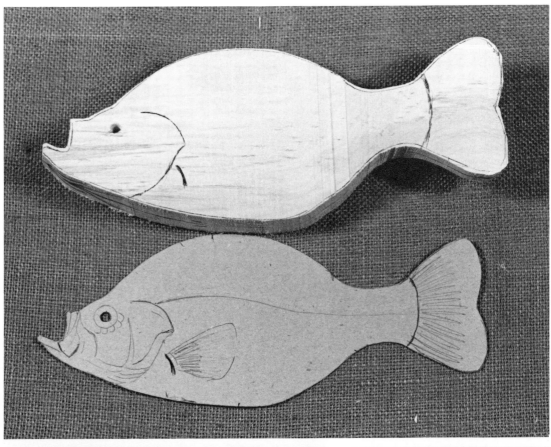

Figure 9

Figure 10

Figure 11

With a carbide cutter on the Foredom tool, thin down the tail where it attaches to the body (FIG. 12) and begin shaping the tail to give it a wavy motion (FIG. 13) by grinding both sides of the tail (FIG. 14) to form a vague letter "W" when viewed from its end (FIG. 15).

Refer to Illustrations B-4 through B-7 for anatomy detail and cross-sections while carving the body of the crappie.

Using a carving knife with which you are comfortable begin roughing out the body by first removing the edges made by the bandsaw (FIG. 16), and carving toward but not erasing the center lines (FIG. 17), making the crappie more rounded in the stomach area (FIG. 18) to create a full, healthy fish.

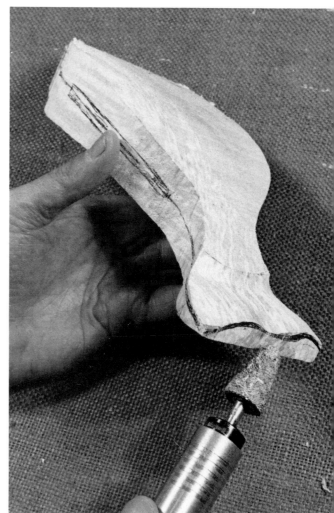

Figure 13

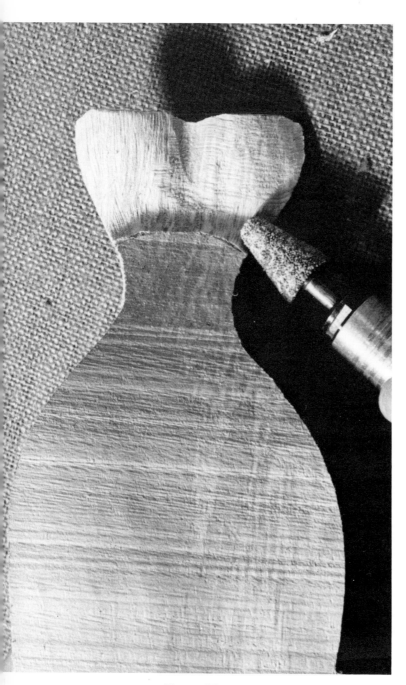

Figure 12

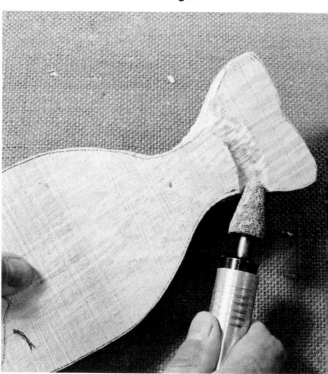

Figure 14

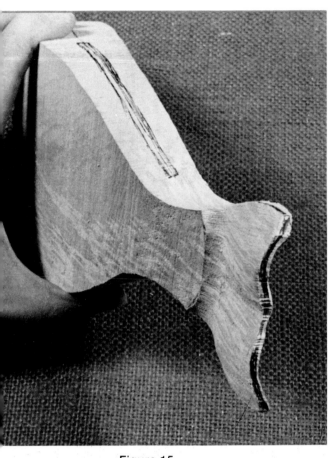

Figure 15

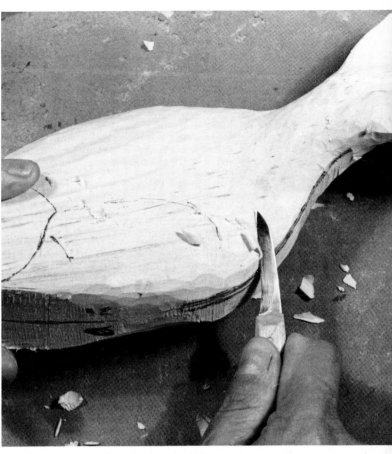

Figure 17

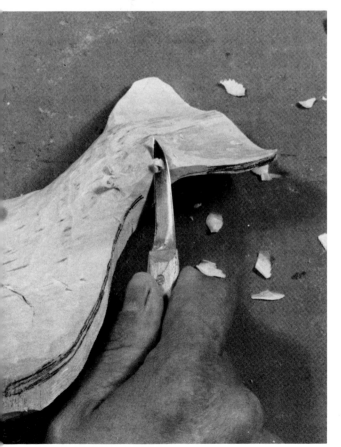

Figure 16

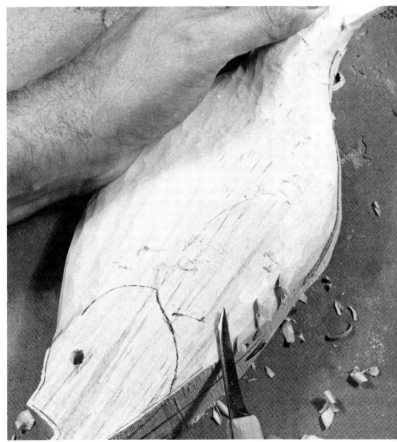

Figure 18

89

Again being careful not to erase the center line, round the crappie toward the dorsal fin and the back (FIG. 19), then the head area (FIG. 20), in preparation for the relief carving of the head, forehead and gill flap. Use stop cuts to define the gill flap lines and the pectoral fin muscles (FIG. 21). Do not worry at this stage about the details of the head.

After sanding out the cut marks on the body with 120 grit crocus cloth or a sanding drum (FIG. 22), and smoothing its surface with 240 grit crocus cloth or sandpaper, it is again time to check the anatomy of the body by drawing in the cross-section lines in conformity with Illustrations B-6 and B-7 (FIG. 23).

To draw the head detail place the side view pattern on the fish and use a hat pin through the pattern to mark the lines. Then connect the dots on the fish with a pencil to transfer the pattern (FIG. 24). Note Illustration B-2.

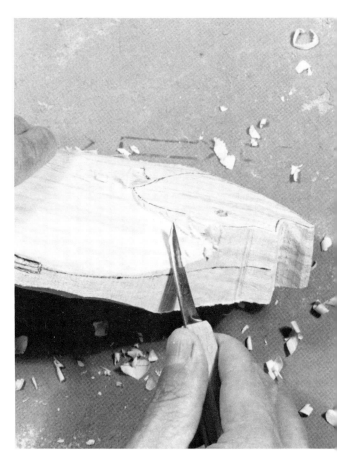

Figure 20

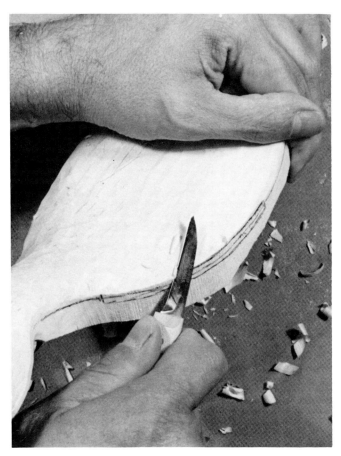

Figure 19

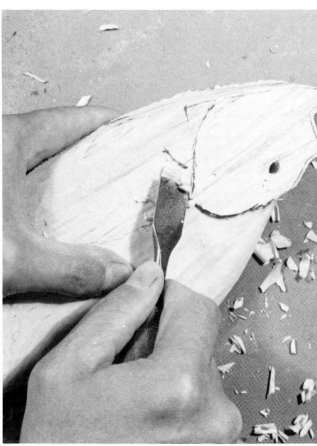

Figure 21

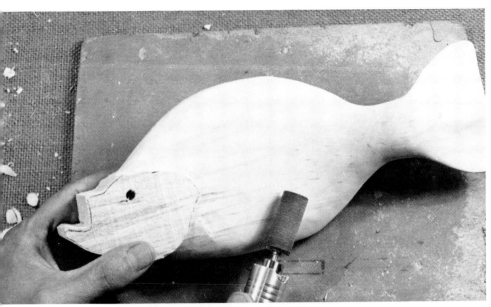

Figure 22

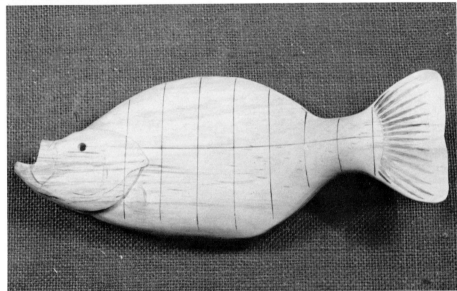

Figure 23

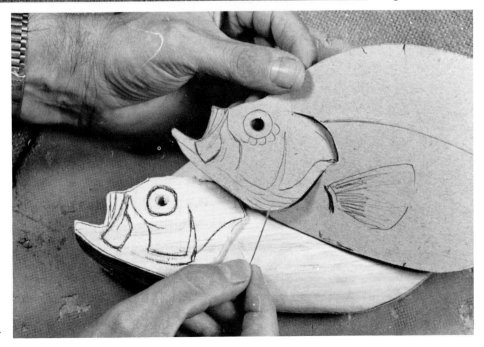

Figure 24

91

Pencil in the detail of the top view of the head by referring to Illustration B-2 or B-4 (FIG. 25), and refer to Illustration B-2 or B-4 for the ventral or bottom detail (FIG. 26).

Begin roughing out the head with a knife by rounding the gills first (FIG. 27), followed by the forehead and head areas (FIG. 28). After further defining around the gills and the upper jaw with a knife (FIG. 29), use a small U-gouge to rough out the jaw parts along the lines transferred from the pattern (FIG. 30). If at all possible study a real crappie's head very carefully and make sketches of detail for later reference. This is most helpful in carving the detail.

Figure 25

Figure 26

92

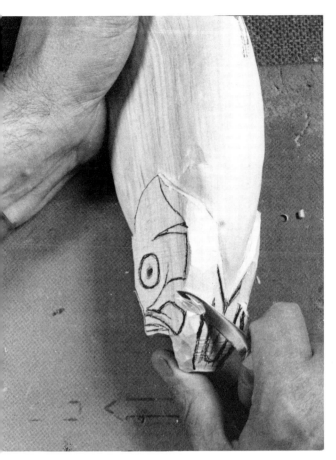

Figure 27

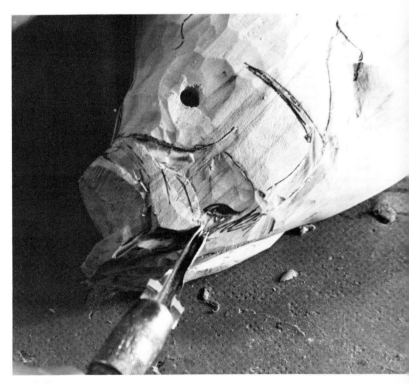

Figure 29

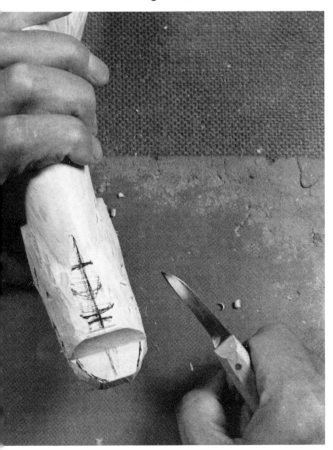

Figure 28

Figure 30

93

Because the mouth of the crappie is paper thin, extreme care will be necessary to finish it. I begin by using a pear-shaped ruby bit on my Foredom to rough out the interior of the mouth (FIG. 31). Though you can finish the interior at this point, you might want to wait until you have refined the detail of the head, gills and exterior of the mouth with a small U-gouge and V-tool (FIG. 32, 33, 34, 35). In either case, finishing the mouth is a delicate operation.

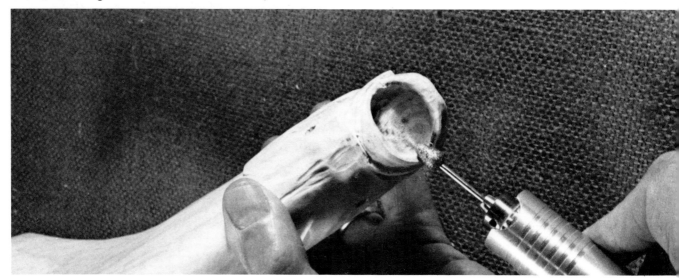

Figure 31

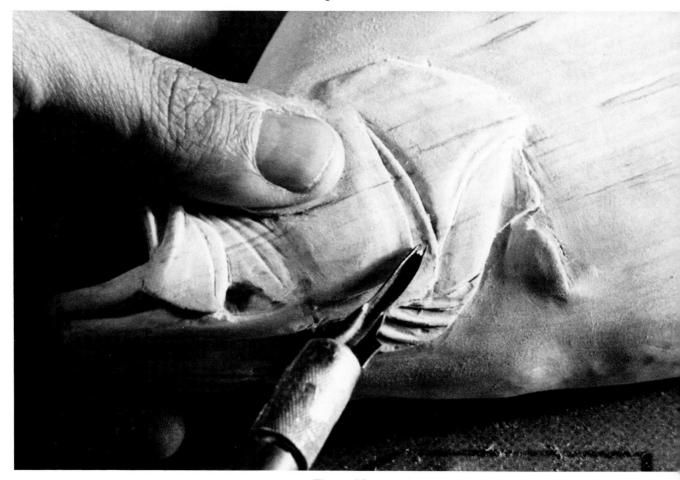

Figure 32

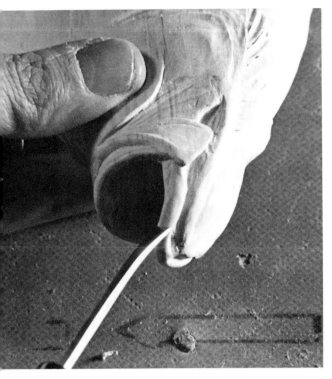

Figure 33

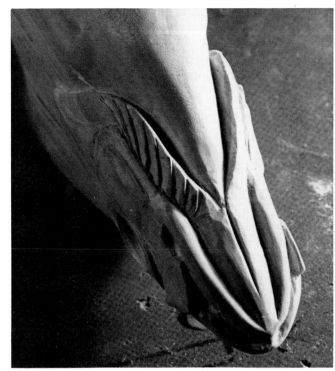

Figure 35

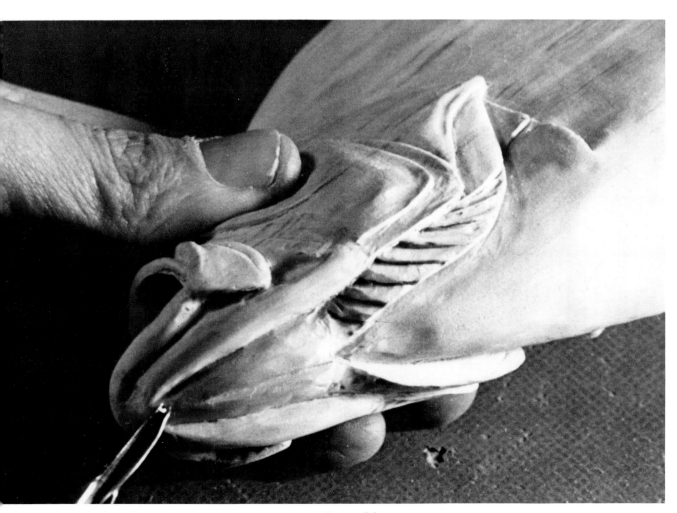

Figure 34

Figure 36 shows the detail of the forehead. Note also the groove on the bottom of the mouth for placement of the tongue, which is carved separately in conformity with Illustration B-4, drawing (1) (FIG. 37). Note the stick attached to the tongue itself. This makes it easier to handle. After carving the tongue and when the mouth is completed, it can be glued into place with wood glue (FIG. 38).

As with the other projects in this book, a template is used to mark the eye, which for this fish is 16 mm (FIG. 39). Again using a small ruby bit, I cut the eye socket to a depth a little greater than the depth of the eye (FIG. 40), and set the eye with wood filler, exactly as was done with the bluegill sunfish (FIG. 41).

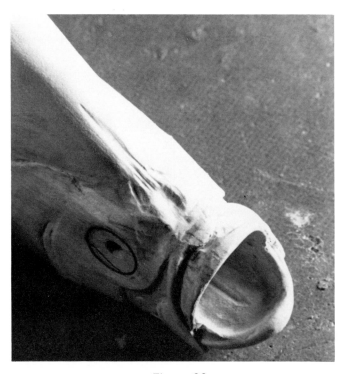

Figure 36

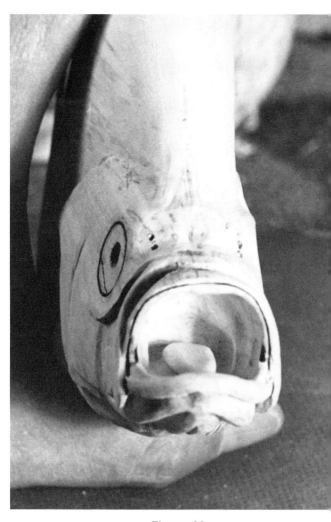

Figure 38

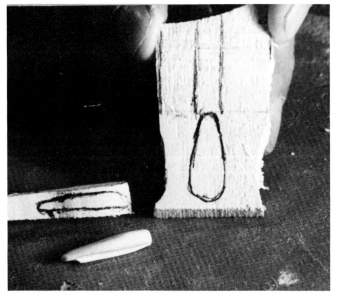

Figure 37

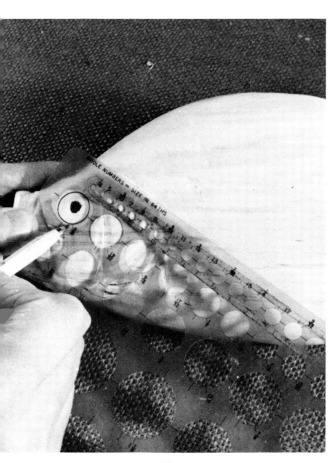

Figure 39

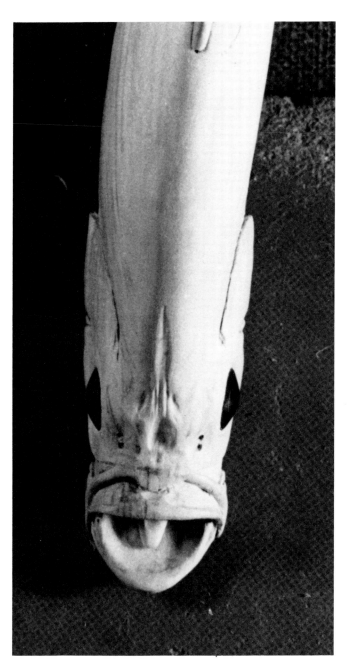

Figure 41

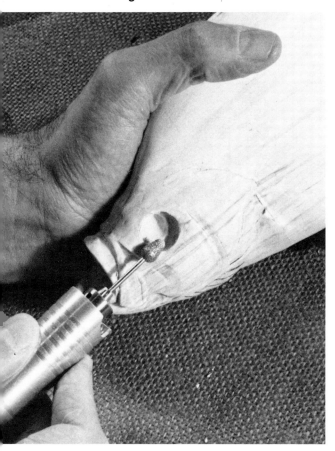

Figure 40

97

At this stage draw in the rays of the tail, carve them with a small U-gouge (FIG. 42) and, after sanding, woodburn them (FIG. 43). Use the woodburner to put in the smaller splits. If larger splits are desired, use a small, 1/16 inch, V-tool before burning.

The crappie's fins are very similar to those of the sunfish, though larger. For woodgrain directions see Illustrations B-10 for the dorsal fin, B-11 for the anal fin, and B-12 for the pectoral and pelvic fins. After cutting out the fins pursuant to the fin patterns, shape the spines of the dorsal fin with sandpaper (FIG. 44), draw in the spines (FIG. 45) in preparation for removal of wood between them with a small U-gouge (FIG. 46). After refining the spines with a small V-gouge (FIG. 47), smooth out the gouge marks with 240 grit sandpaper (FIG. 48). Again, to give the tips of the spines strength, put a dab of Super Glue on each of them (FIG. 49).

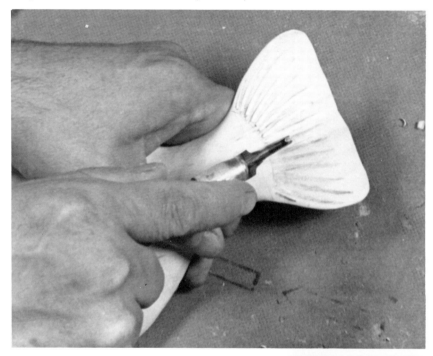

Figure 42

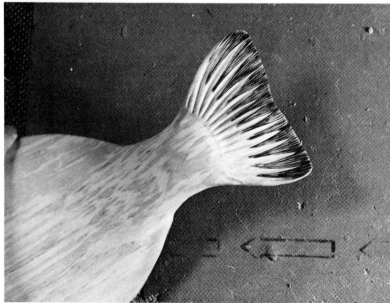

Figure 43

98

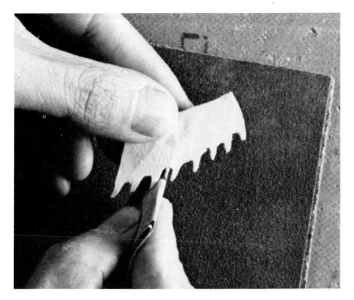

Figure 44

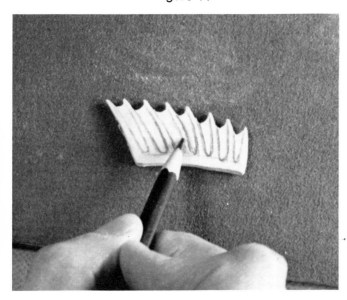

Figure 45

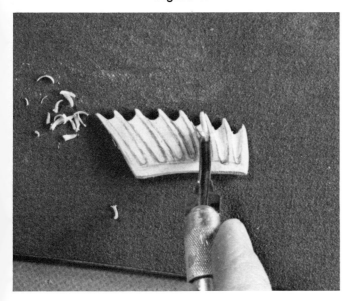

Figure 46

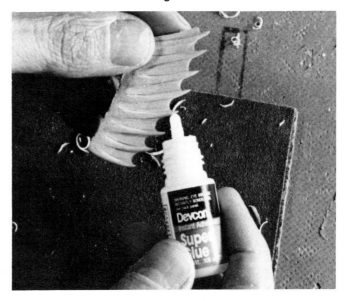

Figure 47

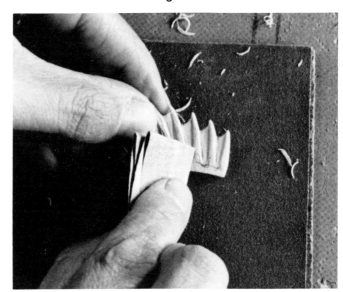

Figure 48

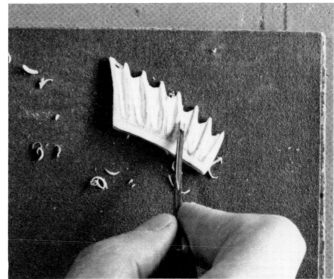

Figure 49

On the cutout of the soft-ray portion of the dorsal fin mark a 1/4 inch thick pattern to conform with the corresponding curvature of the fish (FIG. 50). See Illustrations B-4 and B-5. On the top of the cutout mark (FIG. 51) and carve with a gouge or rotary cutter the wave or ripple of the fin (FIG. 52).

Now that the shape of the fin is complete, make the rays on the dorsal fin by marking them (FIG. 53), carving them with a small U-gouge (FIG. 54), cutting the splits with a small V-tool (FIG. 55), sanding (FIG. 56) and woodburning the rays as was done in the carving of the bluegill sunfish.

To carve the other fins, follow exactly the same procedure. The steps (FIG. 57, 58, 59) in carving the anal fin, the pectoral fins and the pelvic fins are the same as described in carving the fins for the bluegill sunfish. See pages 46 and 48.

Figure 52

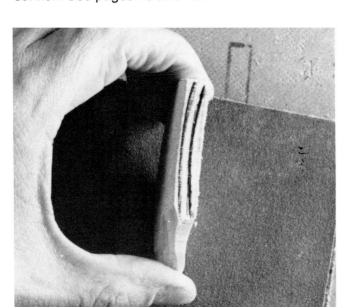

Figure 50

Figure 51

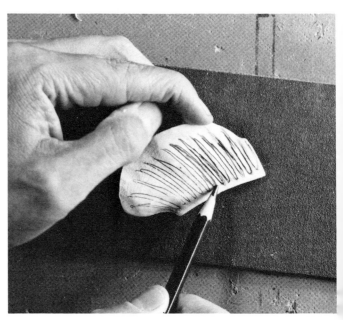

Figure 53

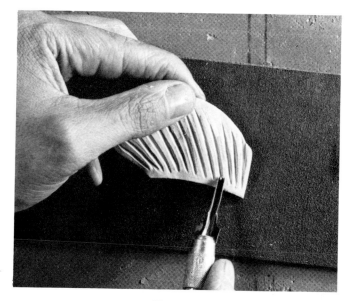

Figure 54

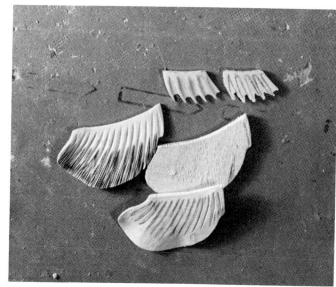

Figure 57

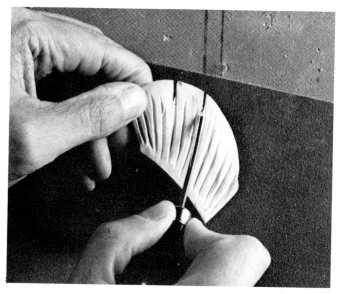

Figure 55

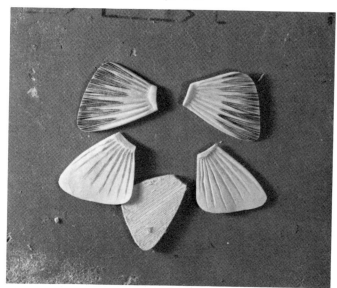

Figure 58

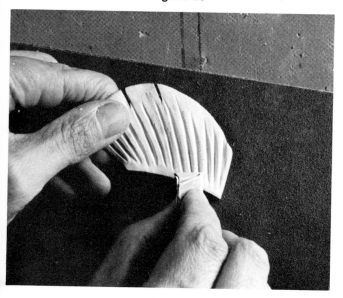

Figure 56

Figure 59

101

Attaching the fins is also the same as with the sunfish. First carve the slots into which the anal and dorsal fins will be inserted, checking the fit as you go, and glue in the fins (FIG. 60). Do not at this time attach the pectoral and pelvic fins.

In preparation for painting, tape the area of the pectoral and pelvic fins before sealing the entire fish with acrylic spray (FIG. 61). Sand the entire fish smooth, lightly sanding away any rough spots or "fuzzies" with 240 grit crocus cloth or sandpaper.

Now we can fit the carved black crappie to the driftwood and base, using the method of drilling the holes in the driftwood and inserting marking pins to determine the location of the corresponding holes on the fish (FIG. 62). Once the holes are drilled, we can trial mount the fish as shown in Figure 63.

Figure 60

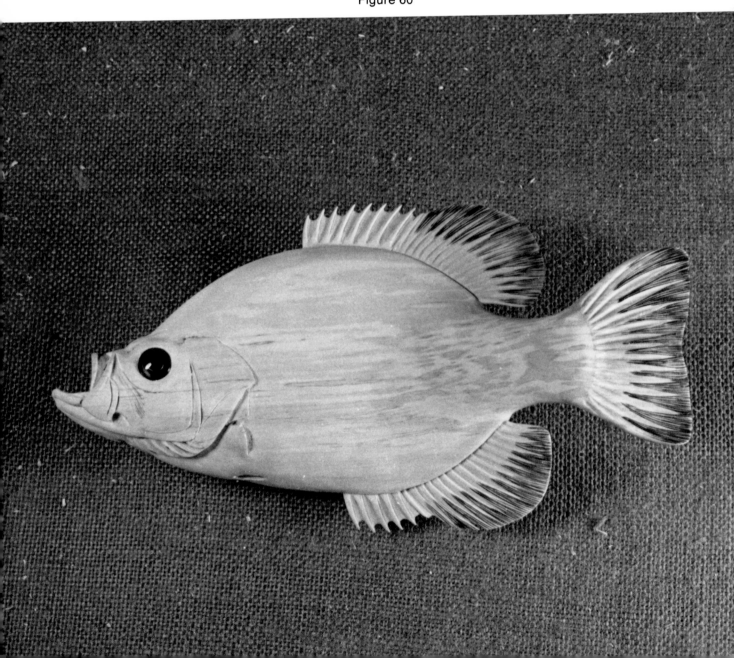

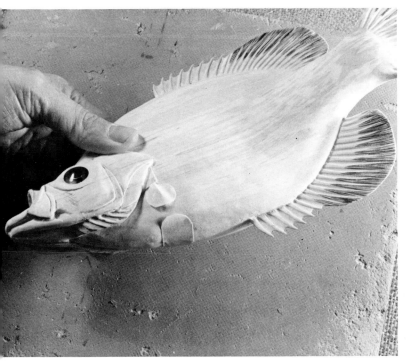

Figure 61

Figure 63

Figure 62

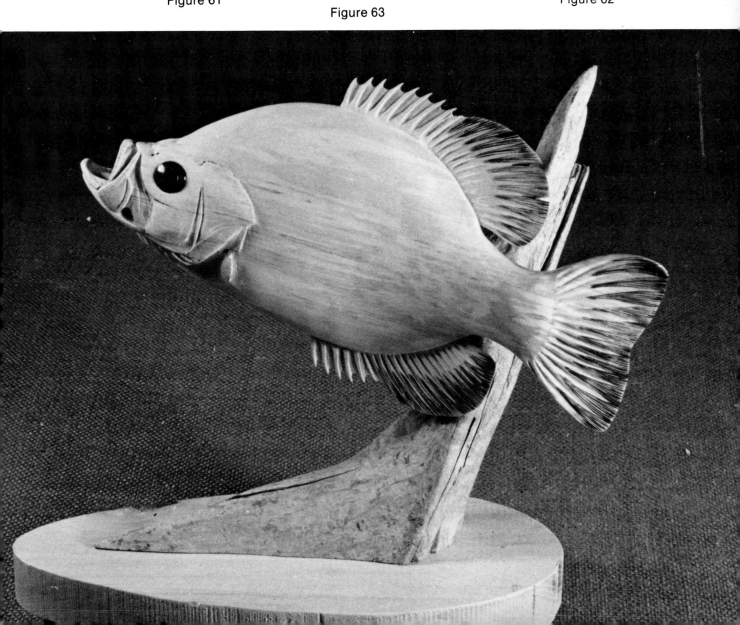

To further prepare the carving for putting on the scales and painting, we again give it two coats of gesso, sanding any rough spots with 240 grit crocus cloth or sandpaper after the first coat (FIG. 64). You can find any rough spots by lightly running your fingers over the fish's surface after the first coat of gesso dries.

With a small knife clean the sealer from the eyes, again being careful not to scratch them (FIG. 65). We are now ready to "apply" the scales, which are shown in Illustrations B-8 and B-9. Again using 8H or 9H lead pencils start at the top of the head and the throat as shown in Figures 144 and 145 of the bluegill chapter.

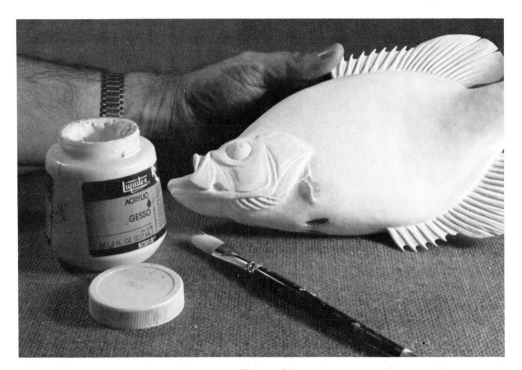

Figure 64

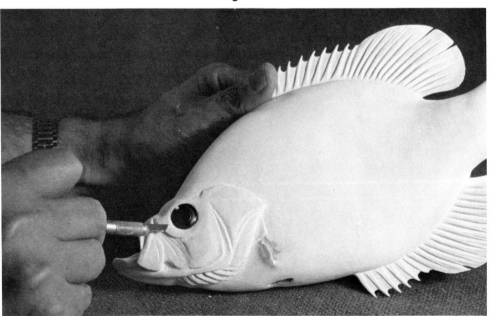

Figure 65

104

Rainbow Trout

Salmo gairdneri

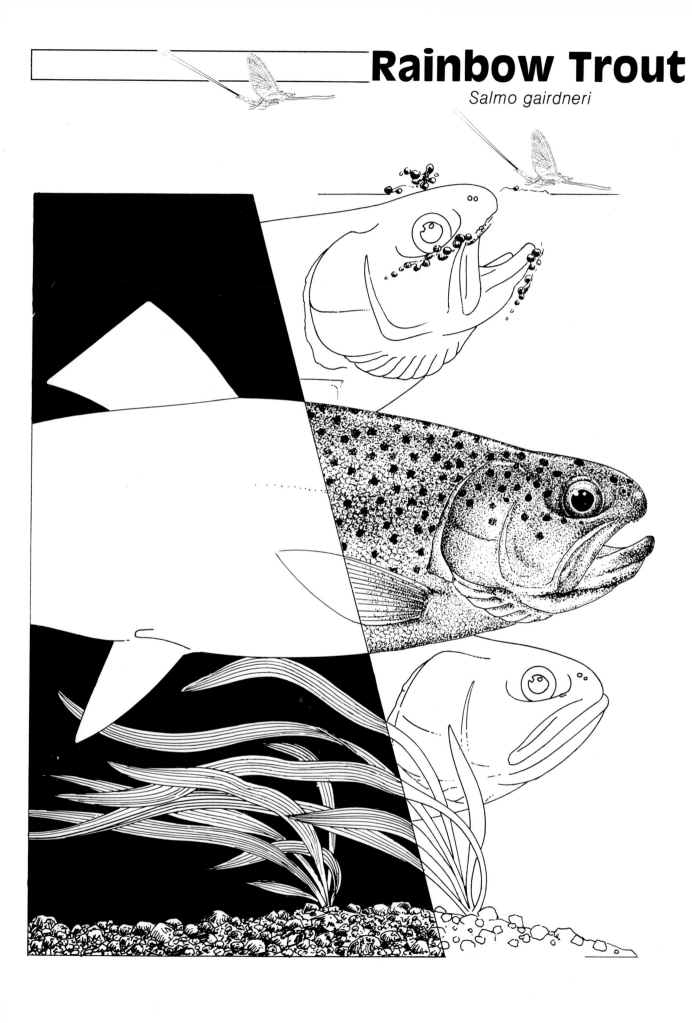

Illustration C-2

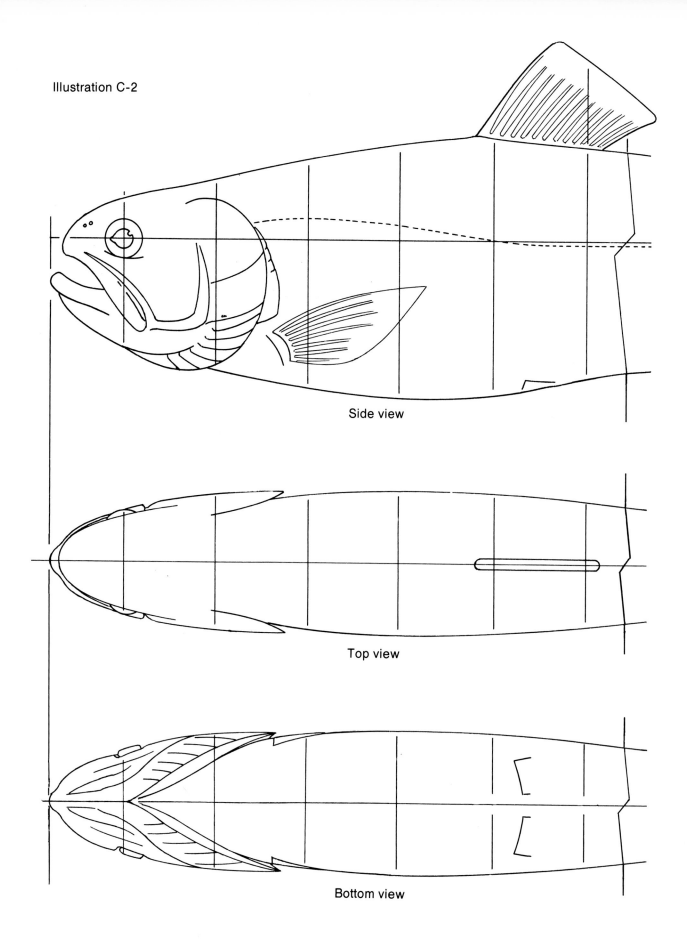

Side view

Top view

Bottom view

Illustration C-3

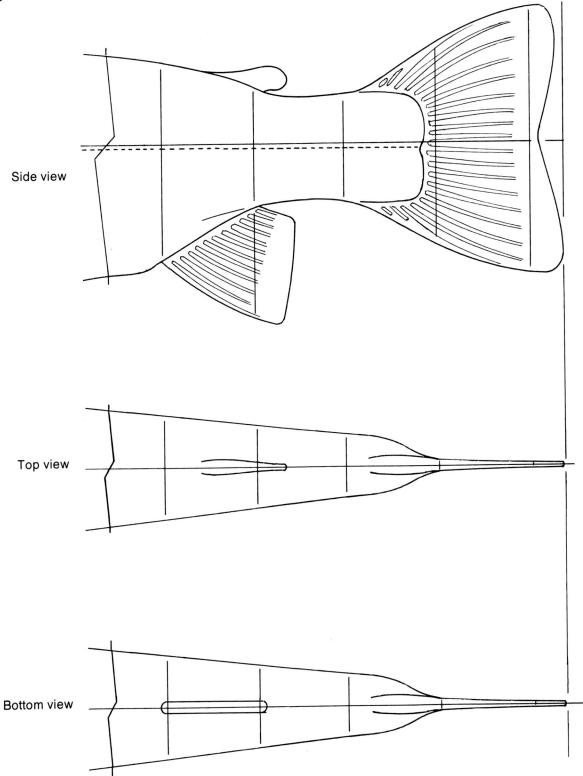

Side view

Top view

Bottom view

Illustration C-4

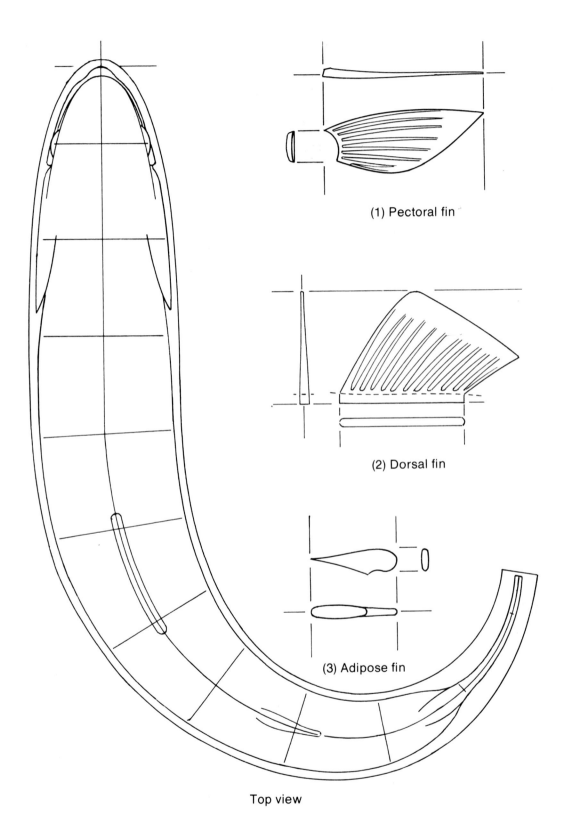

(1) Pectoral fin

(2) Dorsal fin

(3) Adipose fin

Top view

Illustration C-5

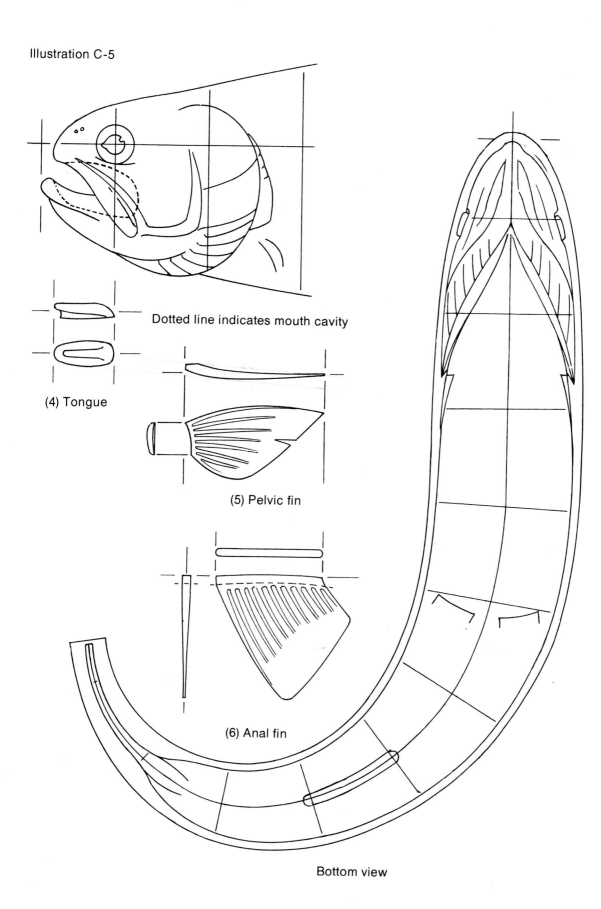

Dotted line indicates mouth cavity

(4) Tongue

(5) Pelvic fin

(6) Anal fin

Bottom view

109

Illustration C-6

Cross sections

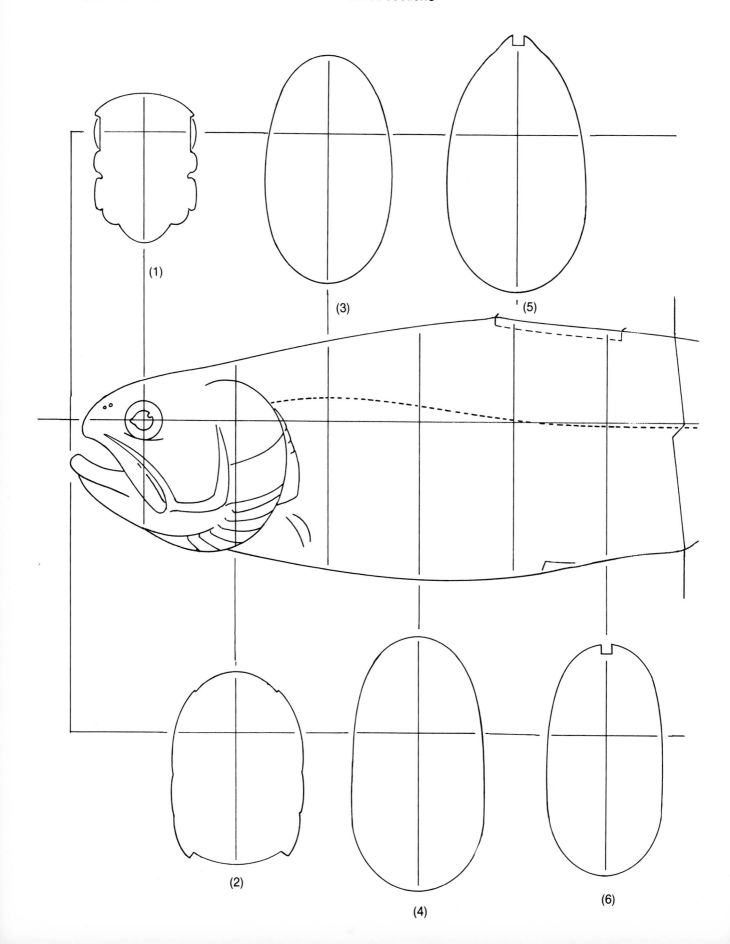

(1)

(3)

(5)

(2)

(4)

(6)

Cross sections

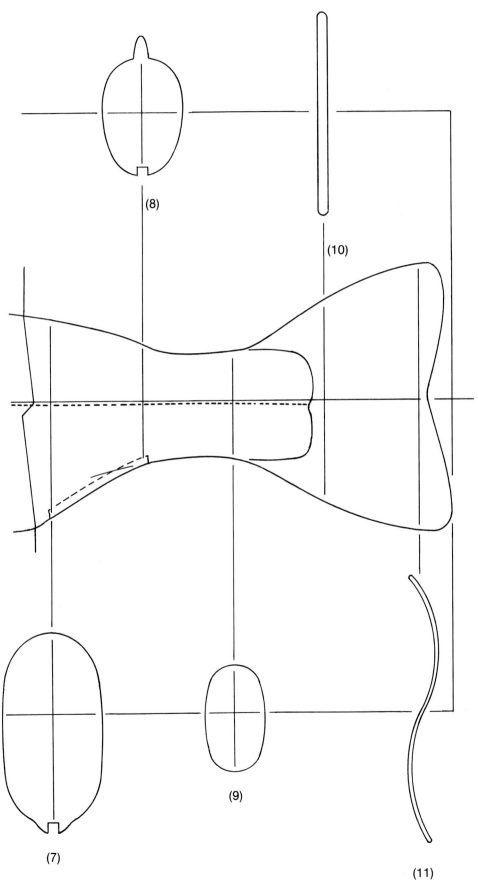

(8)

(10)

(7)

(9)

(11)

Illustration C-8

Carving pectoral fin muscle

Illustration C-9

Undercuts for gill cover

Illustration C-10

Carving pelvic fin muscle

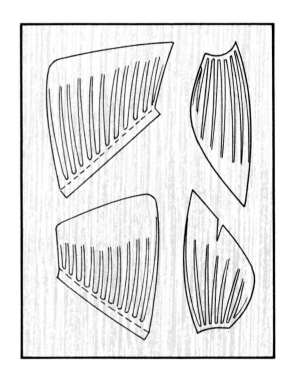

Illustration C-11

Fin Patterns—Woodgrain direction

Illustration C-12

Technique used to paint sand base

RAINBOW TROUT

Of the colorful varieties of trout, genus Salmonidae, the rainbow is probably the most popular. These "soft-rayed" fish are found in virtually all waters of North America where water temperatures range between 55 and 60 degrees and the water is clear. Since rainbows are not native to the Great Plains, they have to be stocked in the lakes and streams. Rainbows differ from the Brown and Brook trout in that the rainbow's tail is completely covered with spots and the rainbow has the conspicuous pinkish-red band under a dull blue-green color on the side.

Catching rainbows, which respond to a variety of lures and bait, provides a most exciting time. They will leap when hooked and, being tremendous swimmers, will always put up a good fight. I particularly enjoy carving rainbows in poses which display those qualities just mentioned.

CARVING THE RAINBOW TROUT

This particular pattern for carving the rainbow trout is to me very exciting. The dramatic curvature of the body evinces vigor and action.

The size of the base and its pattern for this project is 12 inches by 6-1/4 inches (FIG. 1). The pattern and base shape can be changed, of course, depending on the fit of the fish to the driftwood and how the water grass will complement the whole composition. Always choose the size and shape of base and driftwood which best display the fish as part of a balanced, whole piece of art.

The driftwood is attached to the rough base with the decorative sand pattern, which is made from a piece of 3/4 inch particle board or basswood (FIG. 2). Now we can check the approximate position of the trout in relation to the driftwood and the base (FIG. 3).

Figure 2

Figure 1

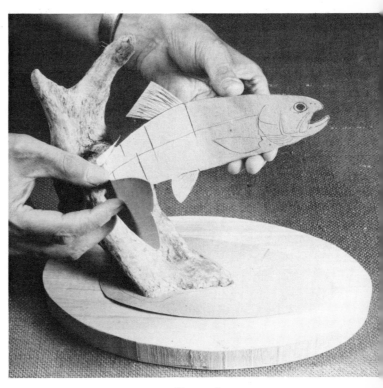

Figure 3

113

After tracing the pattern for the top view onto a block of basswood measuring 5-1/2 by 7-3/4 by 3 inches, cut the top view out on a bandsaw (FIG. 4). Because the body of the trout has such a dramatic curvature, making it difficult to trace the pattern to the wood, before transferring the side view pattern of the trout to the wood draw the vertical lines corresponding to the lines on the side view pattern (FIG. 5). The vertical lines on the inside of the curve will be closer together than the vertical lines on the outside of the curve when viewed after drawing the vertical lines onto the wood cutout, pursuant to Illustrations C-4 and C-5 (FIG. 6).

When the side view pattern has been transferred to the wood, cut it out on a bandsaw as far as the bandsaw will safely allow you to go (FIG. 7), cutting the remainder with a coping saw, which is also used to cut out the mouth opening (FIG. 8).

Figure 4

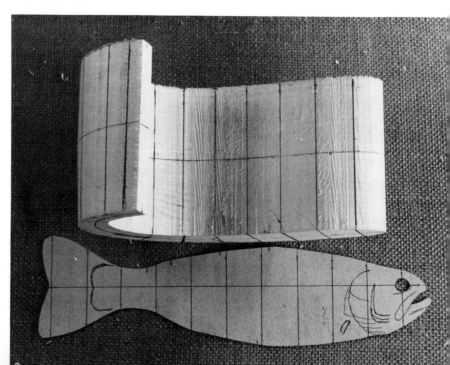

Figure 5

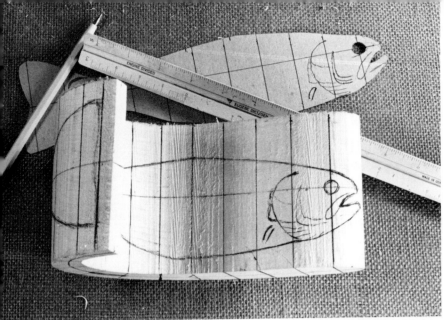

Figure 6

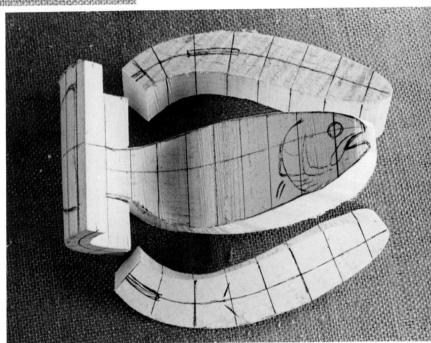

Figure 7

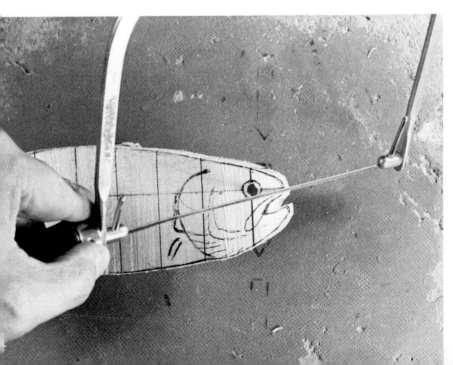

Figure 8

As we did with the other projects in this book, drill the eye location with a 1/4 inch bit (FIG. 9), and mark the gills and pectoral muscles by using a knife to cut along the outline of the gills and the pectoral muscles to a depth of approximately 1/8 inch (FIG. 10).

If you have not already done so, draw the center line and extend the vertical lines on the side view across the top of the fish, perpendicular to the center line, to help you locate and draw in the positions of the dorsal and adipose fins (FIG. 11). Repeat the drawing of the center line and the lines perpendicular to it on the ventral side (FIG. 12).

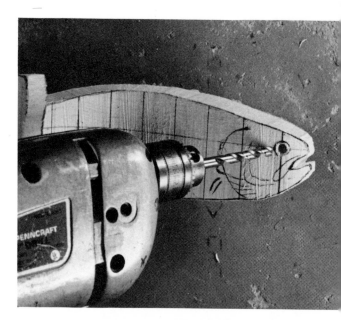

Figure 9

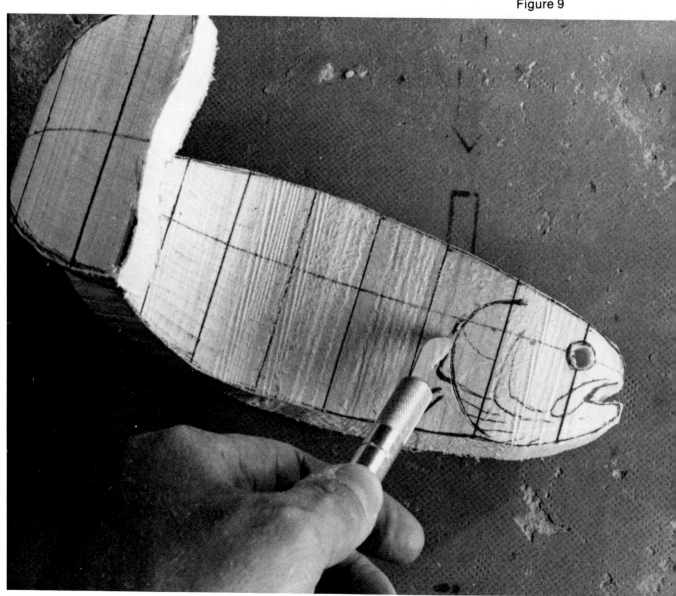

Figure 10

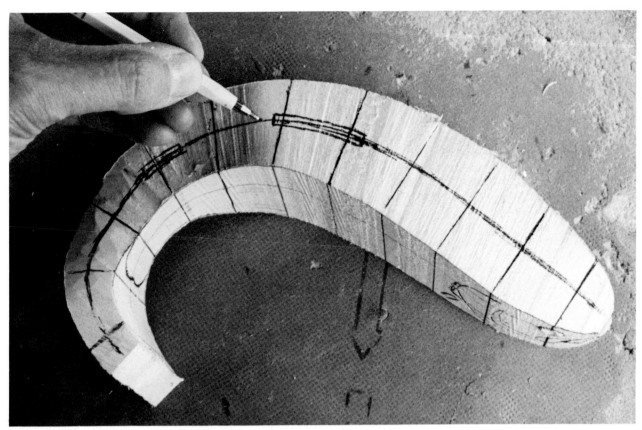

Figure 11

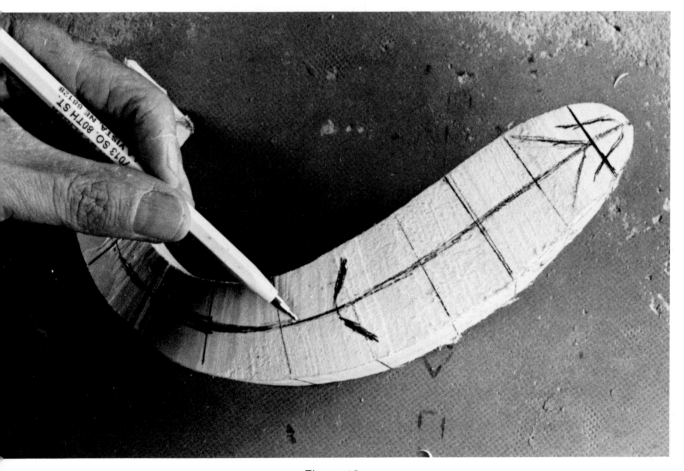

Figure 12

117

Draw the proposed wave in the tail (FIG. 13) before using a Foredom or similar tool with a carbide cutter to thin the tail at the point it meets the body (FIG. 14) and to shape the wave in the tail (FIG. 15). Continue to use the carbide cutter or a knife to round the body on the top of the fish (FIG. 16) and the bottom (FIG. 17) to the center lines.

Once the body is roughed out, we can sand the tail and body with a drum sander to achieve its nearly correct size and shape (FIG. 18, 19), referring to the cross-section lines in Illustrations C-6 and C-7 for proportioning. I then use a Murphy knife to round off the head (FIG. 20) before I transfer the pattern for the head detail to the wood.

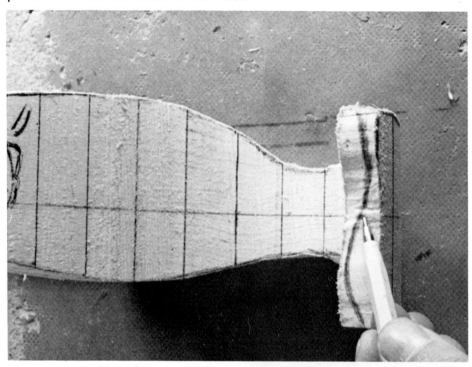

Figure 13

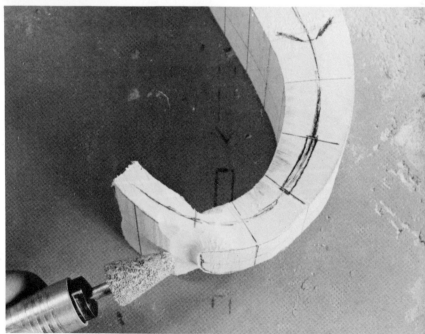

Figure 14

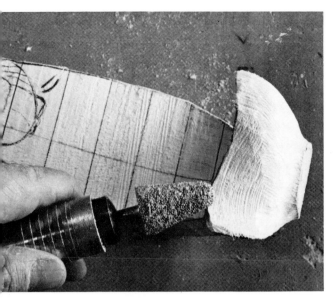

Figure 15

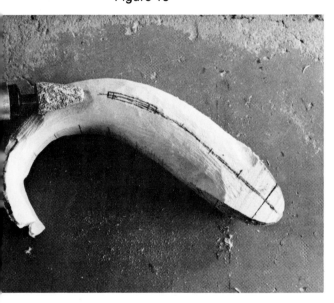

Figure 16

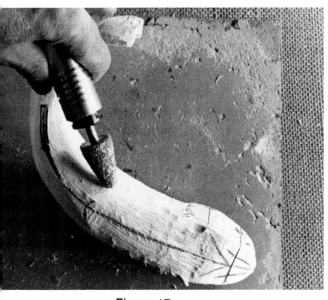

Figure 17

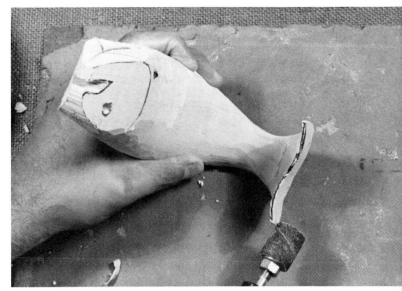

Figure 18

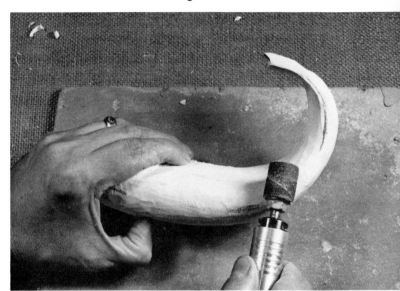

Figure 19

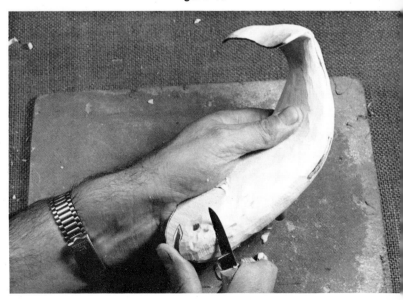

Figure 20

Using a series of stop cuts and undercuts I carve the relief of the gill (FIG. 21). I continue using stop cuts and undercuts to create the gill opening (FIG. 22), being very careful not to make the gill too thin (FIG. 23).

To remove the marks left by the knife or carbide cutter on the body, use a 240 grit sanding drum on the Foredom to make the surface of the body as smooth as possible (FIG. 24, 25). Hand sanding with fine sandpaper will also help.

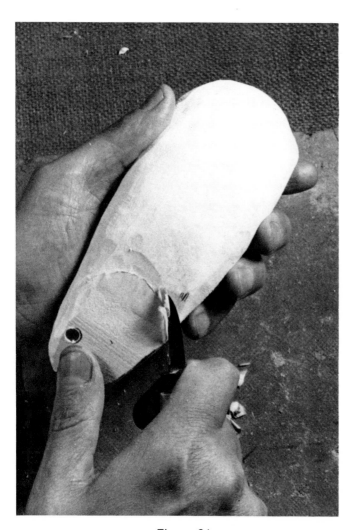

Figure 21

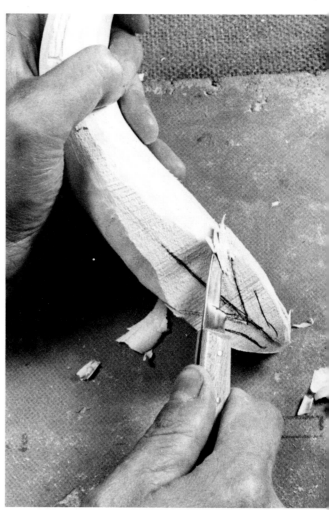

Figure 22

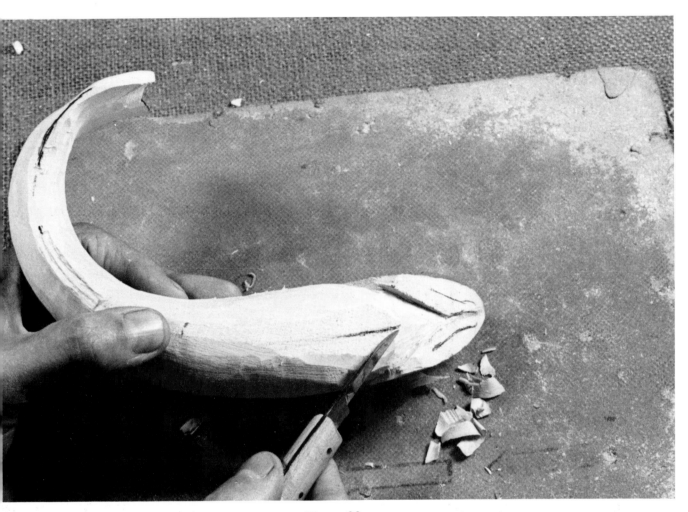

Figure 23

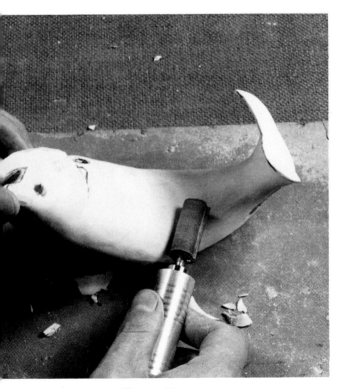

Figure 24

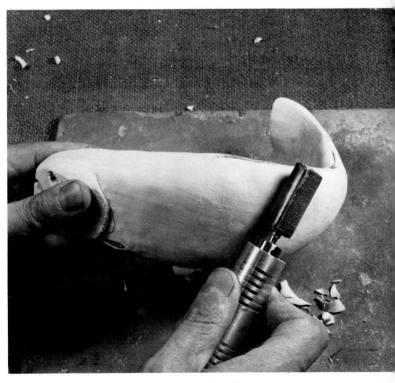

Figure 25

Now we can transfer the head detail from the pattern by placing the pattern on the wood, use a pin to mark the detail lines (FIG. 26) and connect the pin marks on the wood with a pencil (FIG. 27). This should be done on both sides, of course. Also, cut in the pectoral fin muscle, shown in Illustration C-8, as we did with the first two projects.

Carve the detail of the head in conformity with Illustrations C-4, C-5 and C-6, after sanding the roughed-out head features (FIG. 28).

With a knife we carve the detail of the lower jaw gill cover area by carefully using angled stop cuts at the back of the gill and undercutting to them from the tail side of the fish (FIG. 29).

Refer to Illustrations C-5 and C-6, cross-section (1), for the detail of the lower jaw (FIG. 30). Use stop cuts, a small V-tool and a small U-gouge to carve along the lines shown in these illustrations.

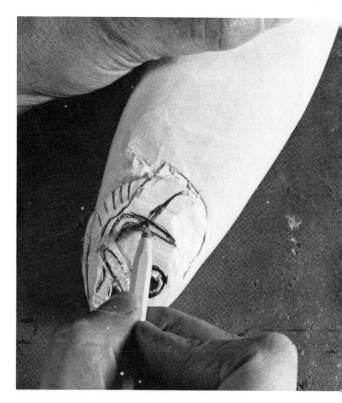

Figure 27

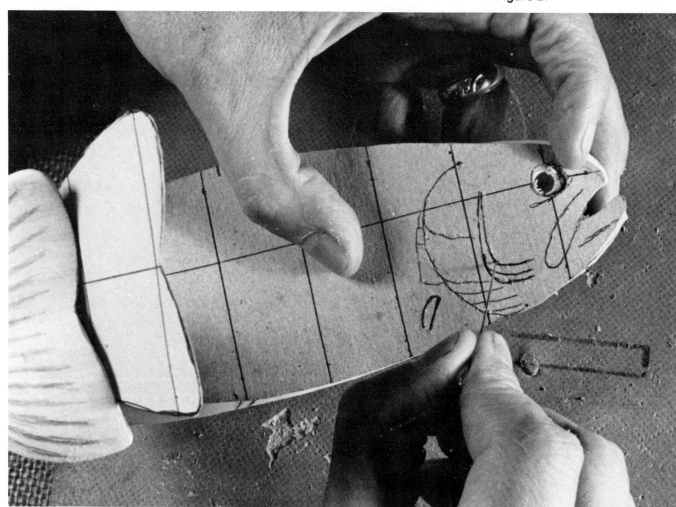

Figure 26

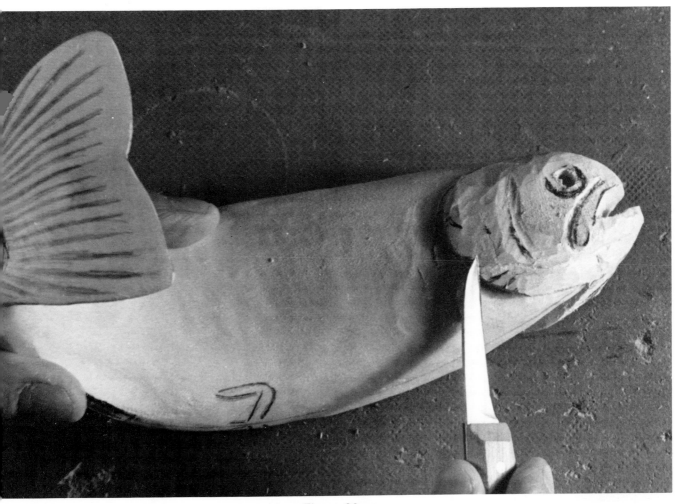

Figure 28

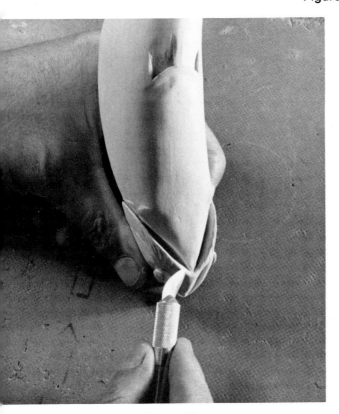

Figure 29

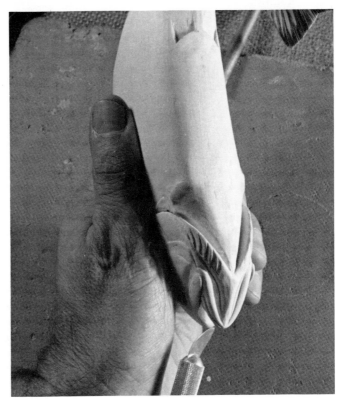

Figure 30

Use the template to mark the eye socket corresponding in size to the eye, which is 12 mm (FIG. 31). With a small round ruby burr on the Foredom carve out the eye socket to a depth of 1/4 inch (FIG. 32).

Cut in the lines of the gill cover and undercut it using Illustration C-9 as a guide (FIG. 33). And carefully sand the gill cover area with folded, very fine sandpaper to remove the carving marks, leaving a smooth surface (FIG. 34).

On the ventral side of the fish carve the pelvic muscle by making stop cuts with a small flat gouge as shown in Illustration C-10 (FIG. 35).

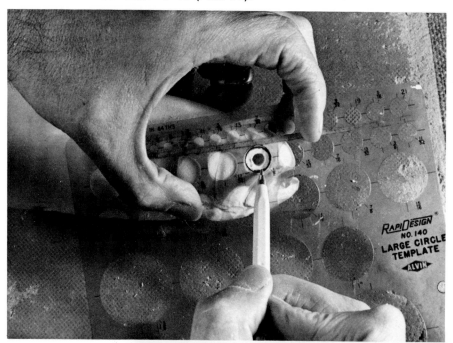

Figure 31

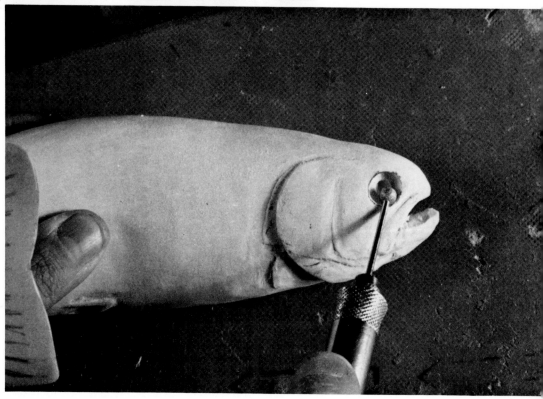

Figure 32

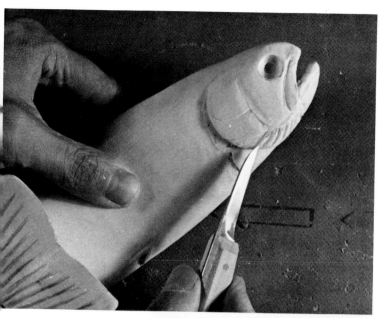

Figure 33

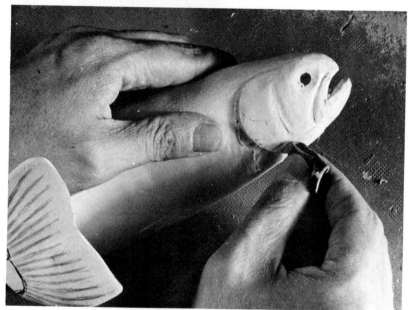

Figure 34

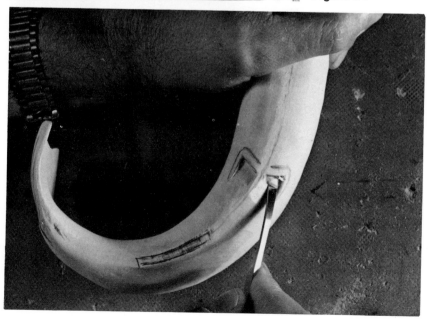

Figure 35

125

Define the area of the pelvic girdle with an X-acto number 16 blade carving tool, Foredom tool with a ruby carving bit, or a piece of course sandpaper (FIG. 36). When shaping is complete use a fine grit sandpaper to smooth the surface.

For detail of the mouth see Illustration C-5. The mouth is carefully ground out using small ruby bits on the Foredom (FIG. 37). When carving the mouth use a study head of the rainbow. I have several heads frozen with different mouth openings for this purpose.

As with the crappie project, the tongue is carved with a stick handle (FIG. 38). Carve the tongue to conform to Illustration C-5, drawing (4). I use a dental pick for positioning the tongue for gluing into the mouth (FIG. 39).

Figure 36

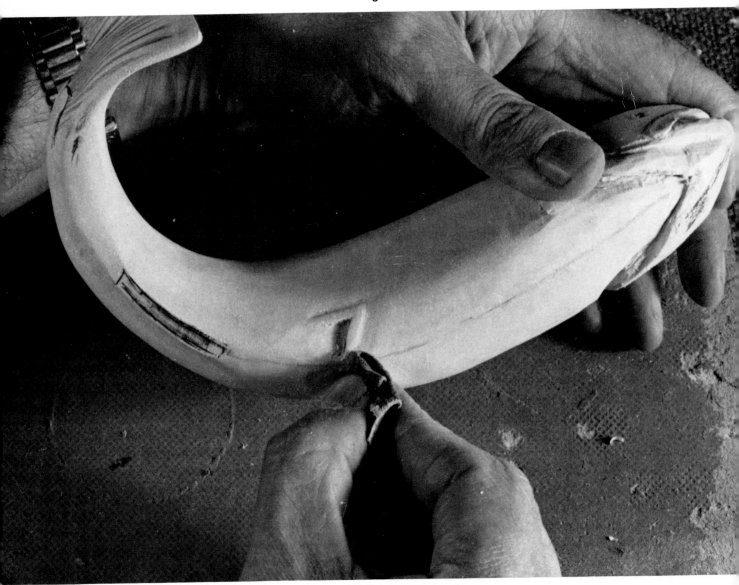

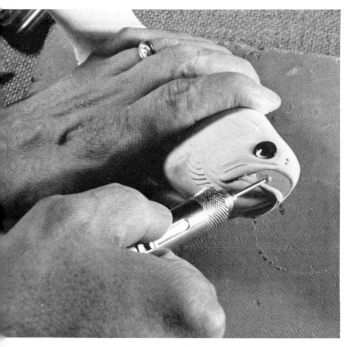

Figure 37

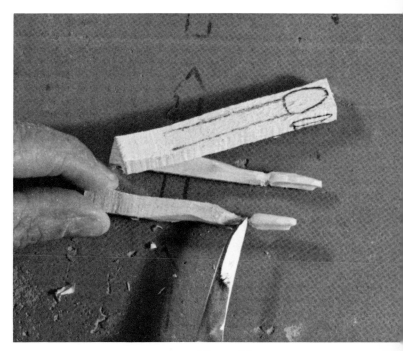

Figure 38

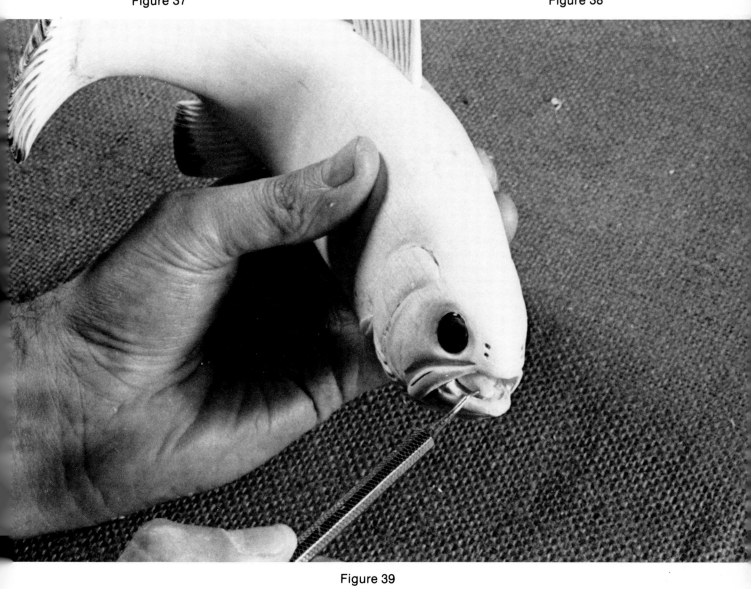

Figure 39

127

After drawing in the rays of the tail, use a small U-gouge to carve them in along the lines (FIG. 40). Carving the rays on the inside half of the tail can be difficult, but with special attention and very sharp tools, it need not be more than a challenge. On the border of desperation I sometimes use a very small ruby bit on the flexible-shaft power tool and a calm, steady hand for the task.

Once carved, the rays are sanded smooth with 240 grit crocus cloth or sandpaper (FIG. 41). The ends of the rays are woodburned, as are the small splits (FIG. 42, 43). The larger splits are carved with a small V-tool before burning.

When the woodburner is turned to a cooler temperature, it becomes a very good tool for fine detail work and refining detail, particularly in the gill area (FIG. 44). It removes small splinters and rough spots sandpaper cannot reach.

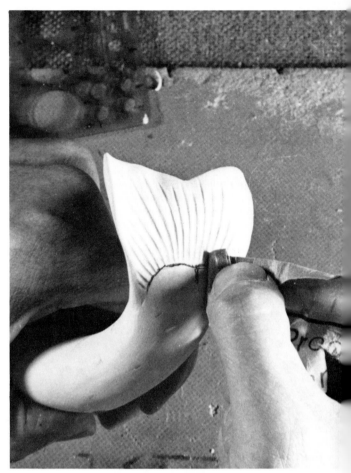

Figure 41

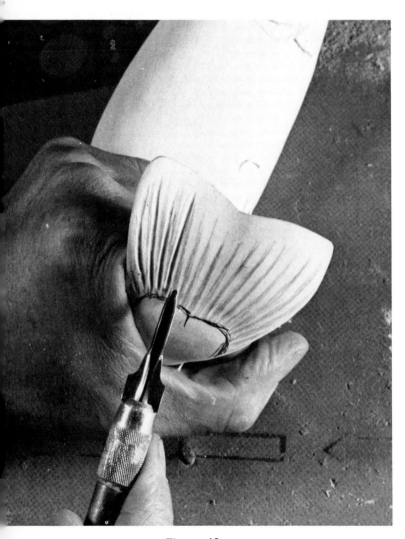

Figure 40

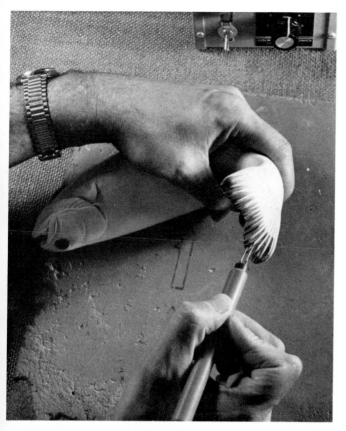

Figure 42

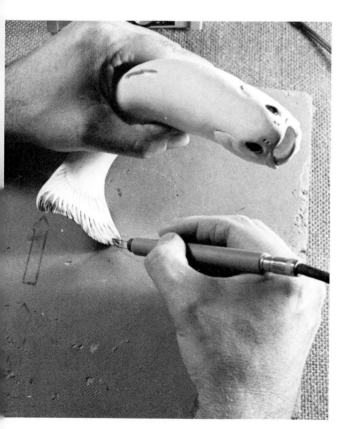

Figure 43

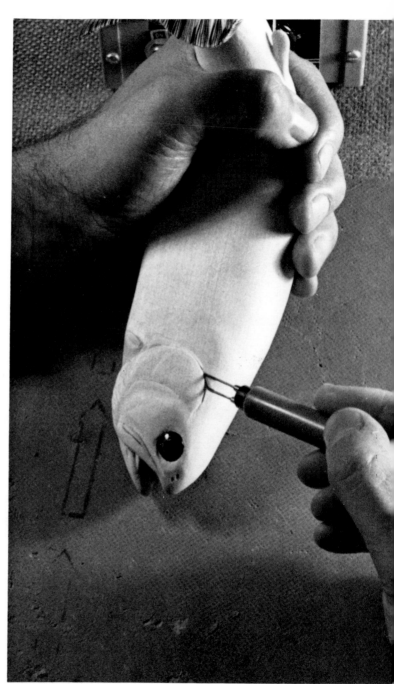

Figure 44

129

The adipose fin is carved out separately, as was the tongue. Carve the adipose fin pursuant to the pattern in Illustration C-4, drawing (3) (FIG. 45), sand it smooth and then glue it into place with white glue (FIG. 46).

The remaining fins are created in the same way we carved the fins for the sunfish and the crappie. Figure 47 shows the pectoral fins in the different stages of development in conformity to Illustration C-4, drawing (1). Note the grain direction for all the fins in Illustration C-11. The same process is used for carving the pelvic (FIG. 48) and the dorsal and anal (FIG. 49) fins. See Illustration C-5, drawing (5); Illustration C-4, drawing (2); and Illustration C-5, drawing (6), respectively.

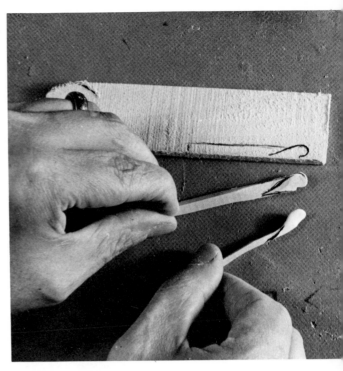

Figure 45

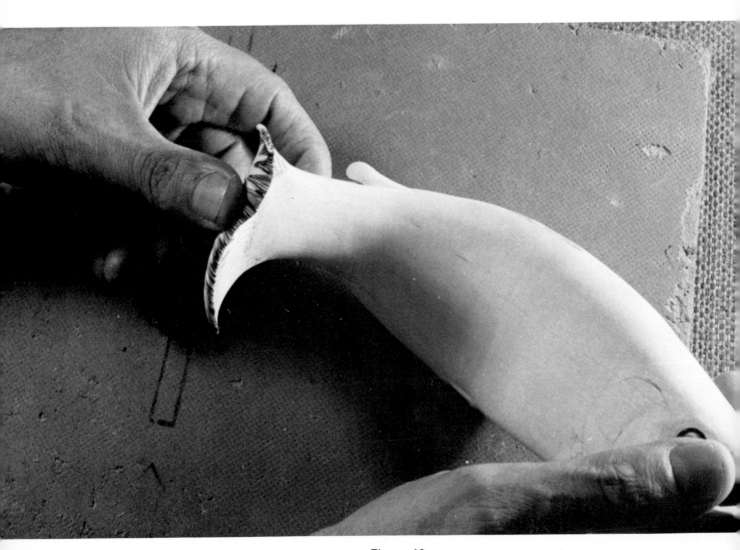

Figure 46

130

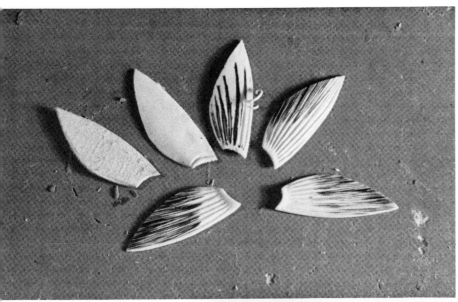

Figure 47

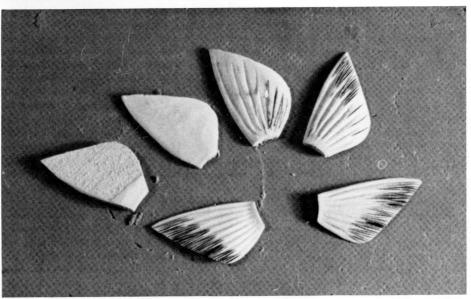

Figure 48

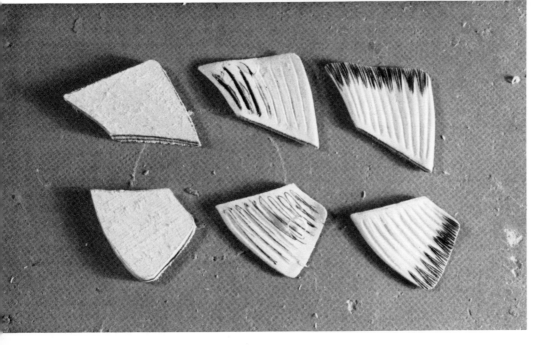

Figure 49

Using the carved dorsal fin as a guide, mark and cut the slot into which it is to be inserted (FIG. 50), and glue the fin into place, remembering that the rays angle toward the tail (FIG. 51). Repeat this process for the anal fin (FIG. 52, 53). Save the pectoral and pelvic fins for attachment later (FIG. 54).

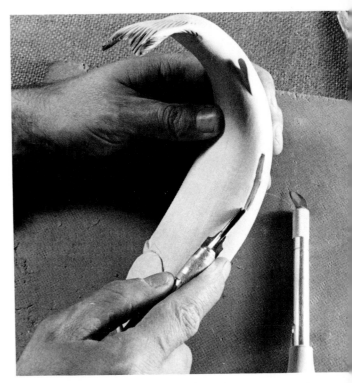

Figure 50

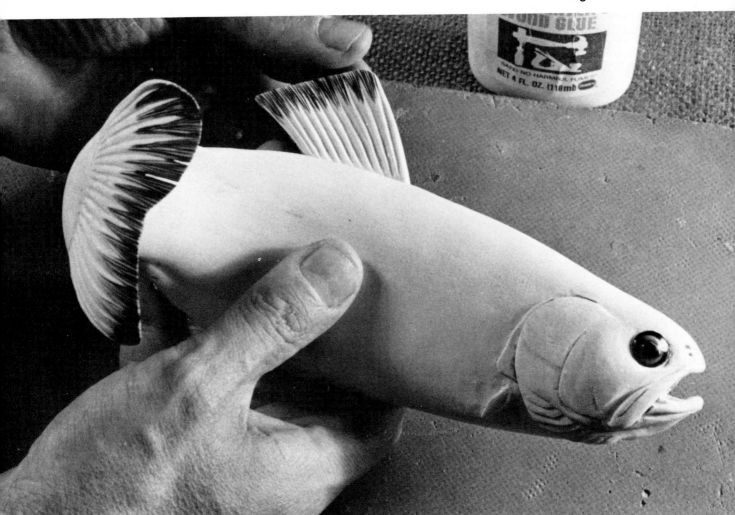

Figure 51

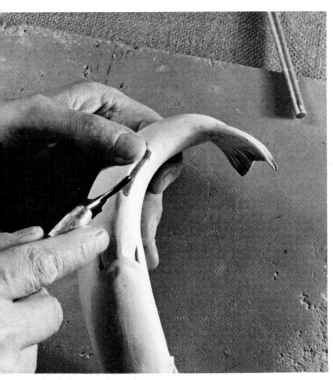

Figure 52

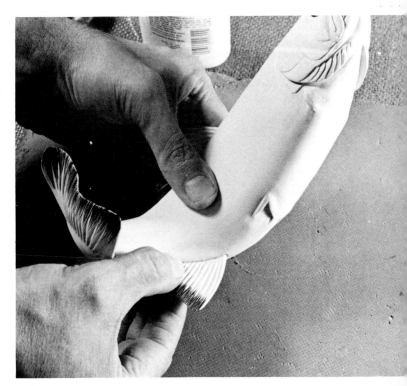

Figure 53

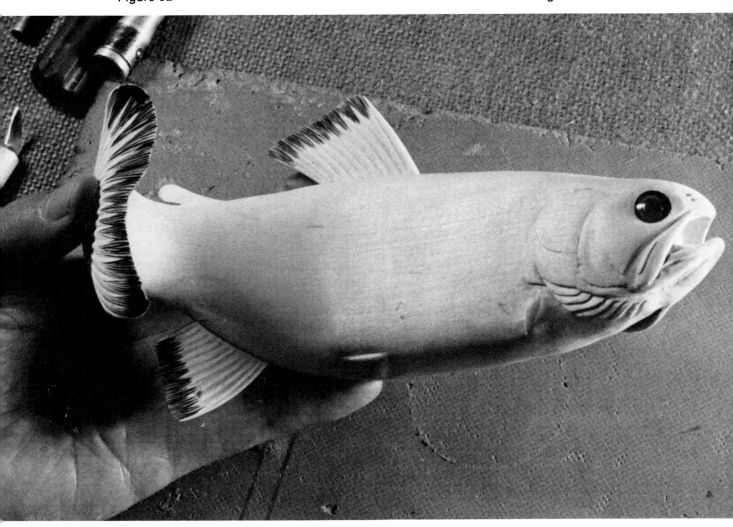

Figure 54

Before sealing the carved fish with Deft lacquer spray, place pieces of masking tape over the pectoral and pelvic fin areas (FIG. 55) to prevent sealing the areas where the fins will be attached.

Notice that I have decided on the sand base pattern to use with this piece. The sand design of 3/4 inch basswood is carved from a pattern showing the outline of where the driftwood is to be attached (FIG. 56). The sand drift ridges are roughed out with a carbide cutter, being careful not to carve inside the driftwood outline on the base (FIG. 57), then sanded with 240 grit crocus cloth on a drum sander (FIG. 58).

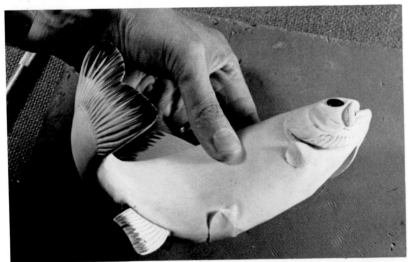

Figure 55

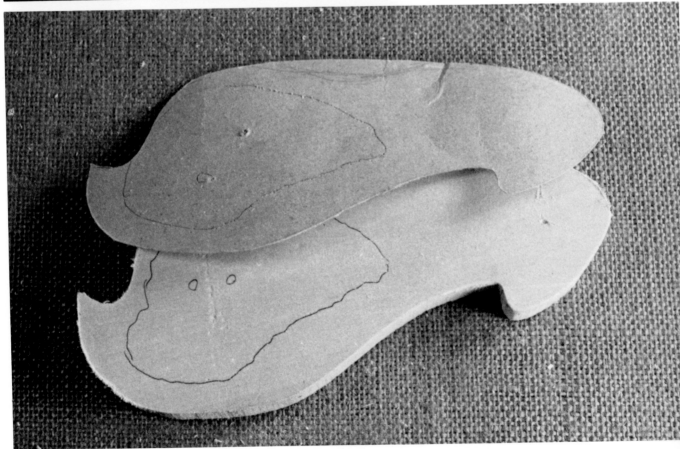

Figure 56

Figure 57

Figure 58

135

At the point on the driftwood chosen to attach the carving, drill two holes and insert two pins to mark where on the fish you need to drill holes for mounting (FIG. 59). Figure 60 shows the carved, unpainted fish mounted.

To make grass blades I rip several 3/32 inch thick strips of basswood (FIG. 61). When drawing and transferring the pattern for the blades I arrange them to get as many as possible from each strip of wood (FIG. 62), and carefully cut them out on a bandsaw or use a coping saw (FIG. 63).

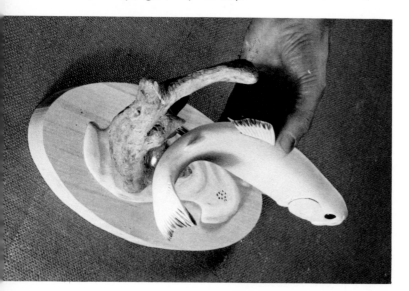

Figure 59

Figure 61

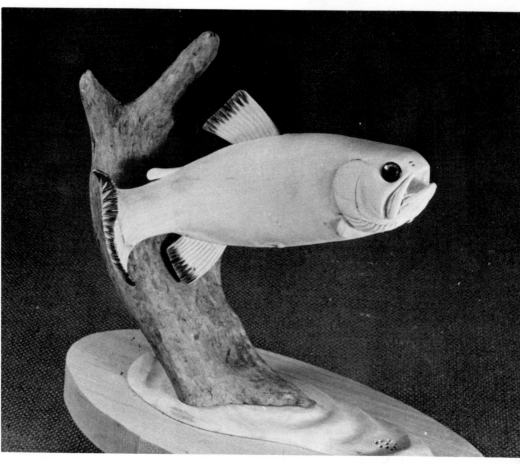

Figure 60

136

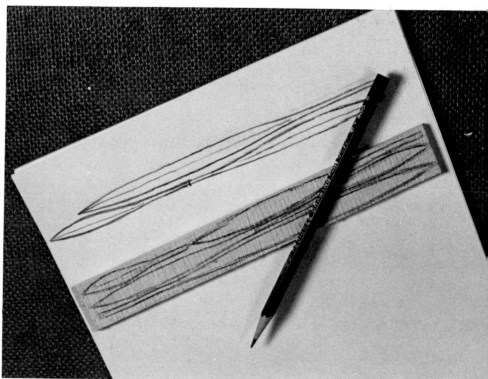

Figure 62

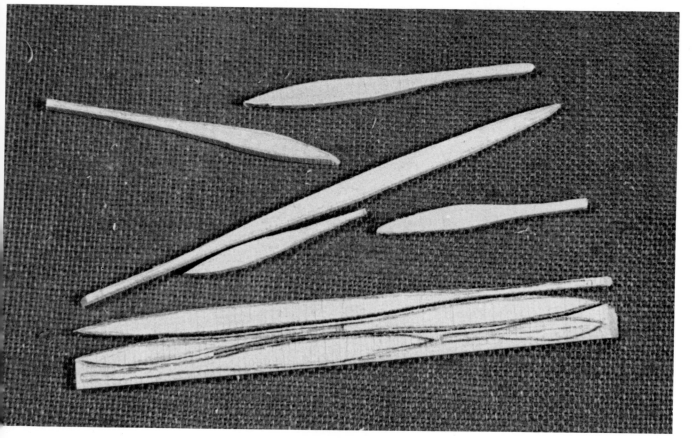

Figure 63

With a flat gouge we then carve the blades with the main stem approximately 1/16 inch in diameter and sand them with 240 grit sandpaper (FIG. 64), after which we burn in the veins with a woodburner. The rays radiate from the base of the stem and run parallel to the center vein (FIG. 65). I always carve more blades than I will probably use on the project, but the time spent carving more than enough is well worth avoiding the additional time that would be required to go back to carve additional blades (FIG. 66).

To obtain the curvature of the grass blades, place the blades in a container of warm water for about one minute to soften them up for bending. Then use clothespins to attach the blades around different sized cans to get the desired curvature (FIG. 67). An "S" curve can be obtained by clipping the tip of the blade to another can, as shown in the middle of Figure 67.

After allowing the blades to dry in the shapes desired, seal them with acrylic spray (FIG. 68) and apply two coats of gesso. Use a clip type clothespin to hold the blades upright so you can paint both sides to save time. Apply gesso to the stems after the blades have dried.

Figure 65

Figure 64

138

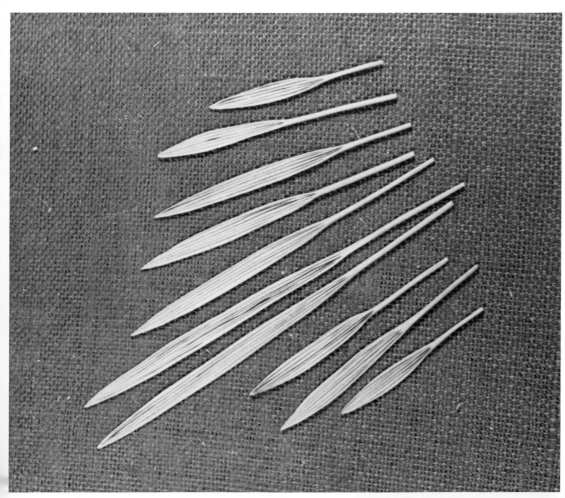

Figure 66

Figure 67

Figure 68

The finished grass blades are attached to the sand base of the composition by drilling 1/16 inch holes for inserting the blade stems. Arrange the blades of grass to best enhance the total composition, being careful not to interfere with the trout itself (FIG. 69). Note that the pelvic fins are not in place at this time, so be careful they will not be in the way when they are attached later.

Before painting the grass and the fish, they are given at least two coats of gesso (FIG. 70).

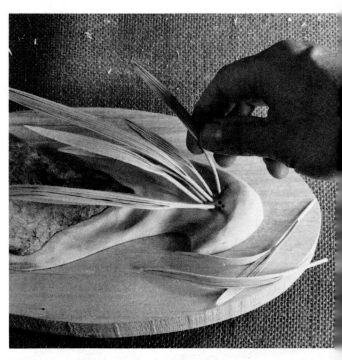

Figure 70

Figure 69

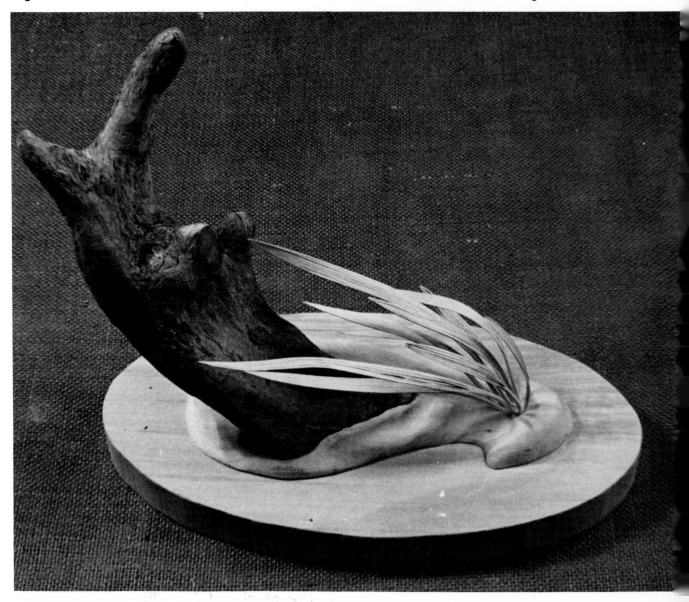

Channel Catfish

Ictalurus punctatus

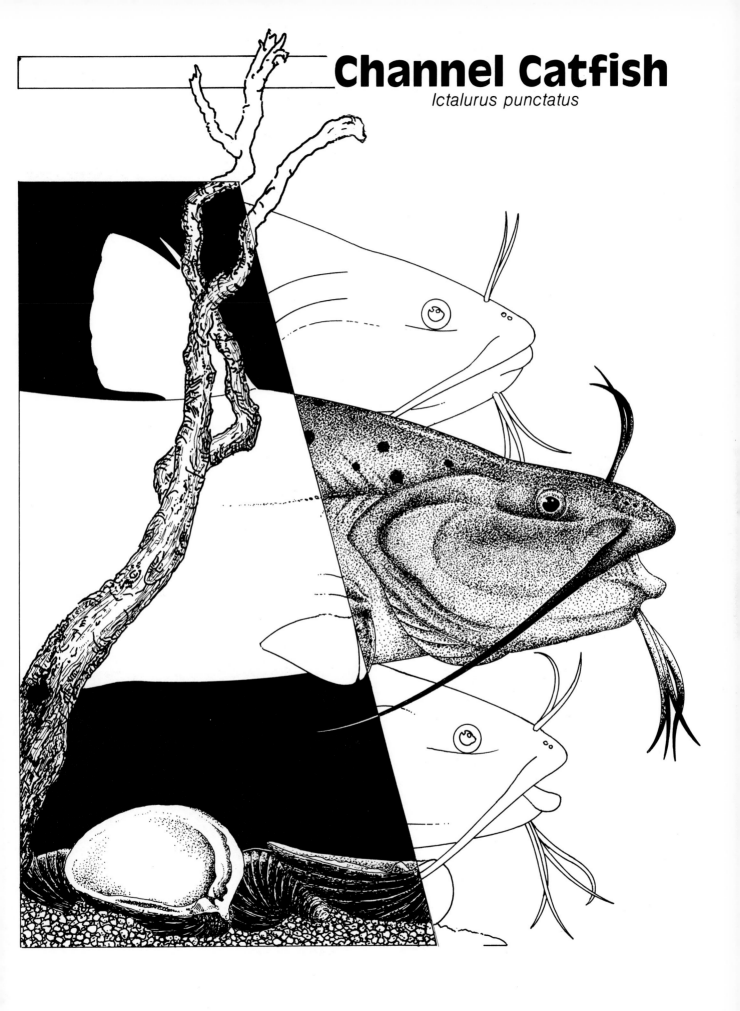

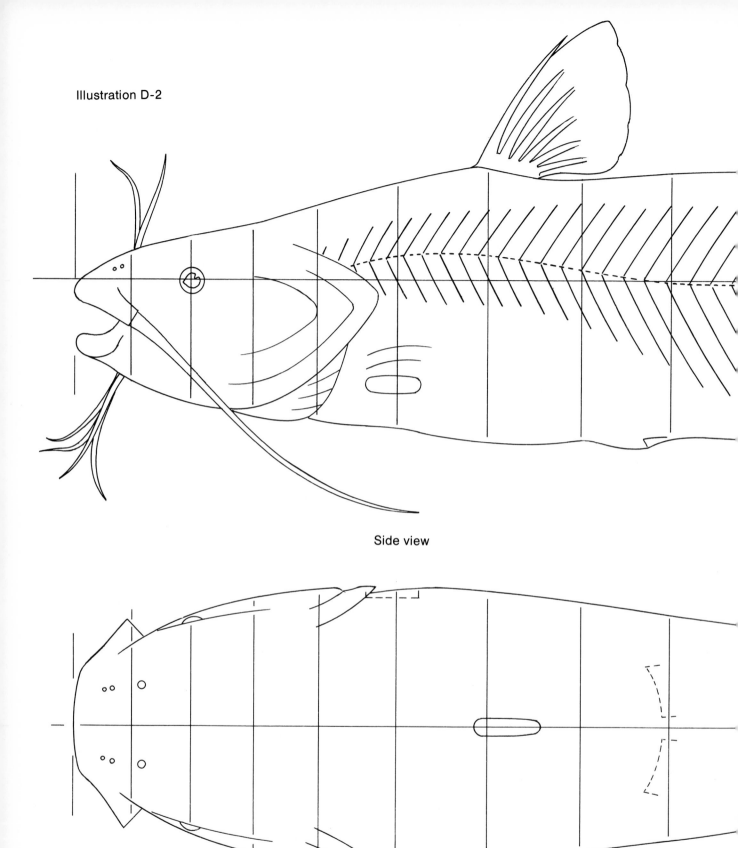

Side view

Top view with bottom detail in dotted lines

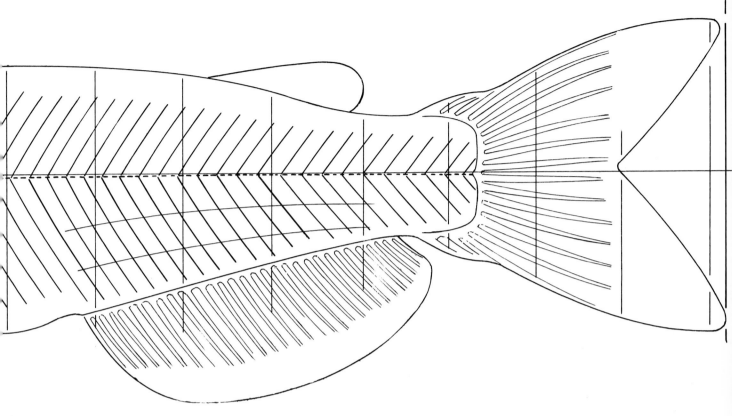

Side view

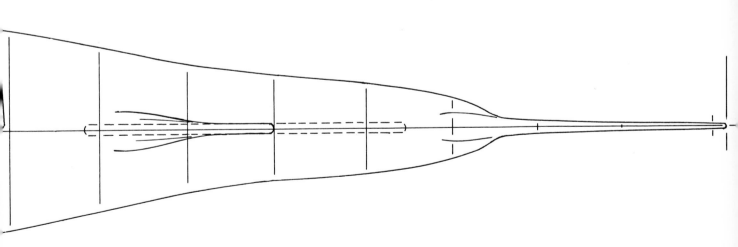

Top view with bottom detail in dotted lines

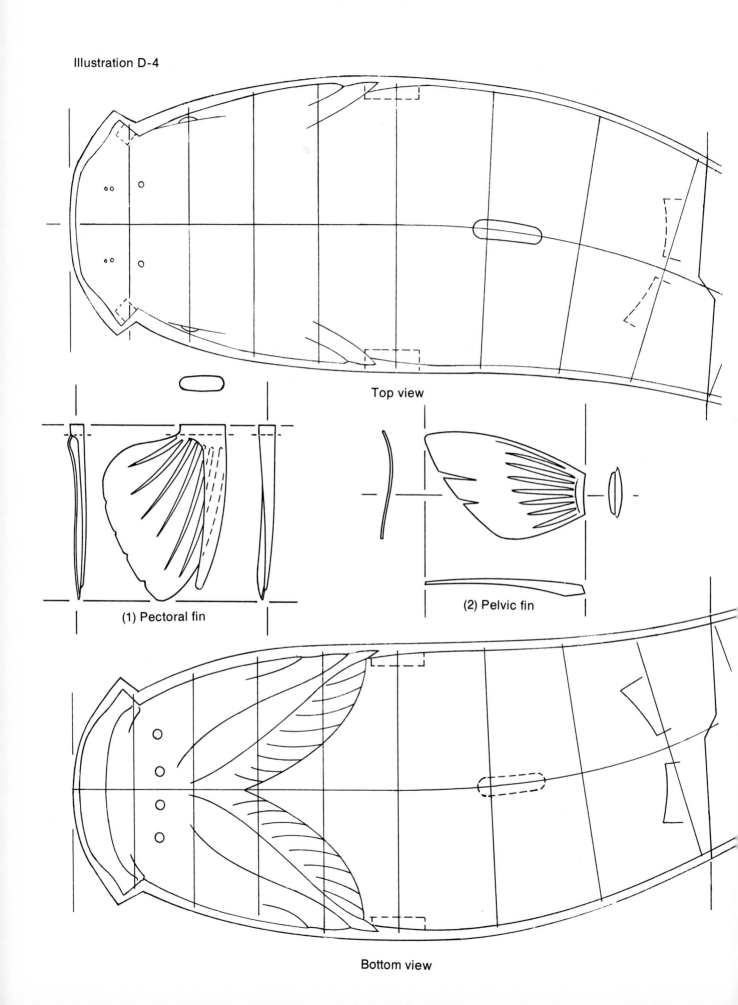

Top view

(1) Pectoral fin

(2) Pelvic fin

Bottom view

Illustration D-5

(3) Dorsal fin

Top View

Bottom view

Channel Catfish have 24 to 30
days in which the anal fin is
rounded on the outer edge.

(4) Anal fin

Cross sections

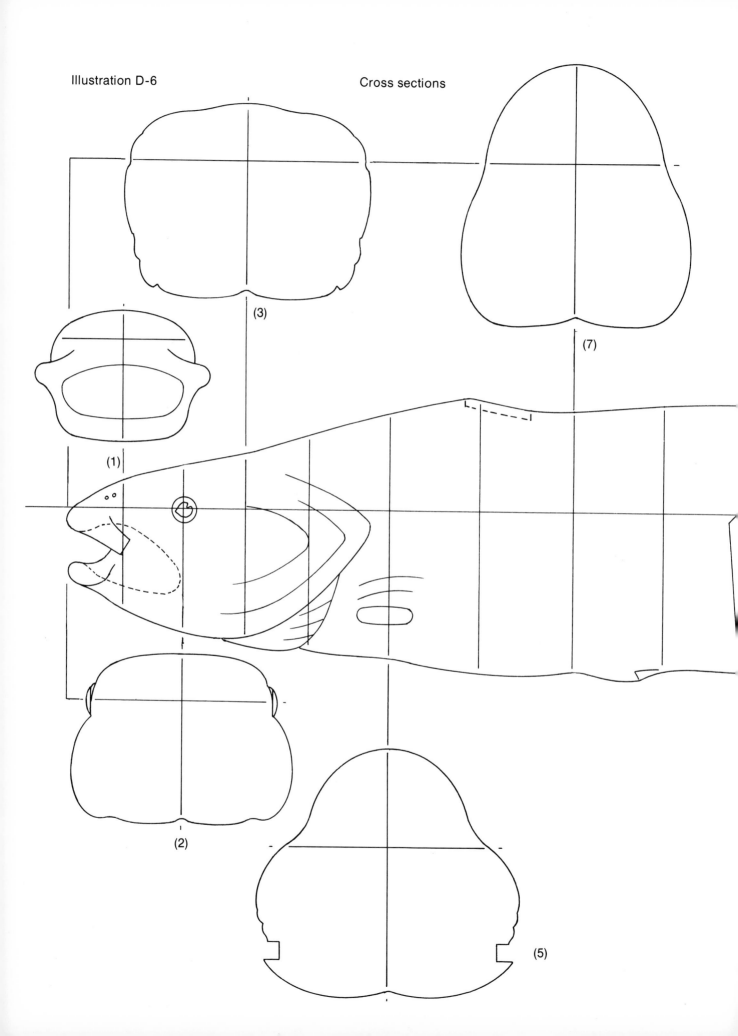

(3)

(7)

(1)

(2)

(5)

Illustration D-7 Cross sections

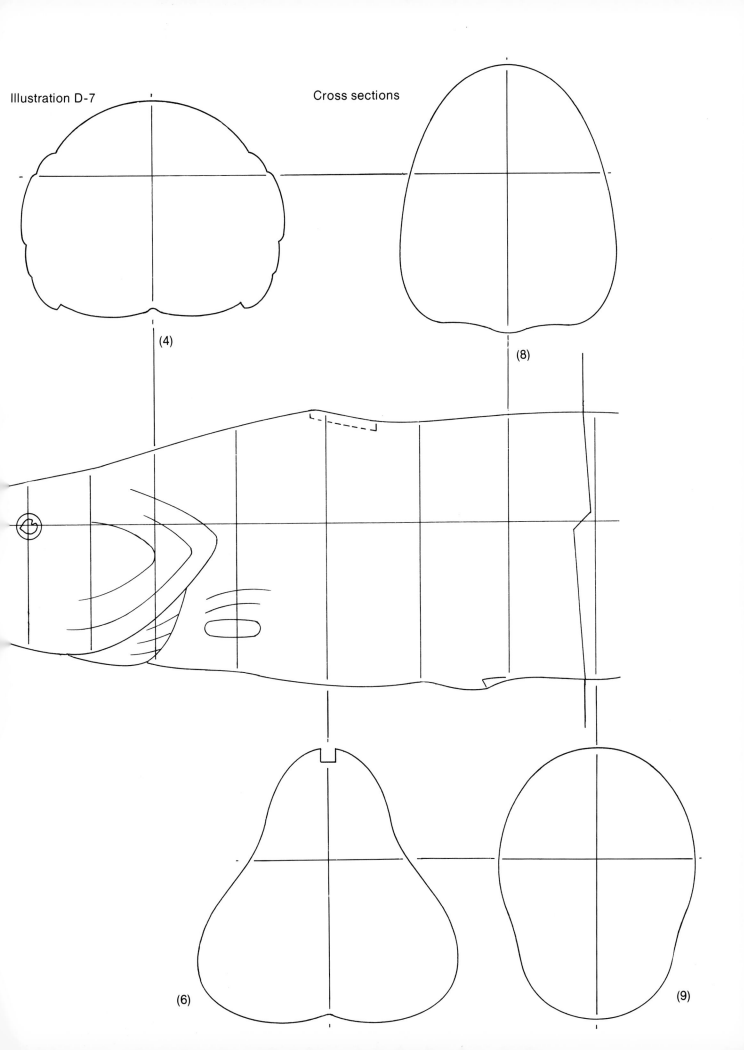

(4)

(8)

(6)

(9)

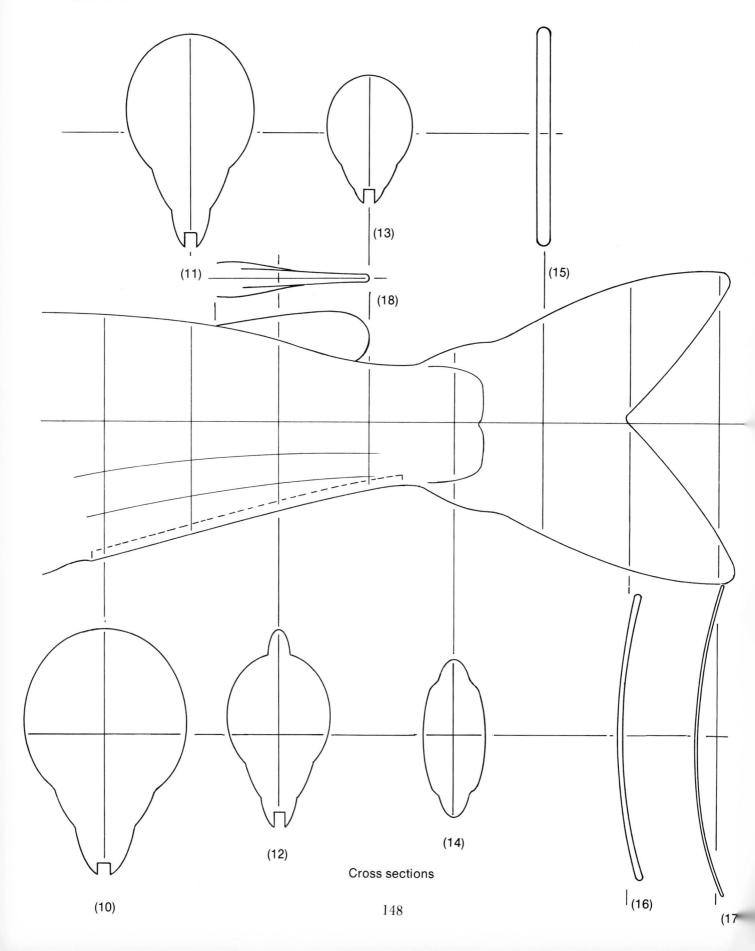

(11)

(13)

(15)

(18)

(10)

(12)

(14)

Cross sections

(16)

(17)

148

Illustration D-9
Carving pectoral fin muscle

Illustration D-10
Angle of line -gills

Illustration D-11
Anal fin -grain direction

Illustration D-13
Angle & contour of pelvic fin to body

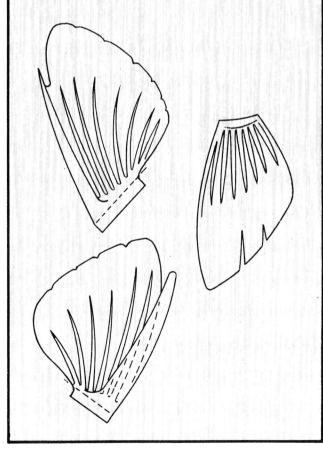

Illustration D-12
Dorsal, pectoral and pelvic fins -grain direction

20 Penny Common

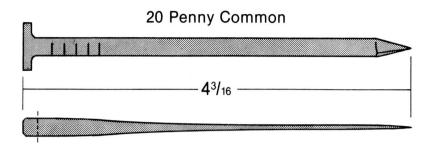

$4^{3}/_{16}$

8 Penny Finishing

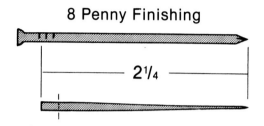

$2^{1}/_{4}$

4 Penny Finishing

$1^{1}/_{4}$

Illustration 14

Barbels from nails

Illustration 15

Patterns for clam shells

CHANNEL CATFISH

The channel catfish of the genus Ictalurus, with thirty-six other members, are found exclusively in North America. They can be distinguished by their deeply forked tails and small irregular spots, which disappear on larger fish. Channel "cats" also differ from the others of its genus by the number of rays in the anal fins, 24 to 30, and the slight rounding of the fins' outer edges. It is known as a soft-rayed fish even though it does possess a spine in the dorsal and pectoral fins.

The eight fleshy barbels, or "whiskers," are, of course, the most interesting feature of this scaleless fish. The whiskers have taste buds for sweeping the bottoms for food. So sensitive are the whiskers and the lateral lines that catfish can know its surroundings and find food in very muddy waters or even complete darkness.

Pound for pound the tenacious channel catfish provides a superb fight for any sport fisherman. For this reason I feel it should have gamefish status. The "cat" is a most interesting and challenging subject for a decorative wildlife carving as well.

CARVING THE CHANNEL CATFISH

In planning the composition of the channel catfish, again remember to experiment with different pieces of driftwood in different positions on the base to determine how the carving can best be exhibited. The willow stump I have chosen for this carving bears the teeth marks of a beaver as he chewed off the bark and small branches, which he ate. Perhaps this piece of wood was driven into the bottom of a river to be stored over the winter. A catfish would also claim such a piece of wood as part of its home.

This particular piece of driftwood I had to sand flat at three points to fit on the base (FIG. 1). A belt sander works best. Figure 2 shows how I decided to fit the driftwood, after experimenting with different positions, on the rather large oval base, which measures 9-1/2 inches by 11-3/4 inches by 1-1/2 inches thick. Holding the catfish pattern in place on the driftwood gives me an idea of the composition when completed (FIG. 3).

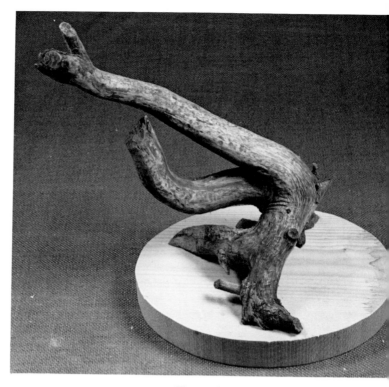

Figure 2

Figure 1

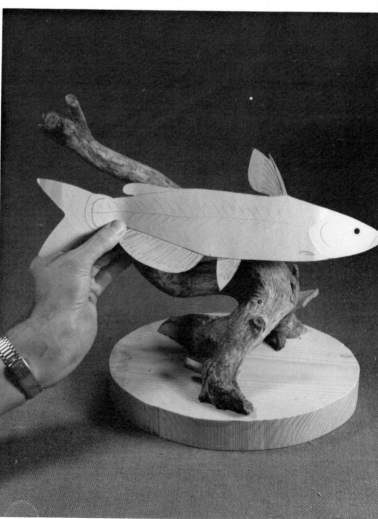

Figure 3

151

Using the pattern of the top view, trace its outline on a block of basswood measuring 15 by 4-1/4 by 3-1/2 inches (FIG. 4) and cut it out on a bandsaw. Do the same for the shape of the side view, saving the scraps for later use (FIG. 5). Now we use the side view pattern to draw the gill outlines and the location of the eyes (FIG. 6). With a knife cut a 1/8 inch deep stop cut along the gill outlines (FIG. 7), and drill the eye sockets to a depth of 3/8 inch with a 1/4 inch drill bit (FIG. 8).

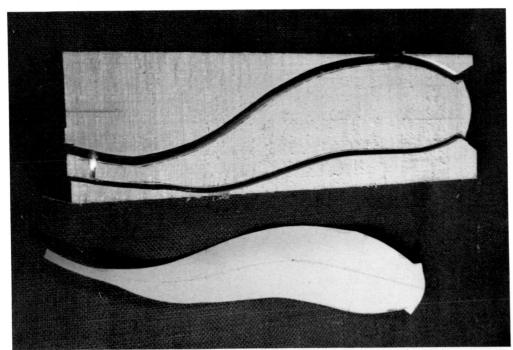

Figure 4

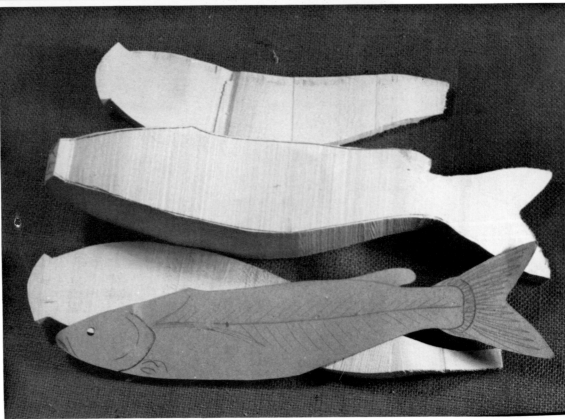

Figure 5

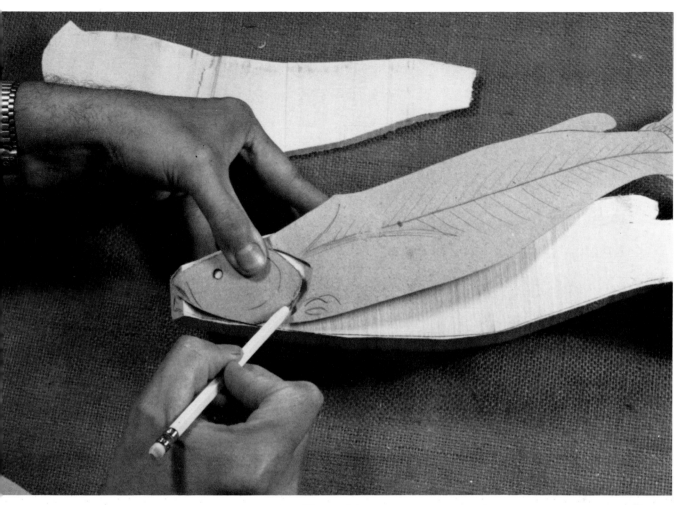

Figure 6

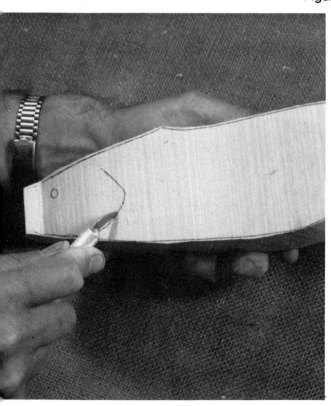

Figure 7

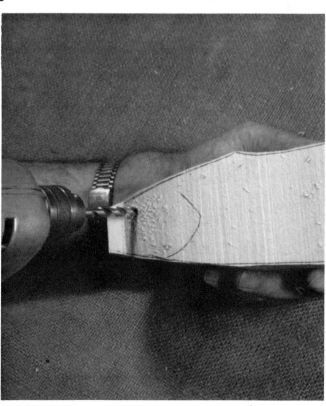

Figure 8

Referring to the pattern and Illustrations D-4 and D-5, draw the center line on the top of the catfish, the location of the dorsal fin (FIG. 9) and the forehead and head areas for use in carving detail later (FIG. 10).

Again referring to the pattern and Illustrations D-4 and D-5, draw in the center line on the bottom of the catfish, the location of the gills, lower jaw, pelvic fin muscles and the anal fin (FIG. 11). We now pencil in lines on the side view, which will help in the roughing out later (FIG. 12).

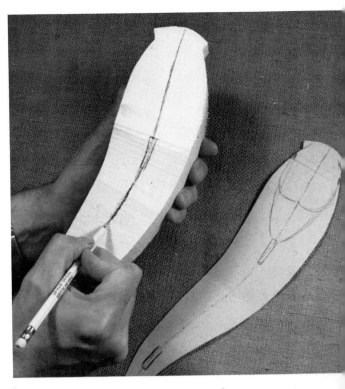

Figure 9

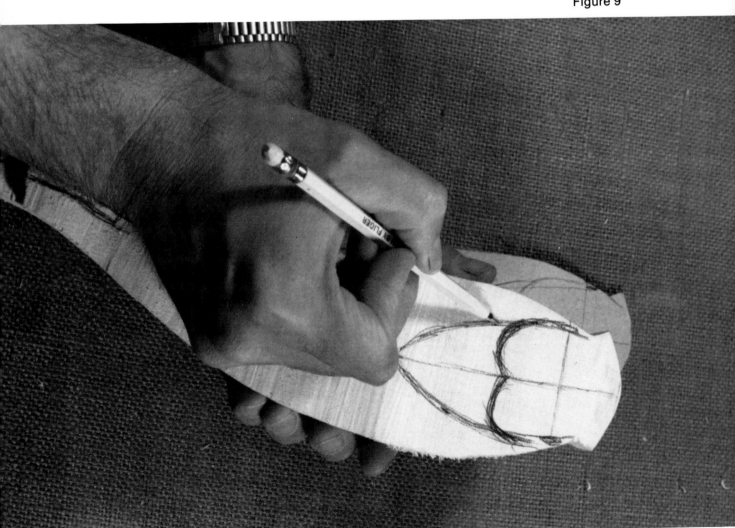

Figure 10

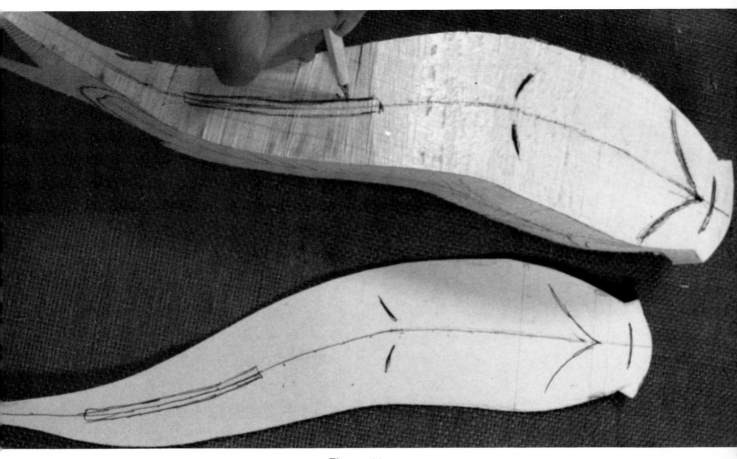

Figure 11

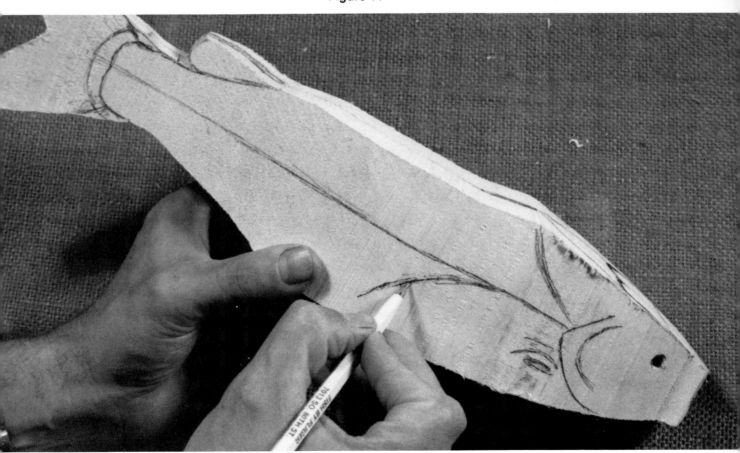

Figure 12

155

To save carving time I pencil in reference lines (FIG. 13) for cutting the edges on a bandsaw. I do not recommend this shortcut unless you are confident and skilled in the operation of a bandsaw, since the wood must be placed at an awkward angle to the saw blade (FIG. 14) to begin the rounding process (FIG. 15). The procedure is the same for cutting the ventral side of the fish (FIG. 16, 17). It takes longer, but the same shaping can be accomplished using a knife or a rotary power tool. If you are not sure of yourself, do not use the bandsaw for this shaping.

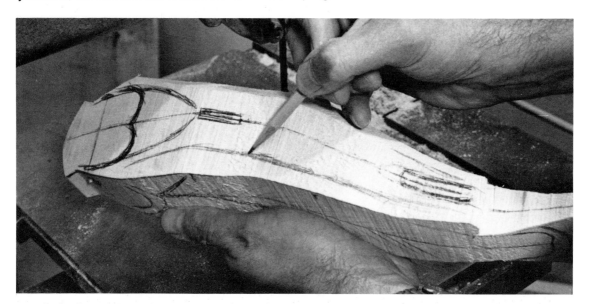

Figure 13

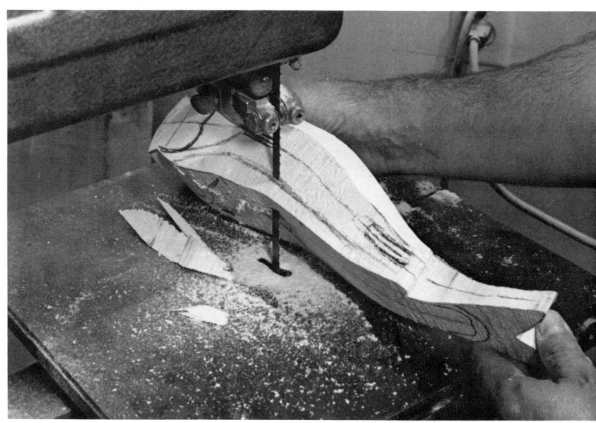

Figure 14

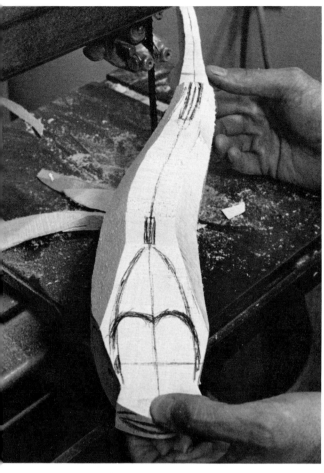

Figure 15

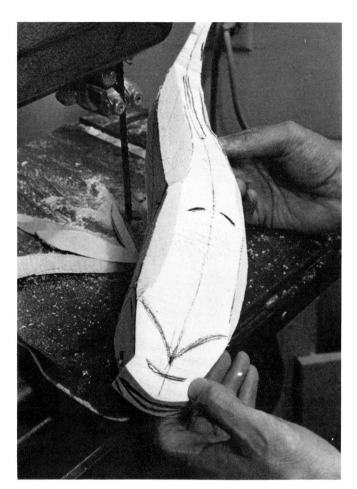

Figure 16

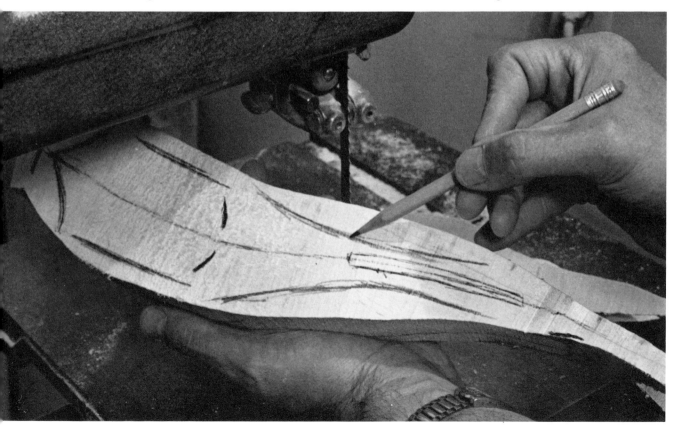

Figure 17

157

I next use an X-acto saw blade to cut down on each side of the adipose fin, roughing it out to between 1/16 and 1/8 inch thick (FIG. 18, 19). Since I am only roughing out the body I do not make the cut all the way down to the back. Further shape the adipose fin with a small flat gouge (FIG. 20). Remember to conform the shape of the fin to the curvature of the body.

I narrow the area where the tail joins the body of the catfish, beginning at the front of the tail, using a Foredom tool with a course sanding drum (FIG. 21) on both sides of the tail (FIG. 22). The curvature of the tail I then carve with a large, 14 mm, No. 7 straight U-gouge for the inside (FIG. 23) and a 3/4 inch flat gouge (FIG. 24) for the outside, being careful not to carve against the grain and split the wood.

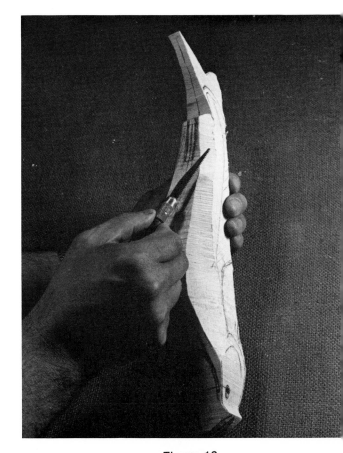

Figure 18

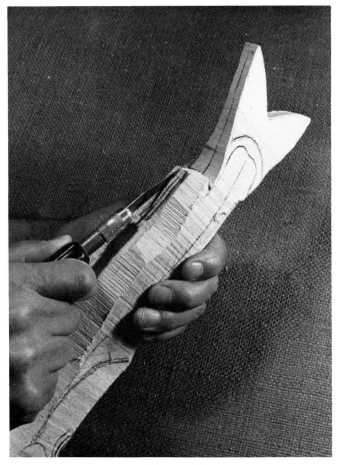

Figure 19

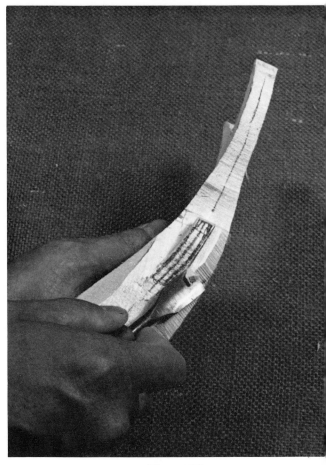

Figure 20

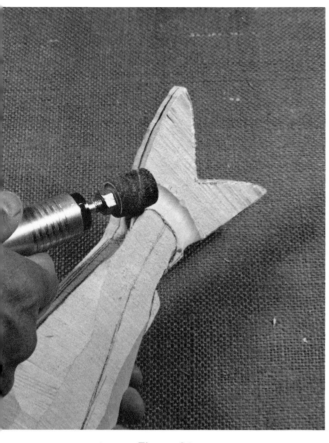

Figure 21

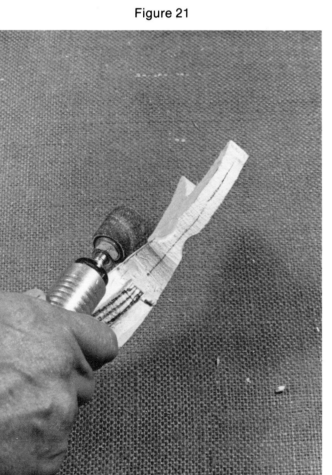

Figure 22

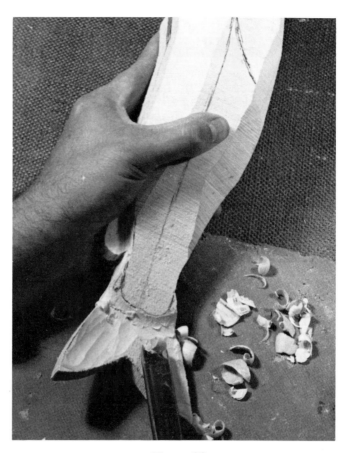

Figure 23

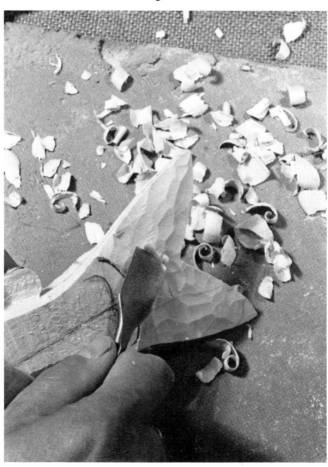

Figure 24

159

We now can further rough out the body with a knife, taking the edge off the cuts we made before (FIG. 25), and remembering that the body tapers in the area of the anal fin (FIG. 26), as shown in Illustration D-8, cross-sections 10 through 13, and Figures 27 and 28.

Working from the tail to the head we use a knife to continue shaping the body and the head area (FIG. 29, 30), removing the edges made when the corners of the blank were cut, and then smoothing out the knife and gouge marks with a 120 grit sanding drum (FIG. 31).

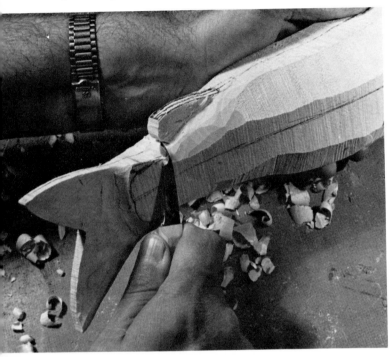

Figure 25

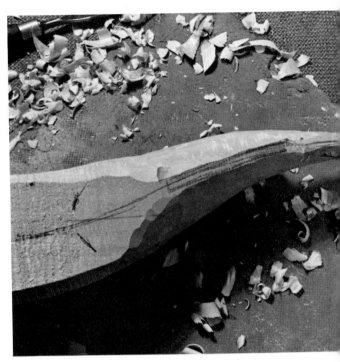

Figure 27

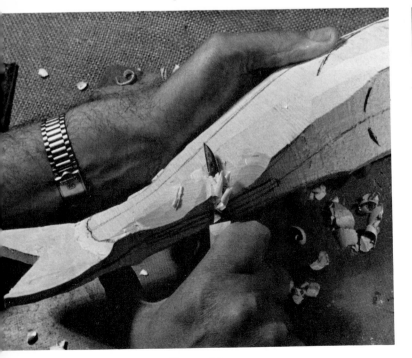

Figure 26

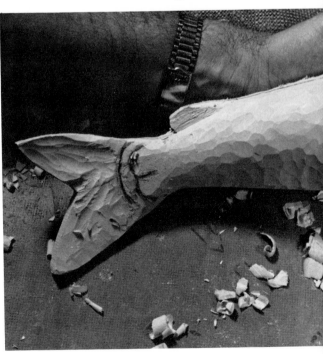

Figure 28

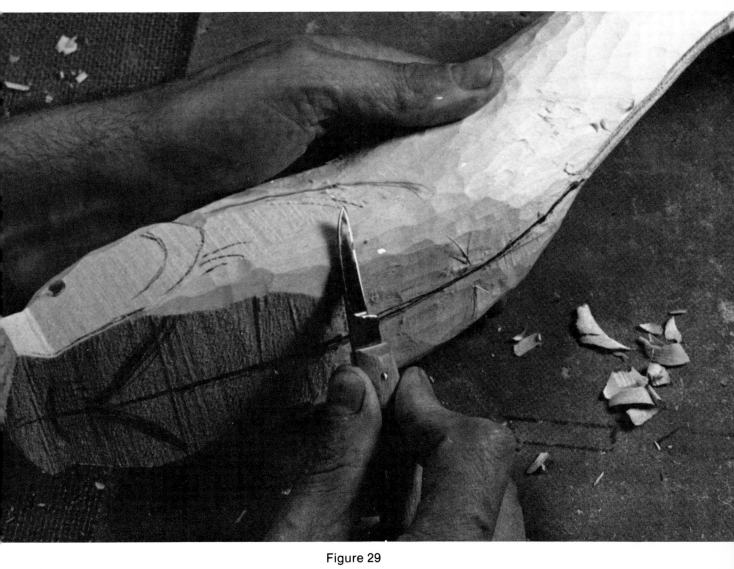

Figure 29

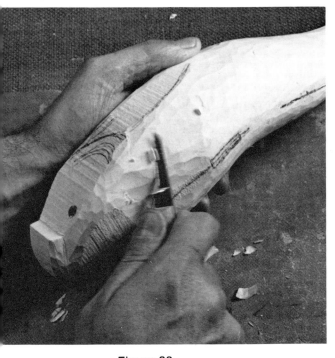

Figure 30

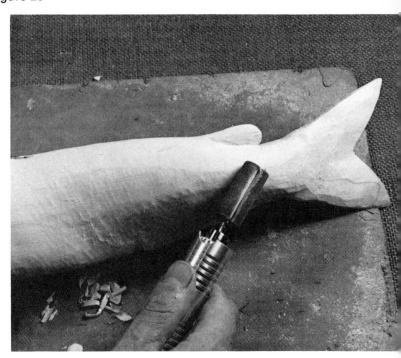

Figure 31

Figures 32 and 33 show what I call the "X" groove, made with a course sanding drum, to separate the head from the forehead, indicated in Illustrations D-6 and D-7, cross-sections 4 through 7. Do not worry too much about exactness in the groove, because we are basically roughing out at this stage. With a flat gouge we now cut away the "X" groove toward the tail (FIG. 34), defining the forehead and belly areas. After smoothing the whole surface with a sanding drum, redraw the center line (FIG. 35).

Referring to Illustration D-8, drawing 18, for size and shape, refine the adipose fin with a gouge and sandpaper. Notice how we seem to be moving around the fish to carve different areas. It is important to maintain an overview of the whole carving, so moving around to different areas assures the proper perspective and balance.

The pelvic fin muscles are not that complicated. First refer to Illustration D-4 and draw on the lines shown in Figure 37. At the lines (Illustration D-9) cut out the muscle areas with a 1/2 inch, 3 sweep chisel. Make stop cuts toward the head of the fish, as shown in Figures 37 and 38. To define the pelvic girdle, cut into the stop cut closest to the head from the head side and into the stop cut closest to the tail from the tail side (FIG. 39, 40). Further define the pelvic muscle on the side of the pelvic fin with a small gouge.

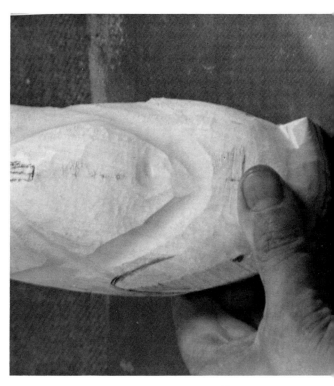

Figure 33

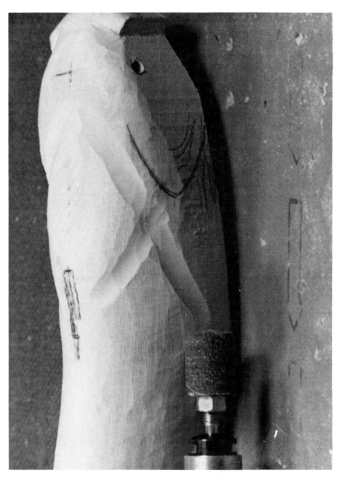

Figure 32

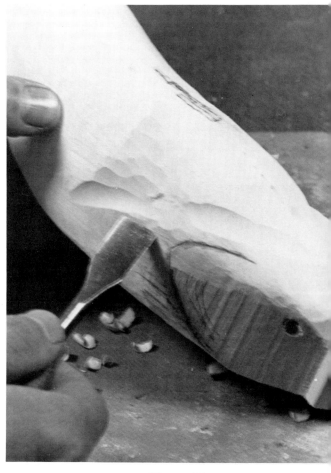

Figure 34

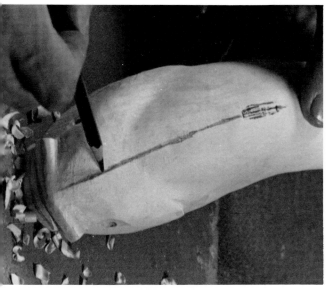

Figure 35

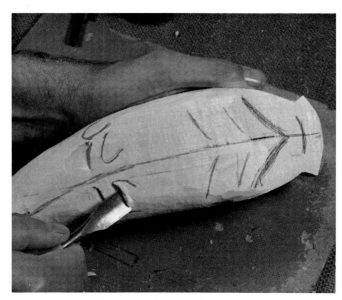

Figure 38

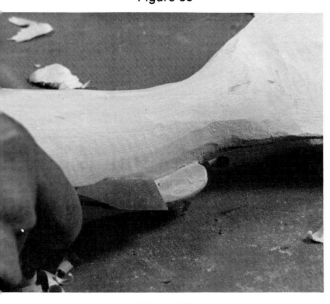

Figure 36

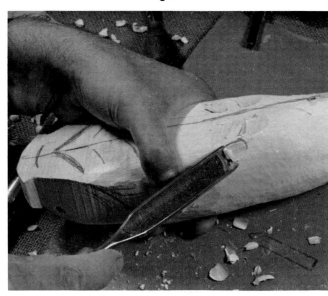

Figure 39

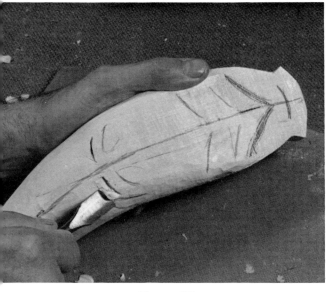

Figure 37

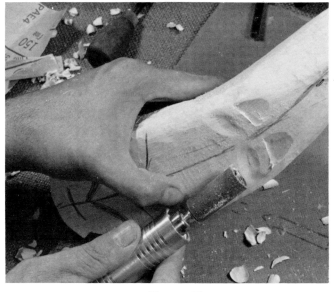

Figure 40

For the location and size of the anal fin muscle use Illustration D-5 and mark it with a pencil (FIG. 41). Then cut along each line with a small V-tool (FIG. 42) to achieve the location and general shape (FIG. 43) needed for defining the muscle area with a 1/2 inch, 3 sweep chisel, in the process removing the lines made by the V-tool (FIG. 44). Refer to Illustration 8-D, drawings 10 through 13, for the cross-sectional view helpful in defining the desire shape. When the desired shape is achieved, and the pelvic fin muscle is cut in relief, as shown in Illustration 9-D, the area is ready for sanding to a smooth surface (FIG. 45).

To further define the belly area, using a large V-tool we cut along the center line from the pelvic girdle to the gill cover (FIG. 46) and taper both sides of the belly into the center line cut just made (FIG. 47). See Illustrations D-6 and D-7, drawings 4 through 7, for the desired shape.

After sanding the belly area, which creates a smooth crease in the belly, we use a drum sander to grind in the pectoral fin muscles and pectoral girdle at an angle toward the center line and the head (FIG. 48), using the lines shown in Figures 46 and 47 as guides.

To define the gill area, first make a stop cut along the gill line we previously drew and cut into it from the tail side of the fish (FIG. 49). Carve detail of lower gill area (FIG. 50) with an X-acto knife.

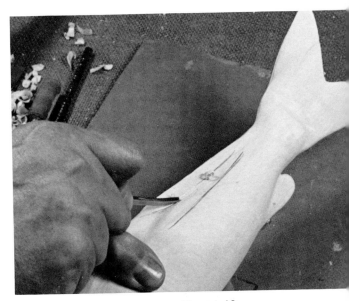

Figure 42

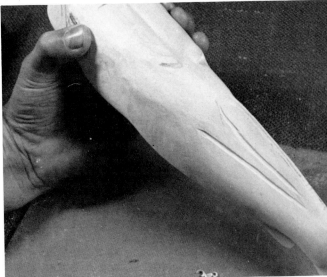

Figure 43

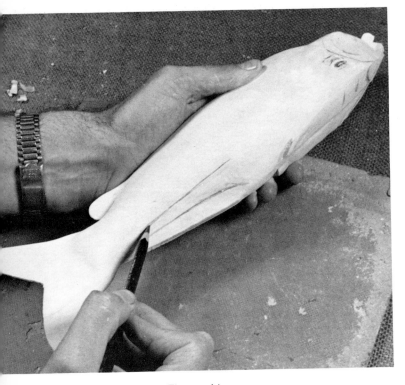

Figure 41

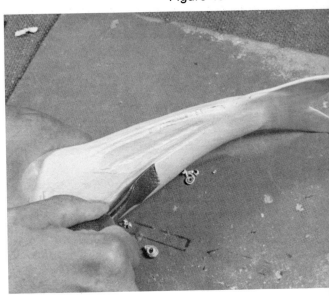

Figure 44

Figure 45

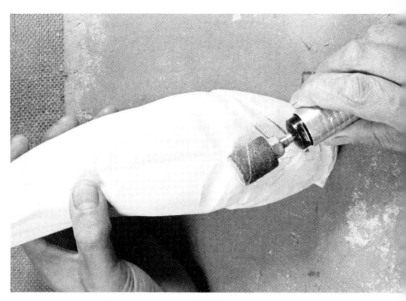

Figure 48

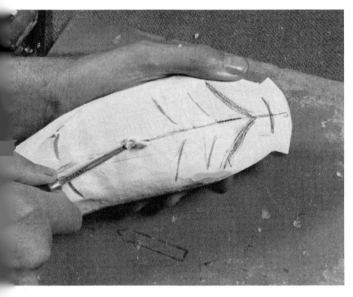

Figure 46

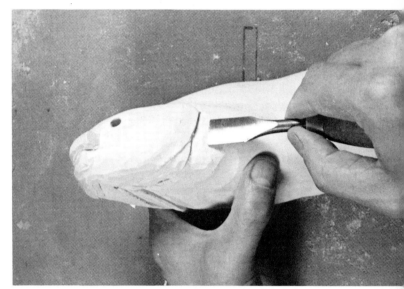

Figure 49

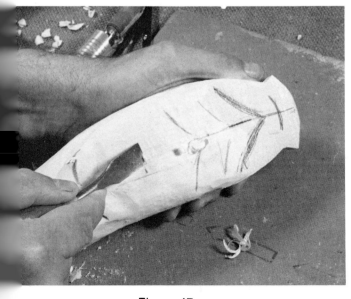

Figure 47

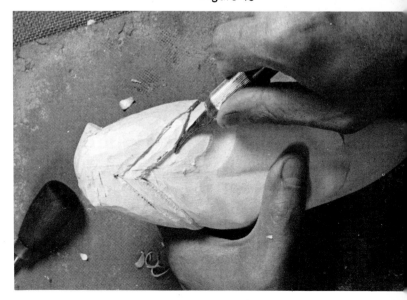

Figure 50

Smooth the detail of the belly area from the gill cover to the pectoral girdle with a drum sander (FIG. 51), then smooth with a piece of 240 grit crocus cloth or sandpaper.

Referring to Illustration D-6, begin carving the lower jaw by cutting with a knife from the gills toward the mouth (FIG. 52).

To carve the mouth, first draw the outline where the mouth is to be opened (FIG. 53), and begin carving with a small U-gouge to effect the initial opening so a small rotary cutter can be used (Illustration D-6, cross-section 1). I use a Black and Decker power tool with a small ruby cutter (FIG. 55). The profile of the mouth reveals the upper and lower jaws in relationship to each other (FIG. 56).

With a small V-tool we now cut the line of the cheek depression behind the eye, shown in Illustration D-6, drawing (2) (FIG. 57), and with a 3/8 inch chisel smooth it out before sanding (FIG. 58).

We finish carving the gill flap area by carving with our small U-gouge along the lines we drew before, then lightly sand the whole area with a small piece of 240 grit sandpaper (FIG. 60).

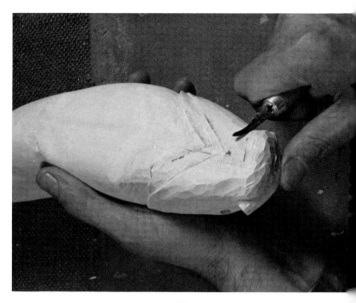

Figure 52

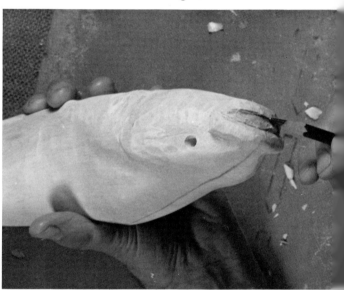

Figure 53

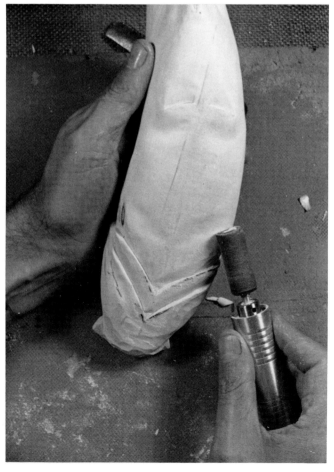

Figure 51

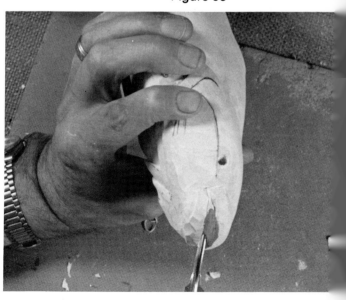

Figure 54

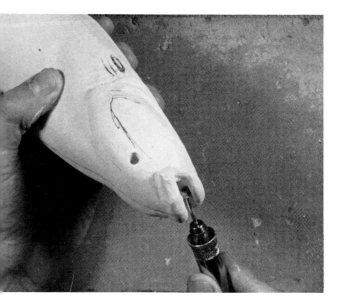

Figure 55

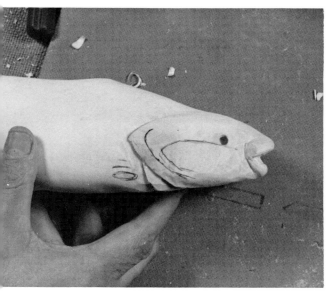

Figure 56

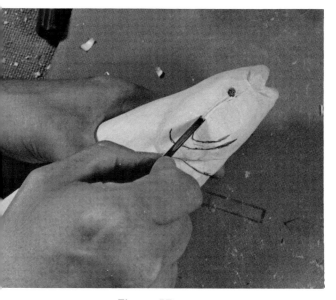

Figure 57

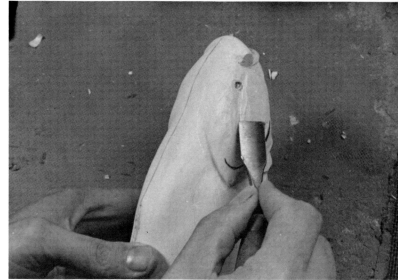

Figure 58

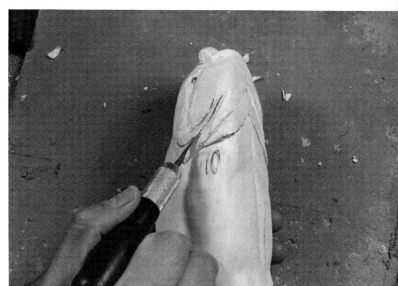

Figure 59

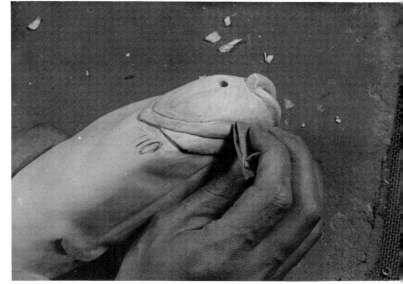

Figure 60

Again referring to Illustration D-6, we mark the exact location of the maxillary whisker (FIG. 61) before we drill a 1/8 inch hole to a depth of 5/16 to 3/8 inch at that point.

On the bottom of the catfish mark the detail of the gill after referring to Illustration D-4 (FIG. 62). To finish the gill simply cut down along the drawn lines with a knife (FIG. 63) to a depth of approximately 1/16 inch before refining the lines with a small V-tool (FIG. 64) and sanding the whole area (FIG. 65). Note the angle of the lines on the gill as shown in Figure 65 and Illustration D-10.

Referring to Illustration D-4, mark the holes for whiskers on the bottom of the lower jaw. These are drilled using a 3/32 inch bit in the Foredom (FIG. 66).

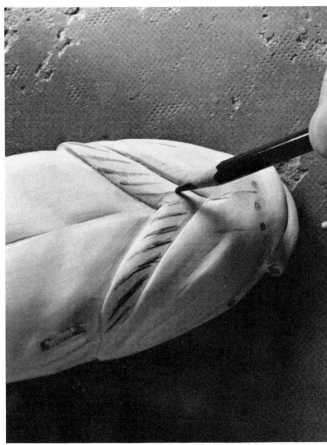

Figure 62

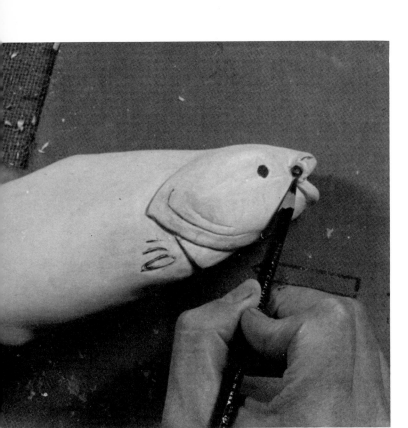

Figure 61

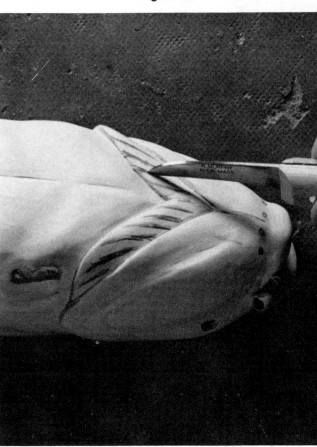

Figure 63

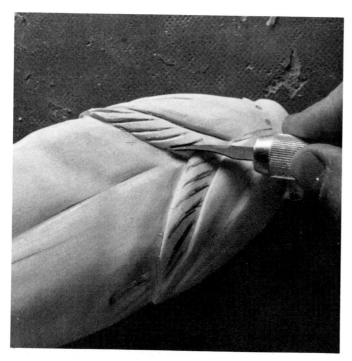

Figure 64

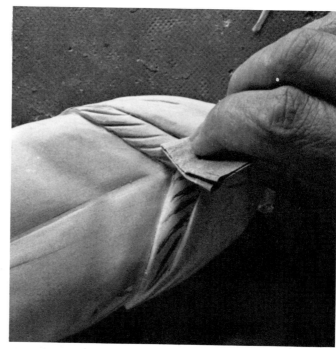

Figure 65

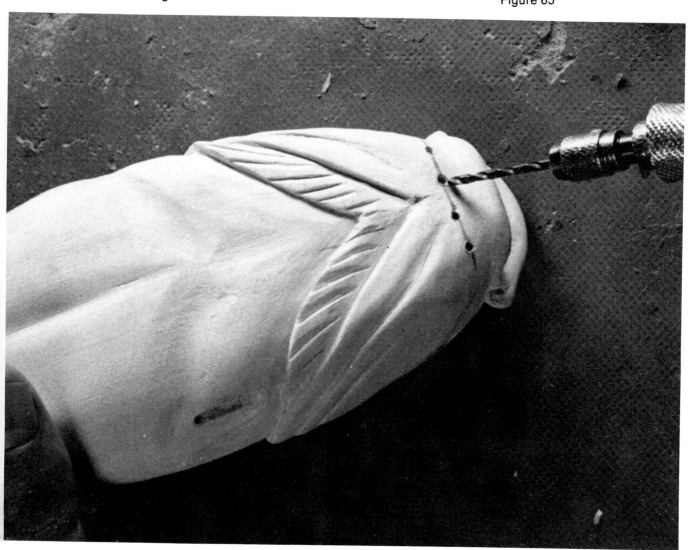

Figure 66

169

For the nostrils and upper jaw whiskers again refer to Illustration D-4 for locations to be marked (FIG. 67). The holes for the whiskers are drilled with a 1/16 inch bit, while the nostril openings are best achieved by again using a dentist's pick (FIG. 68).

Using the pattern and noting the grain direction shown in Illustration D-11, we use the bandsaw to cut the general shape of the anal fin from the scraps left over when we cut out the catfish body. The undulating wave action is created by first marking the areas to be cut, then carving them with the grain, using a 14 mm, No. 7 straight U-gouge (FIG. 69). Be sure to carve with the grain and delicately, as the fin will be only 1/32 inch thick when finished. Alternating the cuts on both sides of the fin will create the wave effect desired on the upper portion of the anal fin (FIG. 70).

After shaping the anal fin, we mark the rays we will be carving in the fin, remembering that channel catfish have less than 30 rays (FIG. 71). Note that the rays in the anal fin run at the same angle as the rib depressions, as shown in Illustration D-3. The rays are carved with a 1/16 inch U-gouge (FIG. 72) and rounded by sanding with 240 grit crocus cloth or sandpaper (FIG. 73), before refining them with a fine-tip woodburner (FIG. 74). Since splits in the rays are common, it is okay to put them in using a small V-tool before the woodburning.

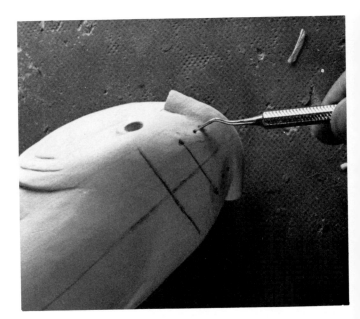

Figure 68

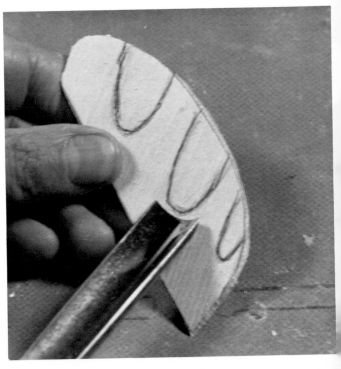

Figure 69

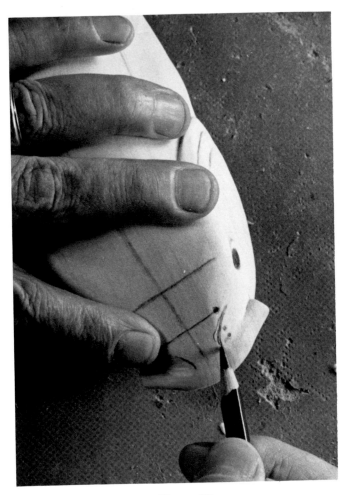

Figure 67

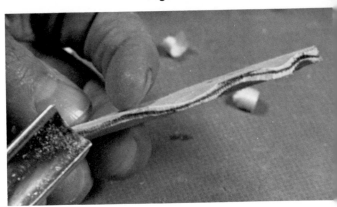

Figure 70

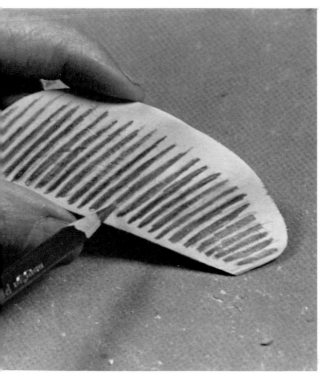

Figure 71

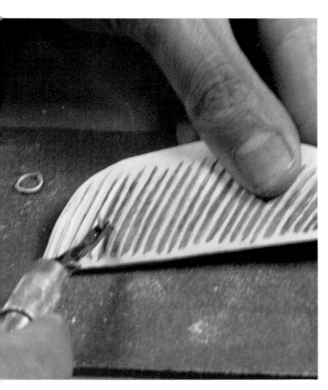

Figure 72

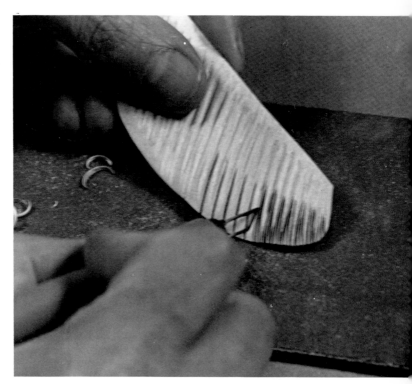

Figure 73

Figure 74

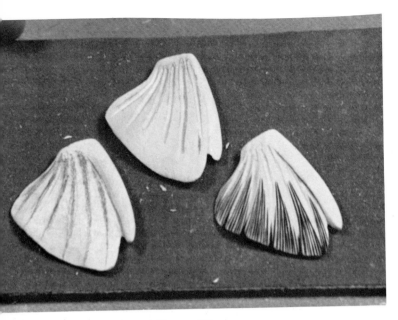

Use the pattern in Illustration D-4, drawing (1), for the pectoral fins. Note the wood grain direction of the pectoral fins shown in Illustration D-12. Figure 75 shows the pectoral fins at different stages of preparation, after they were cut out on the bandsaw. Note the splits and the woodburning of the finished rays.

While referring to Illustrations D-12 and D-4, drawing (2), follow the same procedure to carve the pelvic fins (FIG. 76). Note that the fins are not straight and stiff but more concave to conform to the contour of the body (Illustration D-13), as is true with the dorsal fin (FIG. 77 and Illustration D-12).

To mount the different fins the procedure is essentially the same one we followed for the other carving projects. First mark the location where the anal fin is to be attached and cut along the lines with a knife (FIG. 78) before cutting out a slot with a 1/8 inch U-gouge (FIG. 79).

Figure 75

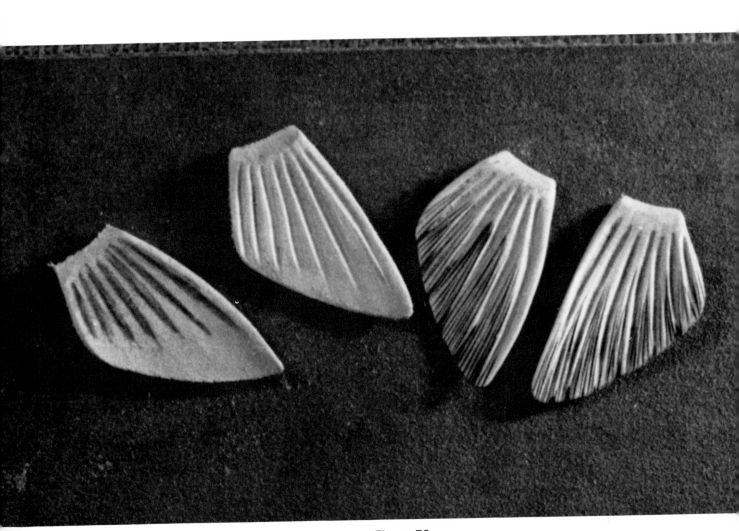

Figure 76

172

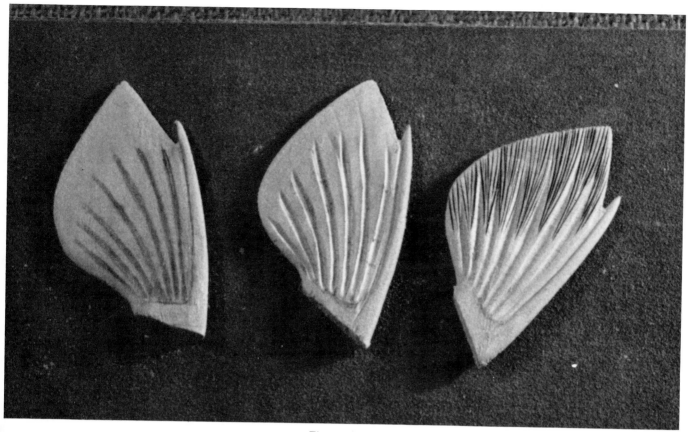

Figure 77

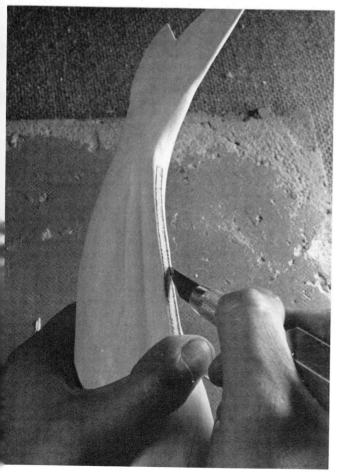

Figure 78

Figure 79

Using Illustration D-2 as a guide, as well as the pectoral fin itself, mark the exact location of the pectoral fin (FIG. 80) and with the small U-gouge cut a slot into which the fin will be inserted (FIG. 81). To achieve the "wrinkles" above the slot, shown in Illustration D-2, use a small V-tool (FIG. 82) and sand lightly to a smooth surface (FIG. 83).

Follow the same procedure to create the insertion slot for the dorsal fin. Mark its location (FIG. 84) and cut out the slot with a small U-gouge (FIG. 85). Do not insert the fins at this time since the catfish will be handled too much and we do not wish to risk breaking them off.

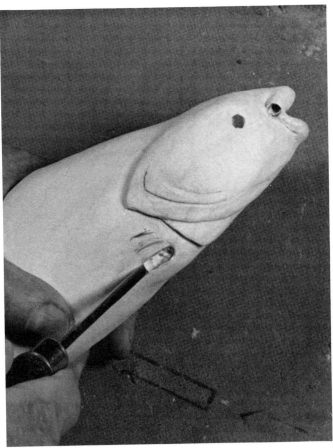

Figure 81

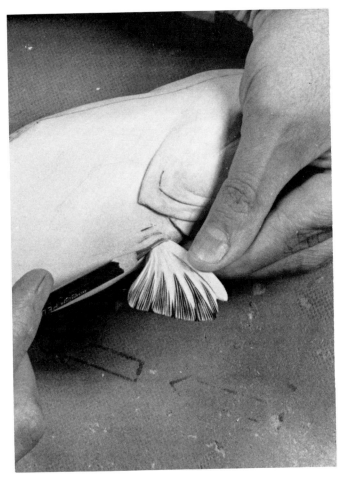

Figure 80

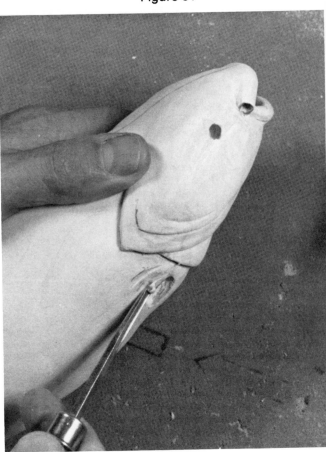

Figure 82

174

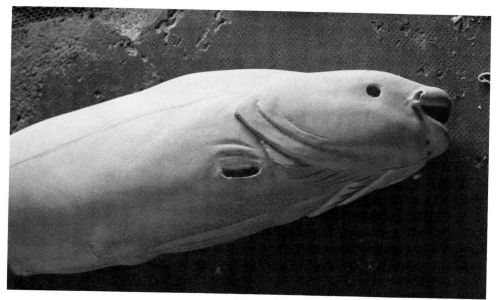

Figure 83

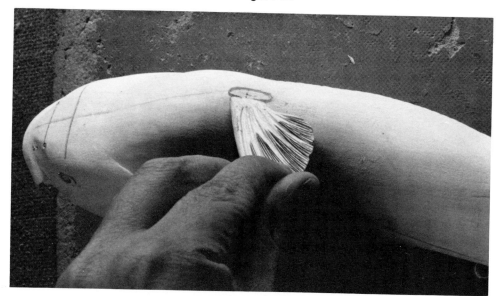

Figure 84

Figure 85

175

Draw the lateral line as shown in Illustrations D-2 and D-3 (FIG. 86). This will be used when carving the rib lines, which we shall undertake shortly.

The procedure for making the rays of the tail is essentially the same as was followed for the fins. First draw in the rays (FIG. 87), then carve them with a 1/16 inch U-gouge (FIG. 88), sand the rays rounded with a piece of 240 grit sandpaper (FIG. 89), and burn in the rays and the splits at the tail's edge (FIG. 90).

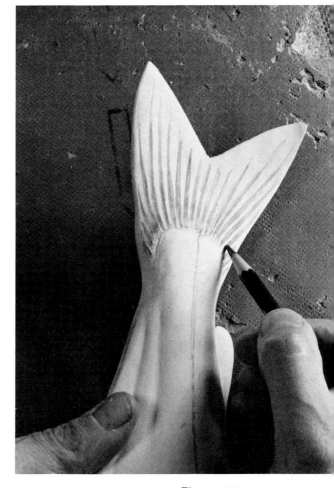

Figure 87

Figure 86

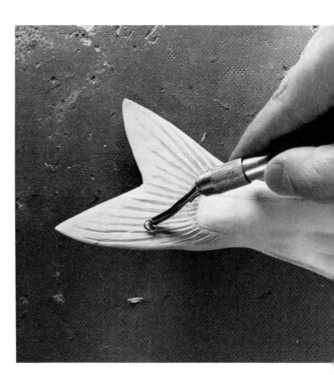

Figure 88

176

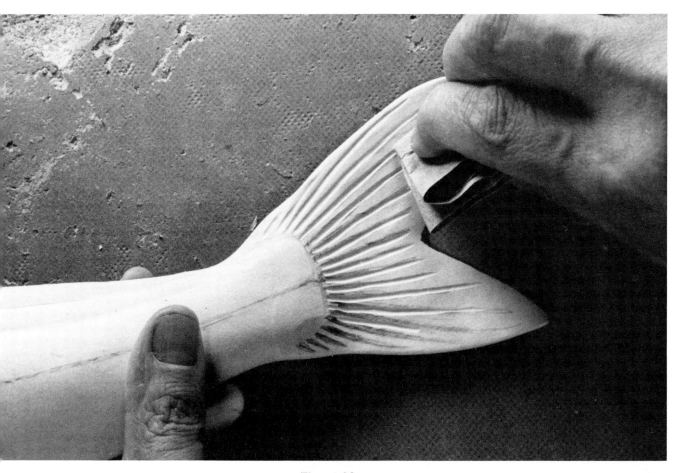

Figure 89

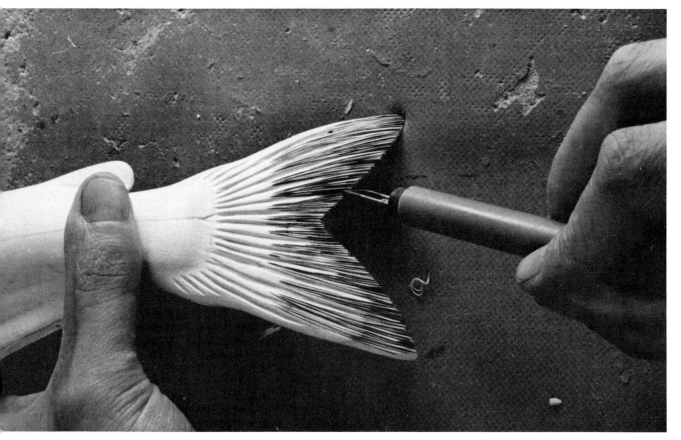

Figure 90

In conformity to Illustrations D-2 and D-3, we now mark the ribbed body sections from the lateral line out and toward the tail of the catfish (FIG. 91). Again note the angle of the rib lines relative to the lines of the anal fin previously mentioned at Figure 71. These lines are then carved with a small, very sharp V-tool from the lateral line toward the top and bottom of the fish (FIG. 92), and sanded lightly with 240 grit sandpaper (FIG. 93) to create the revealed ribs of the catfish (FIG. 94).

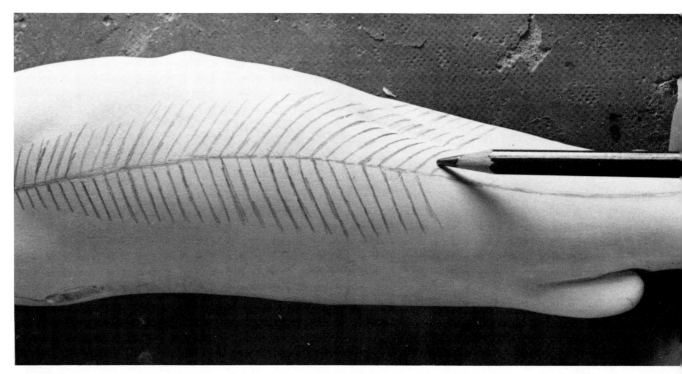

Figure 91

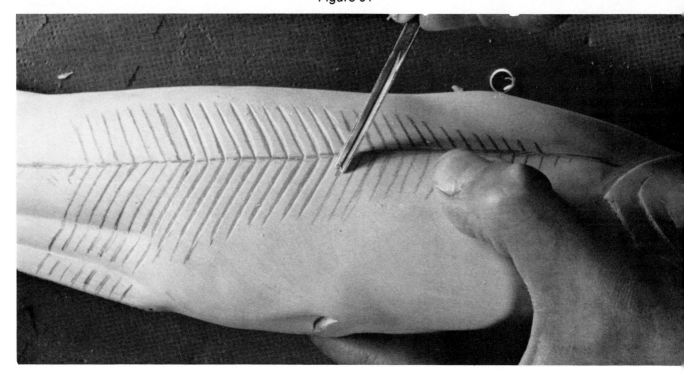

Figure 92

178

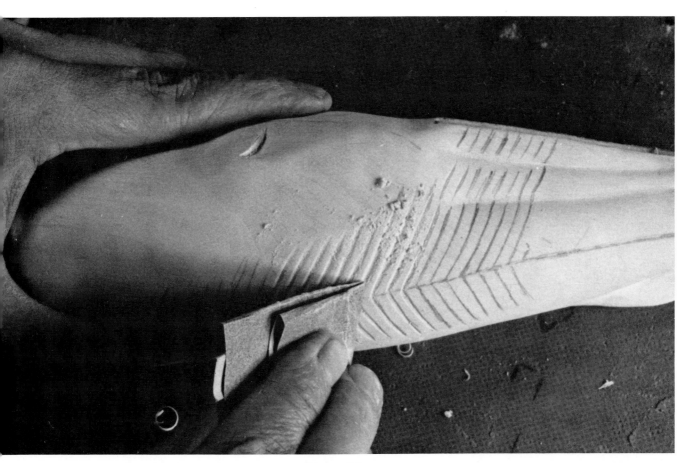

Figure 93

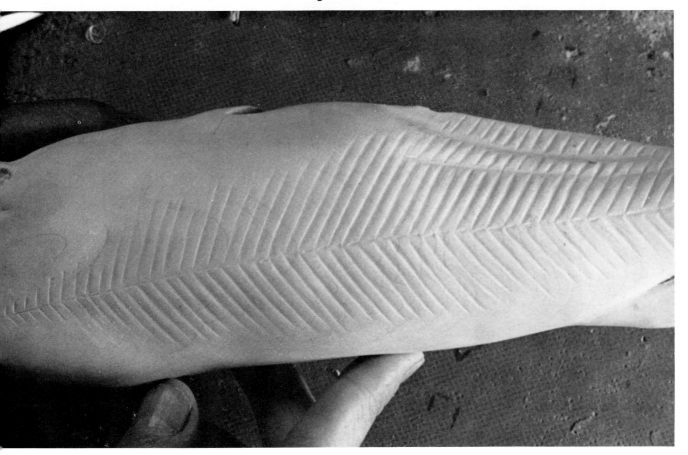

Figure 94

To mount the eye, first use a template to mark the eye socket the same size as the eye (FIG. 95), in this case a 12 mm glass eye. I then use a 1/4 inch ruby cutter on my Foredom to cut the eye socket to a depth of 1/4 inch (FIG. 96). I wet the socket and, using a palate knife, fill it with Elmer's wood filler (FIG. 97). When inserting the eye itself I push out some of the wood filler, which will be used to build up the sclerotic membrane (FIG. 98) formed with the help of a small wet brush (FIG. 99). After being allowed to dry overnight, the whole eye area is finished using a small knife and smoothed by sanding lightly (FIG. 100).

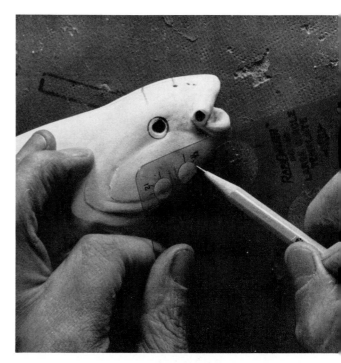

Figure 95

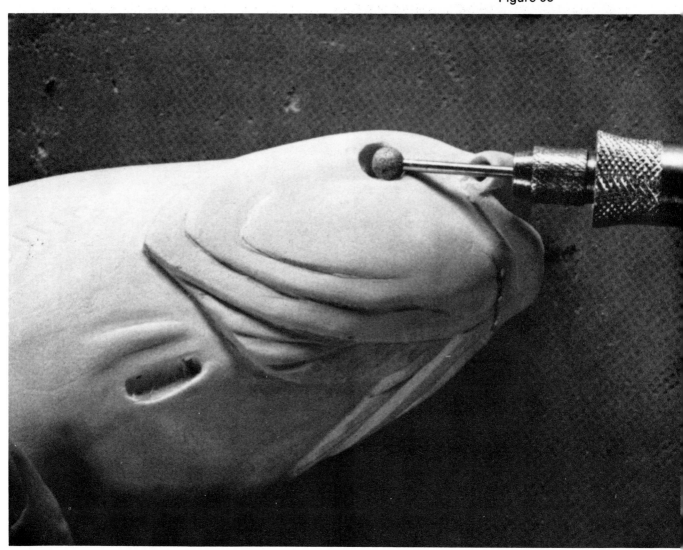

Figure 96

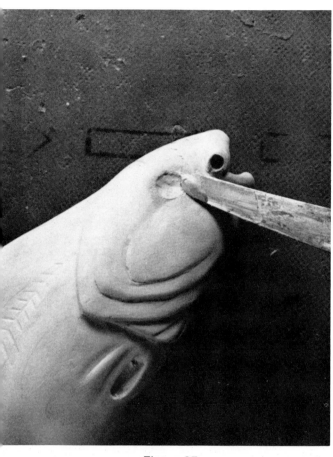

Figure 97

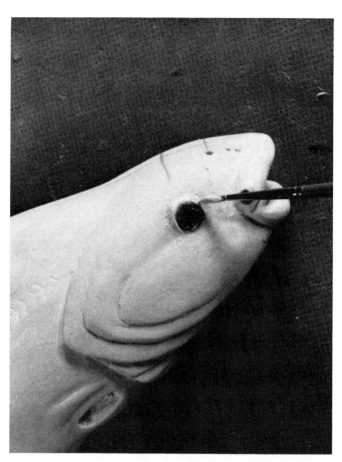

Figure 99

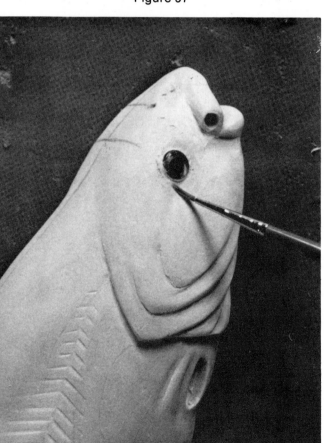

Figure 98

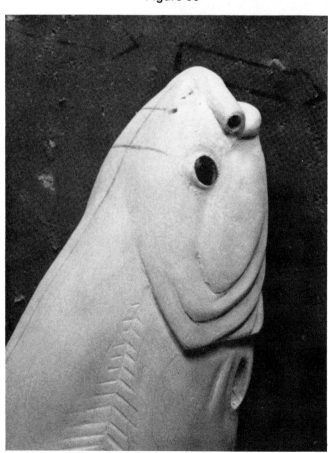

Figure 100

I assembled my own "whisker making" machine out of a used electric motor with a course grit wheel (FIG. 101). The whiskers are ground from nails to conform to the sizes and shapes shown in Illustration D-14. Figure 102 shows various whiskers at different stages of grinding.

The sizes of the nails from which the whiskers are made and their corresponding holes are as follows:

The two whiskers on the upper jaw are 20 penny common nails. If head of nail is ground off, whisker will be 4 3/16 inches long. Drill 3/16 inch diameter holes.

The four barbels on the bottom of the lower jaw are 8 penny finishing nails and are 2-1/2 inches long, but I cut off 1/4 inch, making the finished product 2-1/4 inches. Drill 3/32 inch holes.

The two barbels on top of the head are 4 penny finishing nails and are 1-1/2 inches long. Again I cut off 1/4 inch with a hacksaw. Drill 1/16 inch holes.

After sizing and shaping the whiskers, I carefully bend their tips with the help of a chisel handle (FIG. 103), then cement them into the previously drilled holes with five-minute epoxy (FIG. 104) at roughly the angles shown in Figure 105.

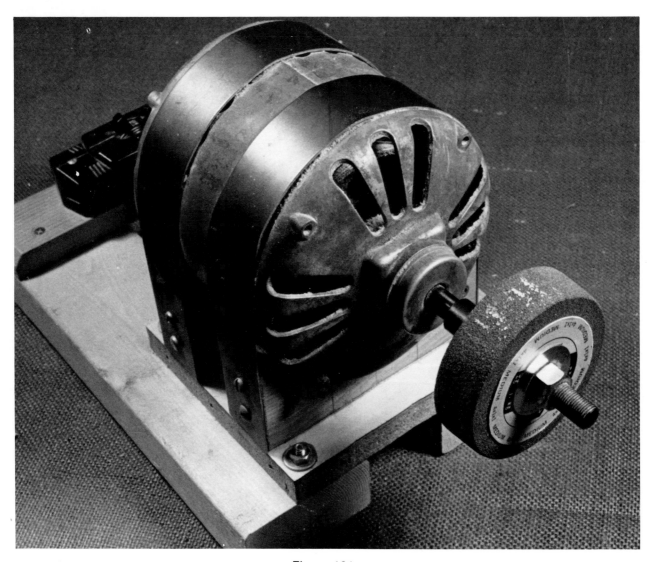

Figure 101

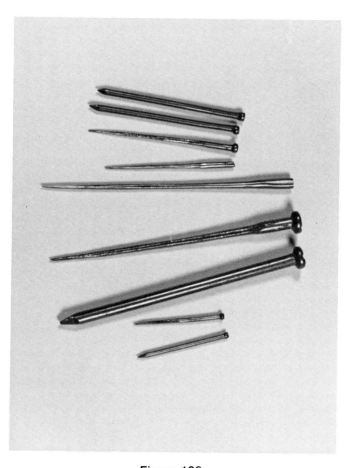

Figure 102

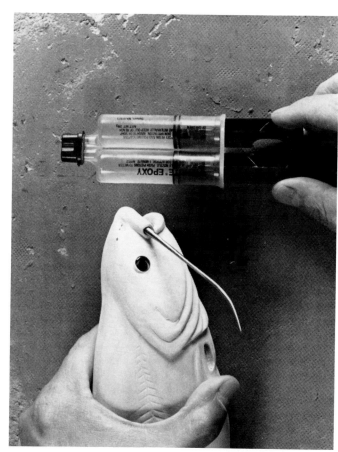

Figure 104

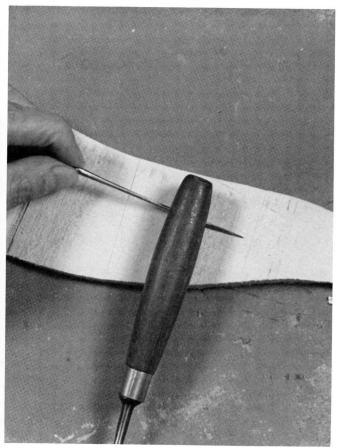

Figure 103

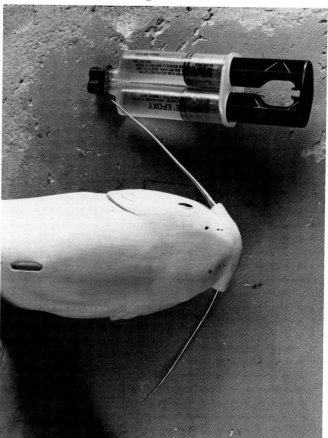
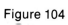

Figure 105

Even while the whiskers are setting, we can carefully glue the dorsal fin into the previously cut slot (FIG. 106). I use Elmer's carpenter's glue to attach all the fins.

I usually allow the epoxy holding the whiskers to set overnight before I taper the wood surrounding the whiskers to meet the metal whiskers (FIG. 107). I use wood filler applied with a brush to finish the taper of the whiskers (FIG. 108) and sand them smooth with fine sandpaper (FIG. 109).

The same process is used in gluing the lower jaw whiskers (FIG. 110) and the two barbels on the upper part of the jaw (FIG. 111), after which we can again use Elmer's carpenter's glue to insert the anal fin (FIG. 112), and the pectoral fins (FIG. 113). Figure 114 shows the top view of the forward portion of the carved catfish.

Figure 106

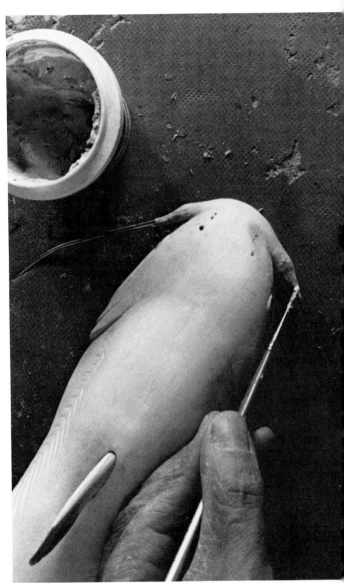

Figure 108

Figure 107

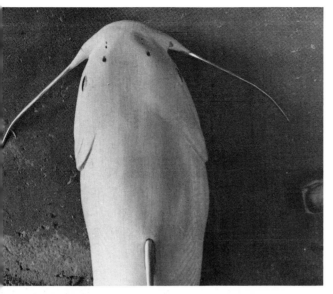

Figure 109

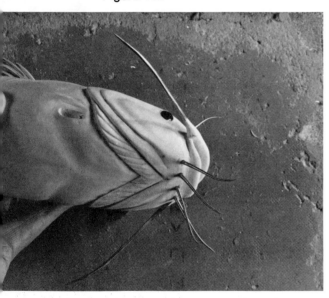

Figure 110

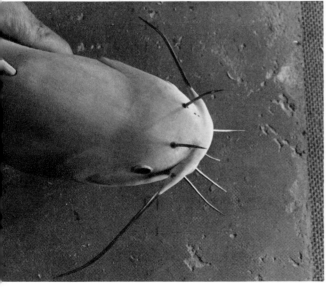

Figure 111

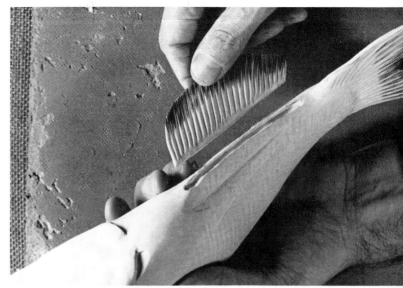

Figure 112

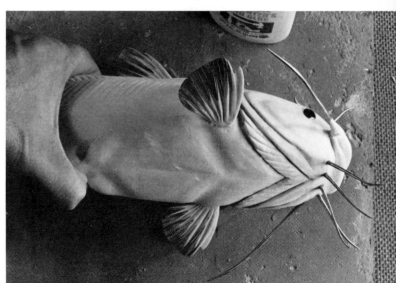

Figure 113

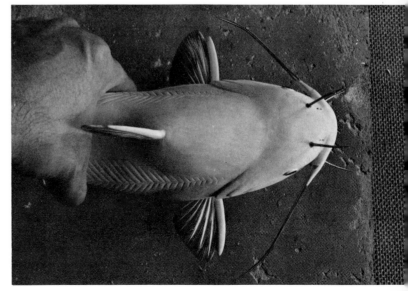

Figure 114

As we did with the bluegill sunfish, we drill the holes at the point where the fish is to be mounted, insert pins, and mark and drill the corresponding holes on the catfish (FIG. 115). Figure 116 shows the catfish mounted before we begin the painting process.

It is now time to complete the preparations for painting. Making sure to cover the pelvic fin area with masking tape, and after sealing the entire catfish with Deft spray, we cover it with two coats of gesso, sanding if necessary to achieve a smooth surface. When the gesso has dried, clean the gesso carefully from the eye with a knife (FIG. 117), and we are ready to paint.

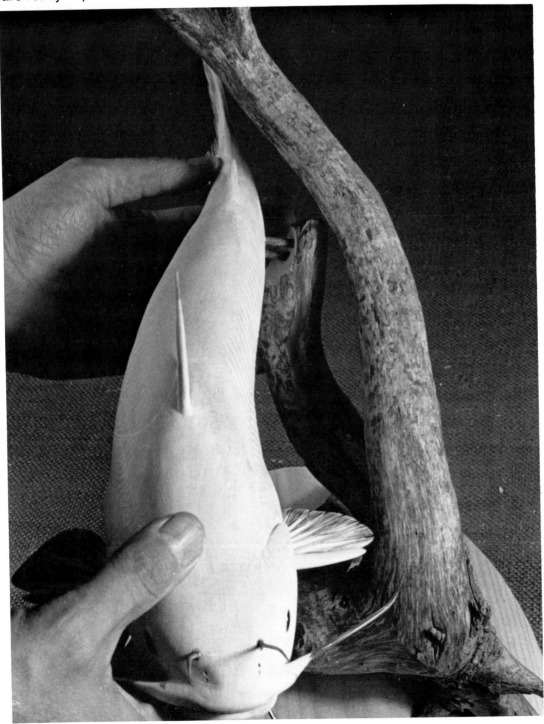

Figure 115

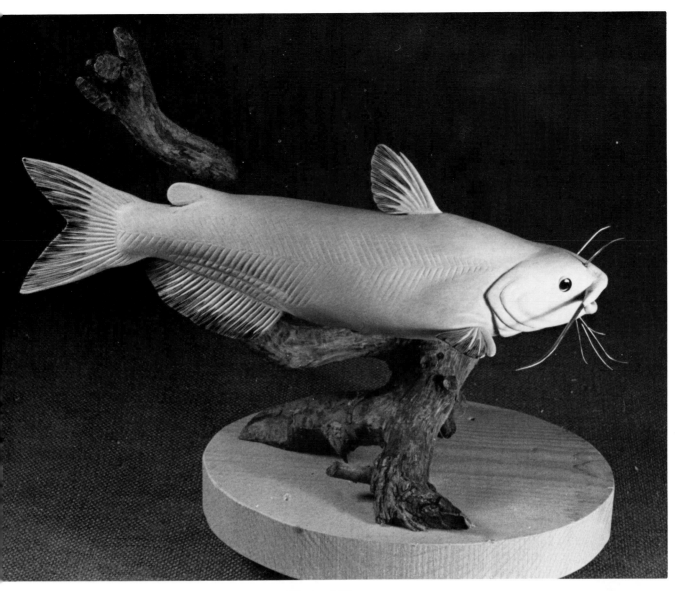

Figure 116

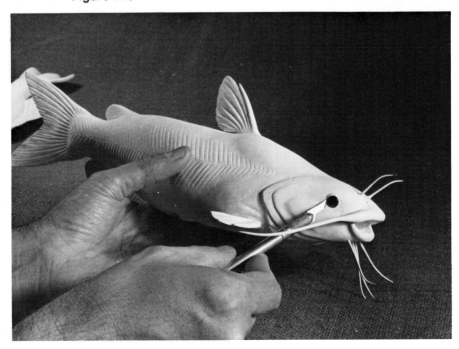

Figure 117

187

Clam Shells

For decoration, clam shells add to the natural habitat portrayal of the total piece. Here I am carving two inside-showing and four outside-showing shells in varying sizes. To carve the clam shells, I used button clams for models. Transfer the patterns (Illustration D-15) to 3/4 inch thick basswood scraps (FIG. 118). Decide which shells will be inverted and draw the inside detail (FIG. 119), and with a knife and Foredom rough out the shell shapes (FIG. 120). The growth rings are carved with a small cylindrical ruby bit on the Foredom (FIG. 121). This can be done with a small V-gouge, but it is more difficult. The same bits on the Foredom are used for the detail work inside the shells (FIG. 122, 123).

Figure 119

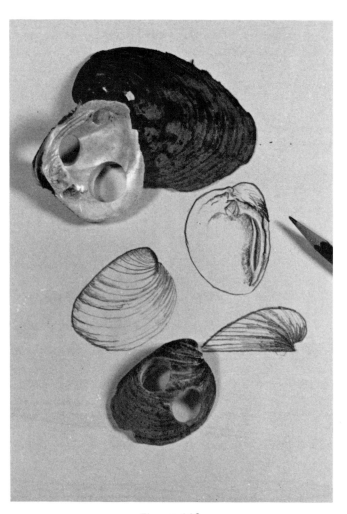

Figure 118

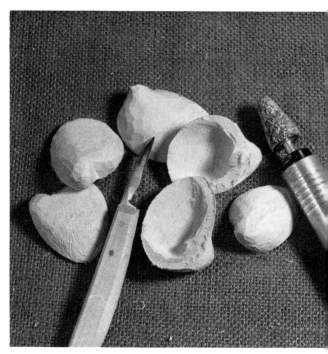

Figure 120

188

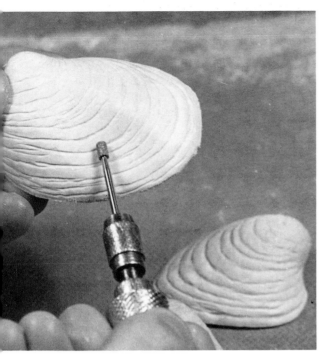

Figure 121

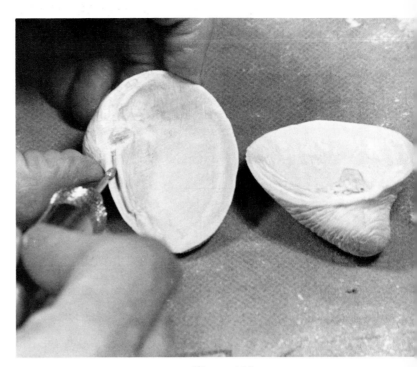

Figure 123

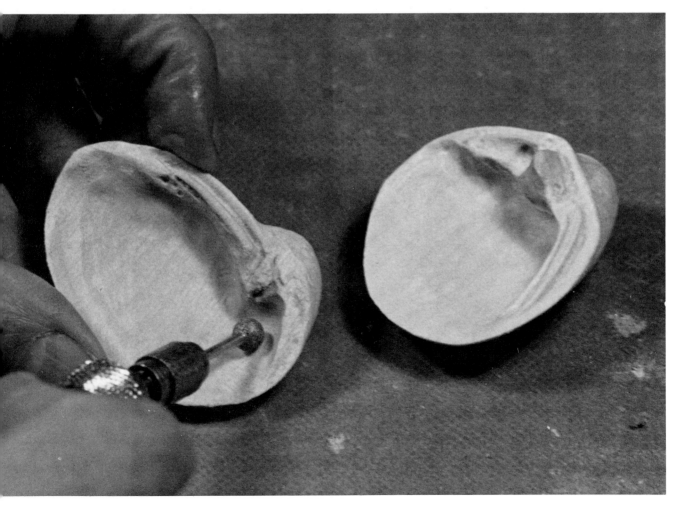

Figure 122

After sanding the shells smooth, especially the insides, place the shells on the rough base to see how many are needed and their placement for the best composition (FIG. 124). I carved six shells but needed only five for this composition. The shells are now ready for sealing and painting (FIG. 125, 126).

Figure 124

Figure 125

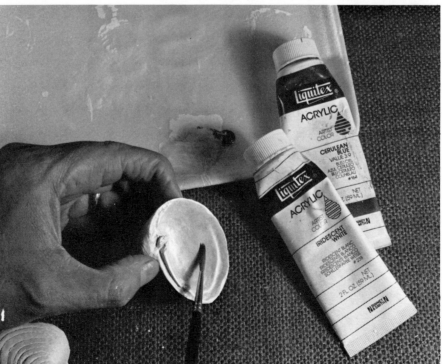

Figure 126

Painting

Painting with either a brush or air brush requires a discipline that each carver or painter must possess to achieve what he or she has drawn from the imagination. Painting, for many people, is like running into the proverbial stone wall. Many times I hear someone interested in carving say they can carve but they can't paint. A brush or air brush is a tool just like a flexible-shaft power tool or hand tool; once you get used to it, it can be mastered quite easily.

Using an air brush suits my technique of painting. I usually paint with washes; the air brush does the same, putting down one thin wash over another until reaching the desired color. However, for painting trout I use both the wash technique and a dry brush technique.

Painting with an airbrush is much like painting with a brush. The paint we will use is thinned like the washes we applied in the previous projects. Because the fluidity of the paint and its fast drying time are not always consistant, acrylic paint is somewhat difficult to use. Also, much time is spent cleaning the paint from the brush, especially the needle. Clean water is essential to purge the paint from the brush at regular intervals. The needle is removed at the same time and cleaned.

To keep the airbrush in its best operating condition, air brush cleaner is periodically used to clean the internal parts of the brush. To avoid deterioration the nylon ring seal is removed before soaking these parts overnight. I clean my brush paint cup at the same time. The bottom of the cup will unscrew for cleaning.

If you purchase an air brush, I suggest you also get several bottles of pre-mixed air brush paints in basic colors for practicing on white paper or board. When feeling confident then move on to acrylic paints. Read the instructions for your air brush very carefully, as different air brushes have their own nuances. I use a Badger 100 brush with a medium needle.

In the dry brush technique only very small quantities of paint are stippled or dabbed onto the carving surface, covering a very small area at any one time. So little paint is used that the brush is almost dry.

The wash technique, as its name implies, uses more water than paint, which is literally washed onto the carving surface, although very small area at a time. This technique requires several applications of the washes to obtain the desired results.

Painting is practice, but more importantly it is experimenting. A color chart will get you started but if your chart does not have yellow oxide and Payne's gray, what do you do? Experiment! Place small amount of each on a piece of heavy paper, add water and grab a brush. Start with various combinations of each; see what colors you can create. Keep those color tabs, being sure to mark them, for future reference.

Now try Payne's gray and a red of your choice. It is amazing what colors come up. So play around with color. Keep the disasters as well as the successes. They could be just the color you want for a future carving or painting.

One other thing about painting: paint small areas one at a time; do not paint large areas. Many times I find myself thinking only about the small area that my brush touches at that exact moment. But as soon as I pull the brush away that tiny spot of paint becomes part of the larger spot or area.

A brush can hold an amazing amount of paint. However, a small amount of paint will go farther than you imagine. Most of the paint I pick up with my brush goes to a paper towel or paint rag before painting the carving.

I will provide a chart of the colors I use for each of the projects discussed in this book. Once you study the chart, what we have discussed should be much easier for you to learn and apply to all your work.

Painting the Bluegill Sunfish

Colors used:

Payne's Gray
Yellow Oxide
Ultramarine Blue
Cerulean Blue
Raw Sienna
Naphthol Red

Unbleached Titanium White
Indo Orange Red
Cadmium Yellow
Iridescent White
Red Oxide

As one develops his or her own style of carving, one repeats techniques and uses tools with which he or she is comfortable. The same holds true with painting. I have seen painting techniques that I know I could not master with all the practice in the world. Oil paints intrigue me but they are not my medium. So go with what works best for you. As you proceed through the color sections of each project I will try to be brief and at the same time precise.

I prefer a number 3 Windsor & Newton sable brush. For a palette I use a white styrofoam meat tray. They are inexpensive, yes. But the main reason I use them is because they are white. When you mix colors on it, what you see is what you'll get on your white gesso carving. I sometimes mark the palette with the name of the fish and the date painted and store it away for future reference.

I put out ready for use only the colors I will actually be using. I place Payne's gray, yellow oxide and ultramarine blue in small amounts on one corner of the tray, usually the upper left. A wash means a higher ratio of water to the acrylics, so only small dabs of paint are squeezed from the tubes. An old rag or paper towels should be readily available to blot excess wash from the brush. A large jar of water, of course, should also be kept on hand and kept clear. Doing several washes of different colors will tend to "muddy" the water, which will affect the color you want in your washes.

The wash controls the color and gradual color tones. The transparent quality of acrylic paints allows one to place one color wash over a different color wash and still have the first color show through, creating a color different from either one. Practice helps greatly in obtaining the desired results.

Two things to remember when painting the scales of the fish: firstly, we paint each individual scale one scale at a time; secondly, we paint each scale from the scale's inside to its outer, flared edge. The flared portions of the scales should always face in the opposite direction as whatever hand is used to hold the brush. Being right-handed or left-handed makes no difference because at the time we start painting we shall be holding the carving inverted. Let me explain. I shall be holding the brush in my right hand, so I shall keep the outer edge of each scale always

facing to my left. In order to do this, I must hold the fish belly-up while painting one of its sides but right-side-up when painting the other side.

We begin by mixing yellow oxide and a small amount of Payne's gray with water. I paint the outer edge of each scale so that the darker color at that edge gives relief depth to each scale (FIG. 1), and work the wash so the color becomes gradually lighter from the top of the fish toward the belly and lower part of the head and jaw.

With this first wash over the entire body we also apply a heavy wash of ultramarine blue and Payne's gray on the gill flap (FIG. 2). Now thin down the blue and gray to wash the top of the head and the scales up to the dorsal fin (FIG. 3). Since the wash on the gill flap is now dry, put another wash over it. You can continue to wash the gill flap, perhaps two more times, to get the desired color.

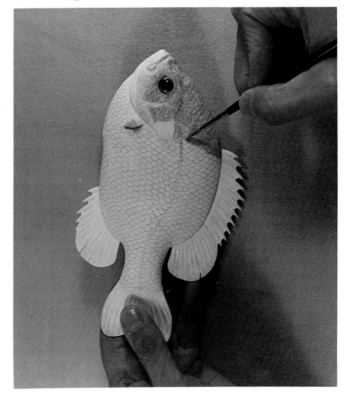

Figure 1

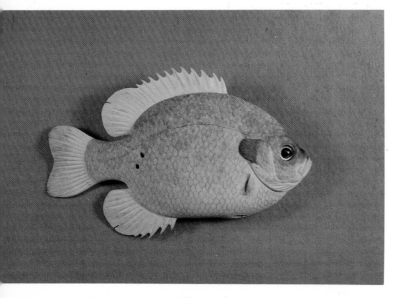

Figure 2

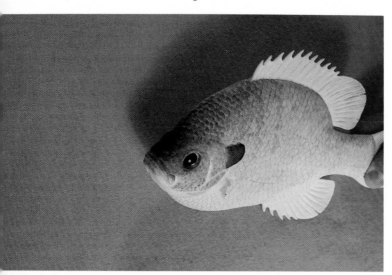

Figure 3

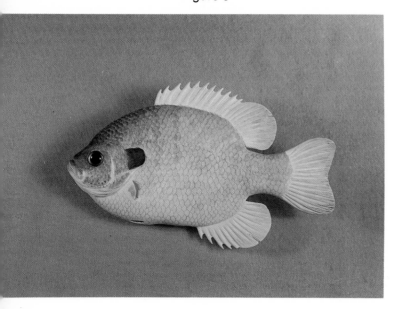

Figure 4

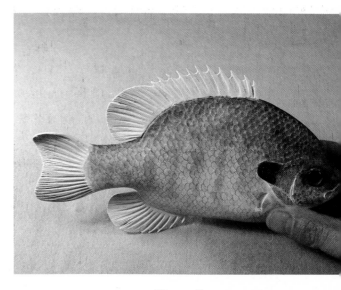

Figure 5

Figure 6

With a wash of cerulean blue and a touch of ultramarine blue we now paint the lower scales of the head and gill cover (FIG. 4). This fish actually derives its name from this coloration rather than the gill flap. As we paint the scales, one at a time, we indicate the bar markings common to bluegills by painting them with a darker wash, thus creating the darker, more pronounced shades of the markings (FIG. 5). With more washes of ultramarine blue and Payne's gray we have now covered the entire fish.

With a mixture of indo orange red and cadmium yellow start your wash of the throat and breast area working back towards the anal fin (FIG. 6). Again gradually lighten the wash as you proceed (FIG. 7). Figure 8 shows the graduated color on the belly area. Note also that we put a wash of yellow oxide and raw sienna on the body to "knock down" some of the blue color, especially near the lateral line.

Figure 8 also shows the elongated spots painted between the soft rays of the dorsal fins, using a mixture of one-half raw sienna and one-half Payne's gray, and the thin washes of raw sienna and burnt sienna applied to the fins and tail. This process sounds complicated, but you need not follow it exactly. Rather, I have washed all these areas because I have the paint on the palette and want to use it up before it dries.

194

Figure 7

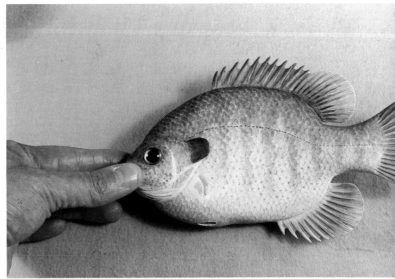

Figure 9

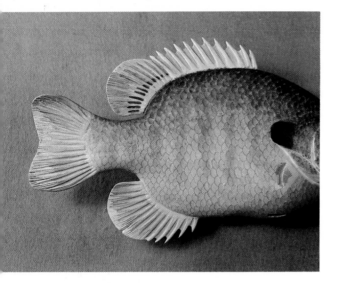

Figure 8

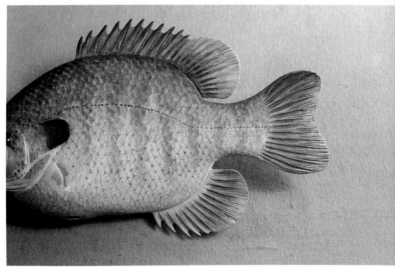

Figure 10

Figure 9 shows the work after we washed another coat of yellow oxide and raw sienna on the body. Note also the raw sienna/red oxide wash to the scales just above the blue paint mentioned in reference to Figure 4.

With a mixture of raw sienna and Payne's gray, we indicate the lateral line by painting a line of dots (FIG. 9, 10). The inside of the body scales are painted with a wash of red oxide and raw sienna.

The fins are colored by successive washes of raw sienna (FIG. 9 through 16). The outer edges of the fins and between their spines are washed with ultramarine blue to give the fin a transparent appearance. The tips of the spines on the dorsal fin are made darker with two or three washes of raw sienna and ultramarine blue (FIG. 10). The spines and rays are highlighted with two or three washes of unbleached titanium white. If the unbleached white is difficult to find in your area, try mixing a little raw sienna with white gesso.

The fish projects in this book, excluding the catfish, have a silvery luminescence to their scales. We achieve this effect by putting a wash of iridescent white over the scales in the same manner as the other colors (FIG. 11).

The pelvic and pectoral fins are carefully painted with a wash of raw sienna and yellow oxide between

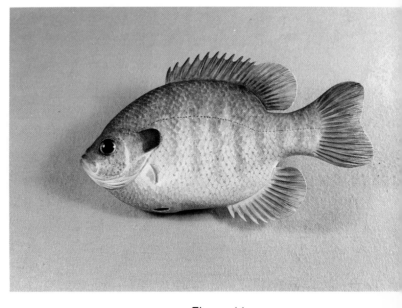

Figure 11

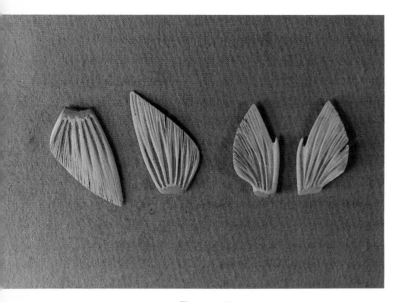

Figure 12

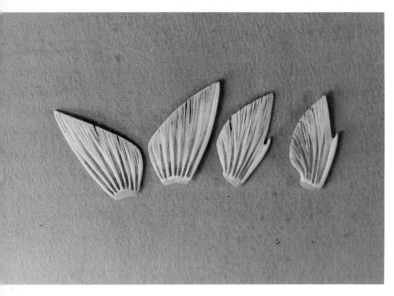

Figure 13

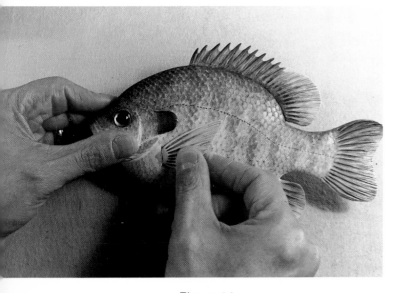

Figure 14

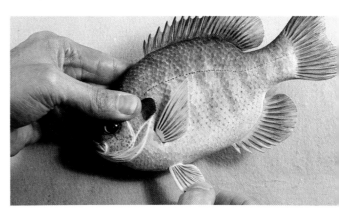

Figure 15

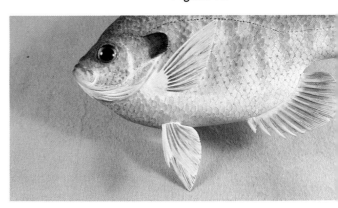

Figure 16

the rays from the base towards the outer edge of the fins (FIG. 12). Several washes of the color may be needed to reach the desired coloration. A very thin wash of cerulean blue on the outer edge of the rays tends to give the fins a somewhat transparent look (FIG. 13). The rays, remaining white near the base of the fins, are "washed" with a wash of unbleached titanium white.

As soon as the fins have dried they are glued into place with white glue (FIG. 14, 15). Fill the seam of the pectoral fin with wood filler (FIG. 16) and after it dries, sand it smooth with 240 grit crocus cloth or sandpaper (FIG. 17), followed by applying two coats of gesso (FIG. 18).

Using Illustration A-5 as a guide, draw the scales of the pectoral fin muscles, noting how the scales decrease in size nearer to the fin (FIG. 19). To the smaller scales we apply a wash of yellow oxide mixed with a small amount Payne's gray (FIG. 20), adding a second coat if needed.

We now continue the coloring of the throat and belly area to the pectoral fin muscle scales just painted by gradually blending, one scale at a time, the combination of Indo orange red and cadmium yellow used for the throat and belly area with the coloring of the pectoral fin muscle scales (FIG. 21).

Satisfied with the painting of the sunfish, we give it one coat of Deft Semi-Gloss Clear Wood Finish (FIG. 22). One coat is all that is needed to achieve a natural, wet look to the carving. More than one coat will give the fish a shiny, plastic, unnatural appearance.

196

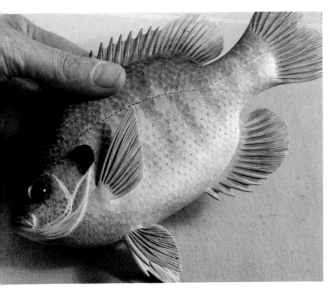

Figure 17

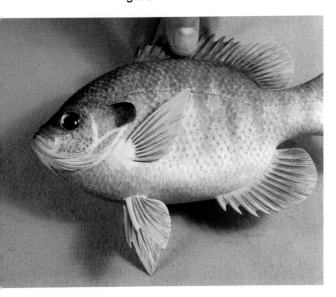

Figure 18

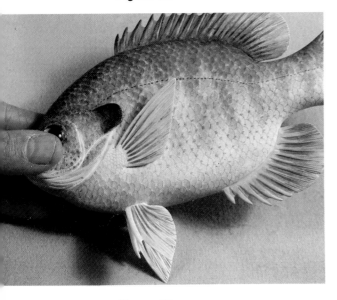

Figure 19

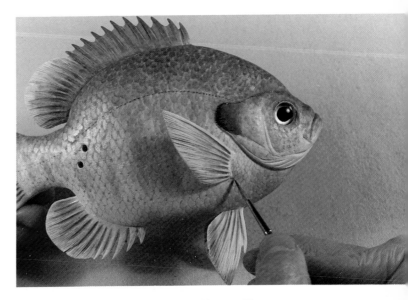

Figure 20

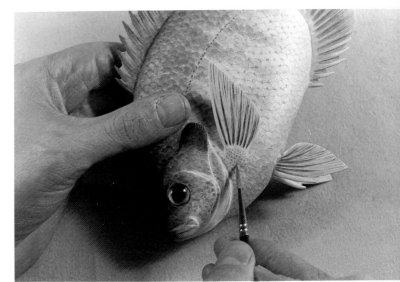

Figure 21

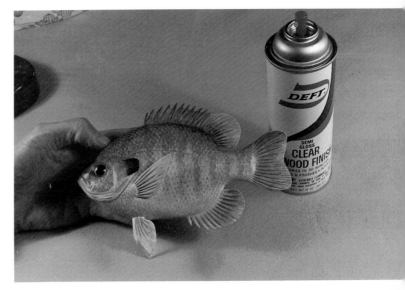

Figure 22

197

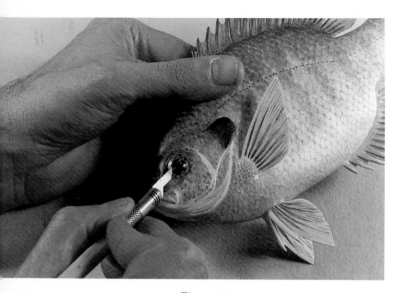

With an X-Acto knife very carefully clean off the lacquer from the eyes so as not to scratch the glass or scrape any paint around them (FIG. 23).

To mount the driftwood to the finished walnut base (FIG. 24), we follow the same procedure we used to mount the driftwood to the rough base cut-out in the sunfish carving chapter. After mounting the driftwood using wood screws, (FIG. 25), we attach the sunfish to the driftwood, gluing the pins into the fish and the driftwood with five minute epoxy.

We now have a unique decorative carving, to be treasured and admired for many, many years. This particular piece has joined the collection of Mr. and Mrs. Jack Curran.

Figure 23

Figure 24

Figure 25

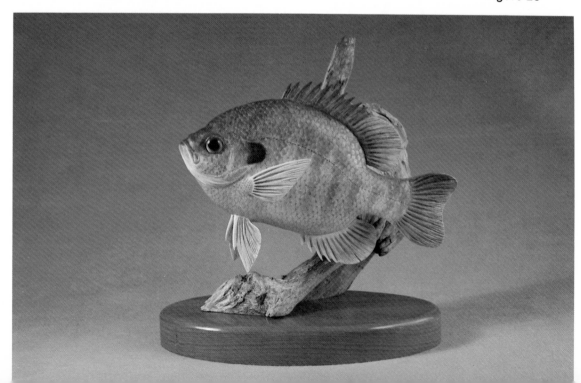

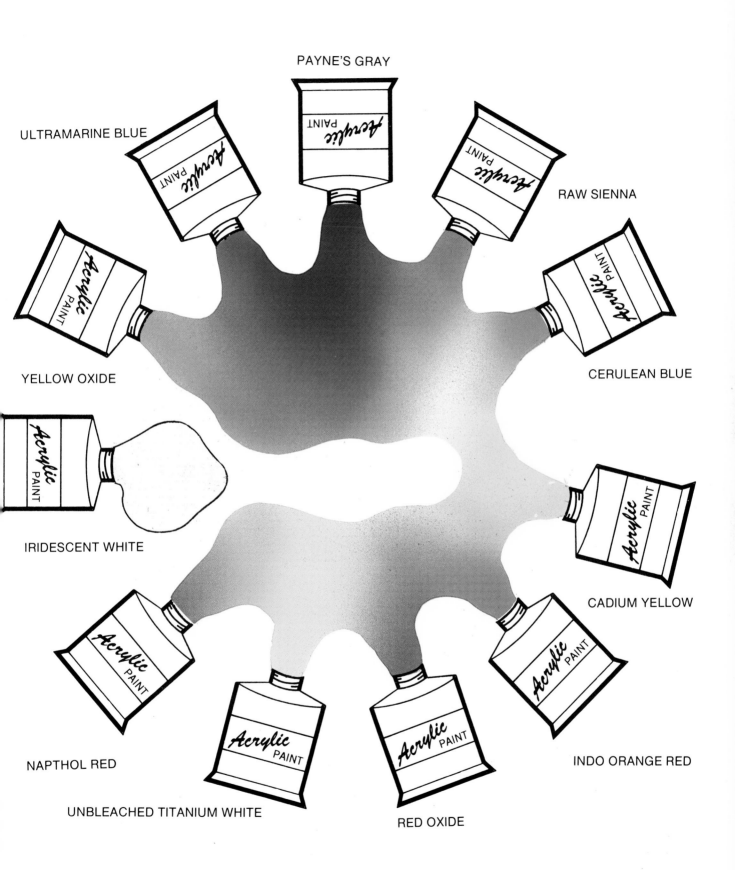

PAYNE'S GRAY

ULTRAMARINE BLUE

RAW SIENNA

YELLOW OXIDE

CERULEAN BLUE

IRIDESCENT WHITE

CADIUM YELLOW

NAPTHOL RED

INDO ORANGE RED

UNBLEACHED TITANIUM WHITE

RED OXIDE

Painting the Black Crappie

Colors Used:

Payne's Gray	Iridescent White
Yellow Oxide	Red Oxide
Naphthol Red	Cerulean Blue
Raw Sienna	Unbleached Titanium White

Figure 28 shows the scales drawn on the now ready-to-paint black crappie and how we begin adding color. Two parts Payne's gray to one part yellow oxide will provide the first wash. Start applying the wash around the eyes, working up over the head to the upper lip. By the time you reach this point, the paint around the eye will be dry enough for you to go back and repeat the same procedure, the second wash shown in Figure 29.

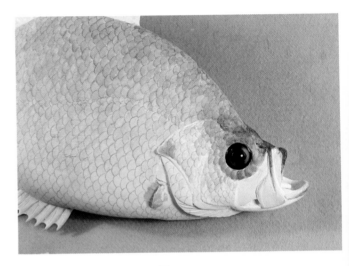

Figure 29

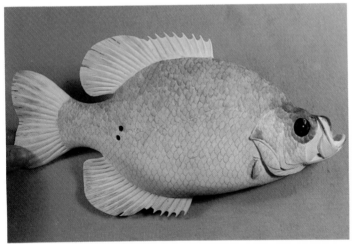

Figure 28

With a bit more Payne's gray in the wash we paint the first wash on the tip of the gill cover (FIG. 30). Notice how we are working both sides of the fish and remember to wash one scale at a time toward the back or flared part of each scale. Having now painted a wash further down on the cheek and having darkened the gill cover with another wash, we can begin working the top area of scales with washes (FIG. 31). Though it seems to be more

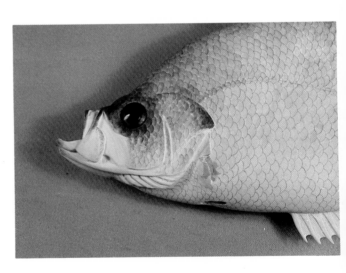

Figure 30

difficult to graduate the color towards the ventral side when the fish is inverted, with a little patience it will work out.

We now turn our attention back to the head. With several washes we detail the cheek area (FIG. 32) and begin painting the random dark markings which give this beautiful fish its name (FIG. 33). In washing more of the upper scales, we add more of the dark markings (FIG. 34).

Figure 35 shows the top of the head and forehead. We are still using our original Payne's gray and yellow oxide mixture but adding more gray to achieve the darker washes toward the top of the fish.

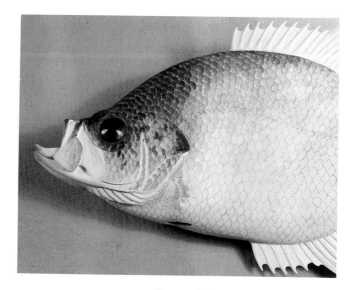

Figure 33

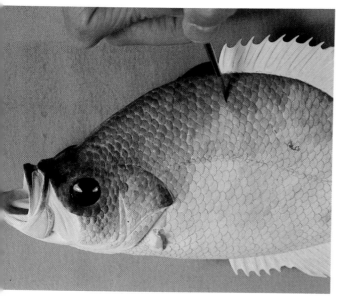

Figure 31

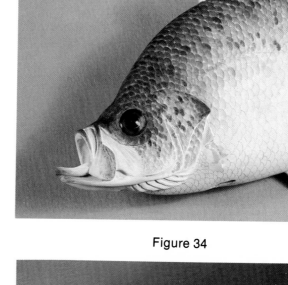

Figure 34

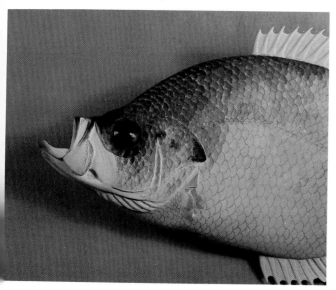

Figure 32

Figure 35

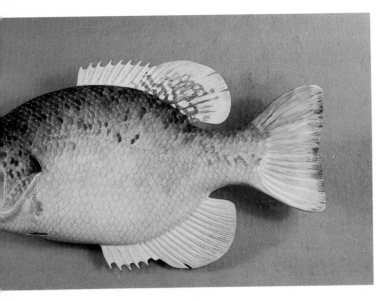

Figure 36

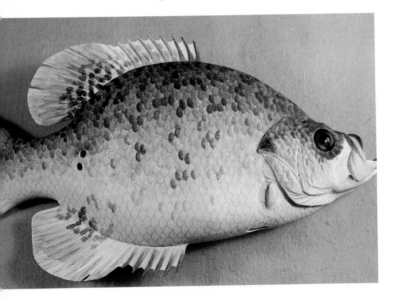

Figure 37

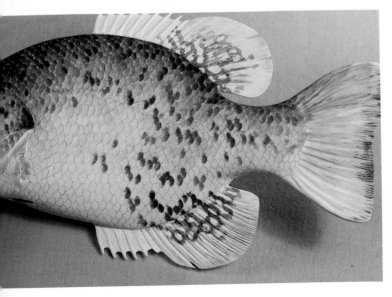

Figure 38

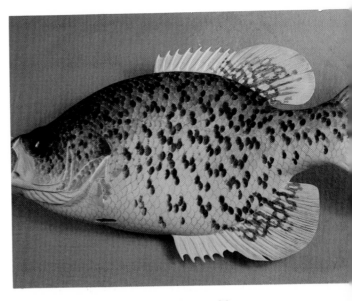

Figure 39

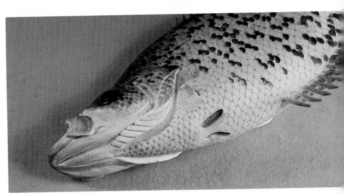

Figure 40

Now we begin to paint the barred lines and outline the spots on the soft rays of the dorsal fin (FIG. 36), as well as wash some color on the tail. With the darker wash in the brush we add more random markings on the body (FIG. 37). Note that we also painted a few barred lines on the anal fin similar to those on the dorsal fin. The markings on the dorsal fin going toward the spiny rays are somewhat fainter than those closer to the body of the fish.

Figure 38 shows how the markings are more pronounced from additional washes. I keep working back toward the head. I don't have any particular reason for this except to say I feel comfortable doing it. Having completed the markings to the head, we then darken them. It will take several washes to accomplish this. The mottled look from using washes is more natural looking than if you were to use the Payne's gray or black straight from the tube.

The scales on the throat, belly and lower sides of the crappie are colored with red oxide and a touch of Payne's gray on what I call the inside of the scales (FIG. 39). Note too that the tip of the lower jaw has received a couple washes of the Payne's gray/ yellow oxide color we used before. The gill areas and lower jaw areas are washed to a slightly diminished color with a mixture of naphthol red and white gesso.

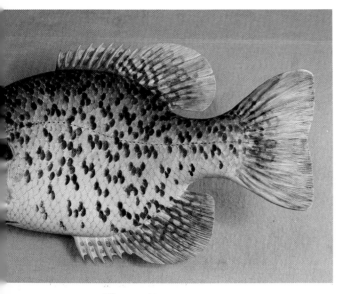

Figure 41

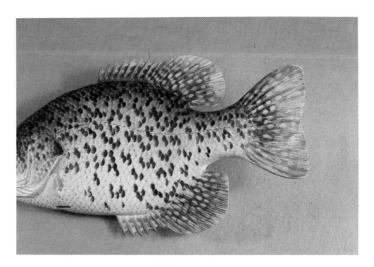

Figure 43

Figure 42

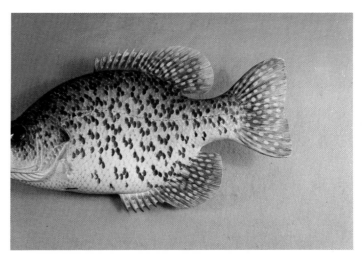

Figure 44

The dorsal fin, anal fin and tailfin are all painted using the same procedure (FIG. 40, 41, 42, 43). The best way to describe this is to say I paint a wash then enhance the white spots with gesso. Then another wash, gesso the spots, and so on, alternating each until you feel you have the color you desire. Each wash darkens the dark areas while it mutes the harshness of the white gesso.

A mixture of cerulean blue with a bit of yellow oxide will give your wash a greenish tint. Applied to the tips of the soft rays this creates the desired transparent look. The tips of the spines are painted with several washes of a raw sienna and Payne's gray mixture.

To paint the gills use a number two liner brush to apply naphthol red mixed with a small amount of water (FIG. 44). To create the shiny character of the fish a wash of iridescent white is now painted on each scale and on the head. Though difficult to capture this iridescent quality on film, perhaps we caught enough so it can be seen in Figures 45 and 46.

The pelvic and pectoral fins are painted with gesso, except the areas that will be glued to the fish (FIG. 47), then colored from the base of each fin toward the middle with a mixture of red oxide and raw sienna (FIG. 48).

Figure 45

Figure 46

Figure 47

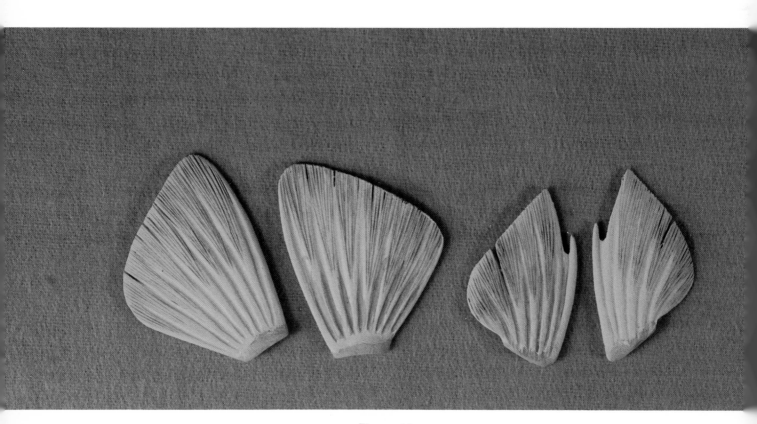

Figure 48

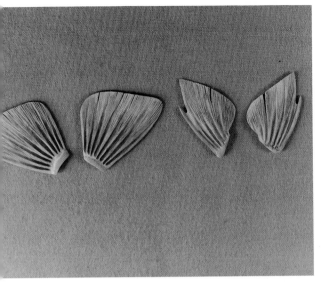

Figure 49

Figure 51

Figure 50

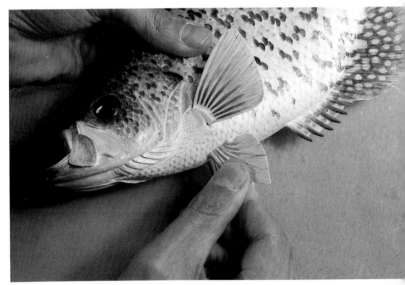

Figure 52

After the fins have dried, they are glued to the fish with a water-based white glue (FIG. 49, 50, 51). A et brush will smooth out the wood filler used to over the seams where the fins were attached (Fig. 2). Give the wood filler time to dry, then sand mooth with 240 grit crocus cloth or sandpaper. fter applying two coats of gesso, draw the scales n the pectoral muscle using the same pencils used o draw the other scales (Fig. 53). These new scales re then painted with a wash of the yellow oxide and ayne's gray mixture (FIG. 54). Figure 55 shows the ompleted pectoral muscle scales after an additional ash of the mixture used in Figure 54.

Now spray a coat of acrylic spray on the painted rappie (FIG. 56). While it is drying mark the walnut ase using the pattern and drill holes (FIG. 57). igure 58 shows the driftwood attached to the nished base with wood screws. When the work is ry, carefully scrape the lacquer from the eyes and ount the crappie on the driftwood, gluing the pins to the driftwood and the fish with five minute poxy.

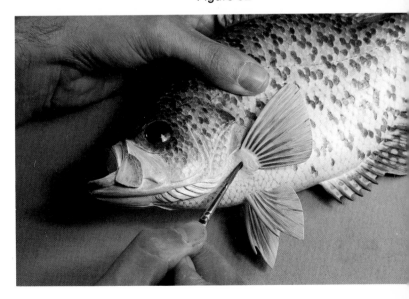

Figure 53

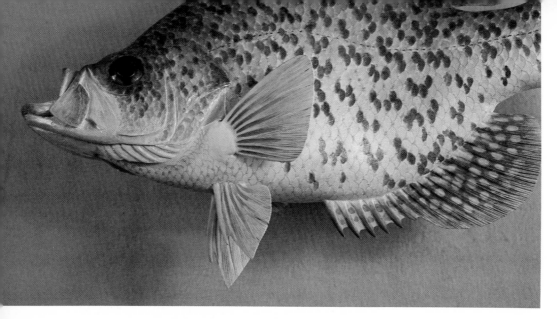

Figure 54

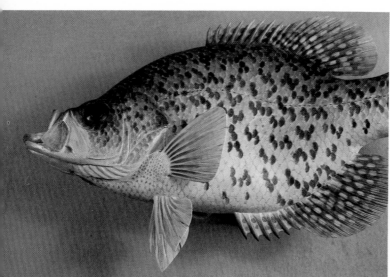

Figure 55

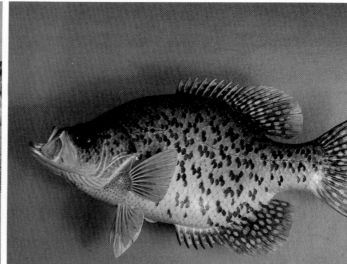

Figure 57

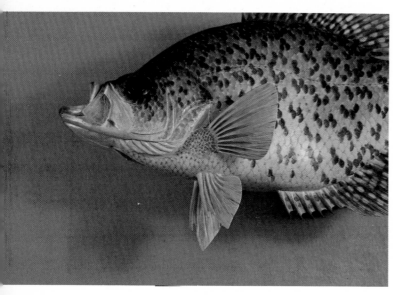

Figure 56

Figure 58

206

Figure 59

We now have a beautiful black crappie for a lighted bookshelf or coffee table. This particular project is now in the collection of Mr. and Mrs. Gerald Hockemeier.

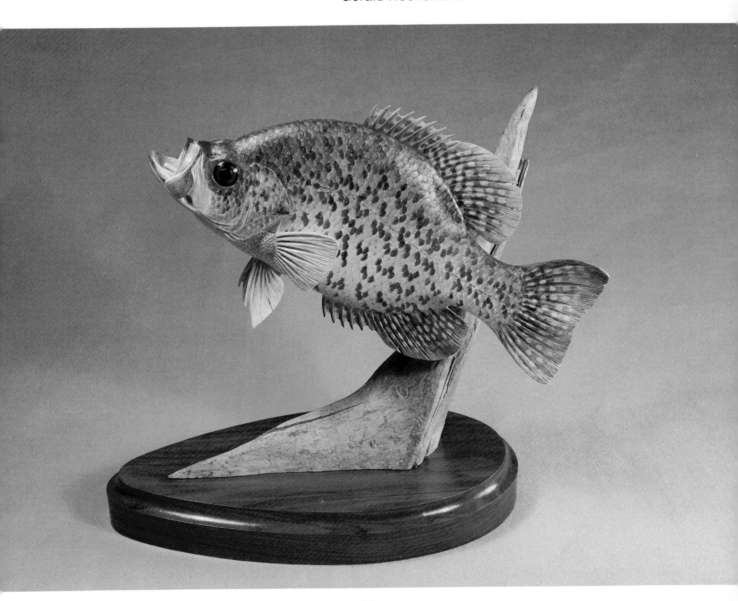

Figure 60

207

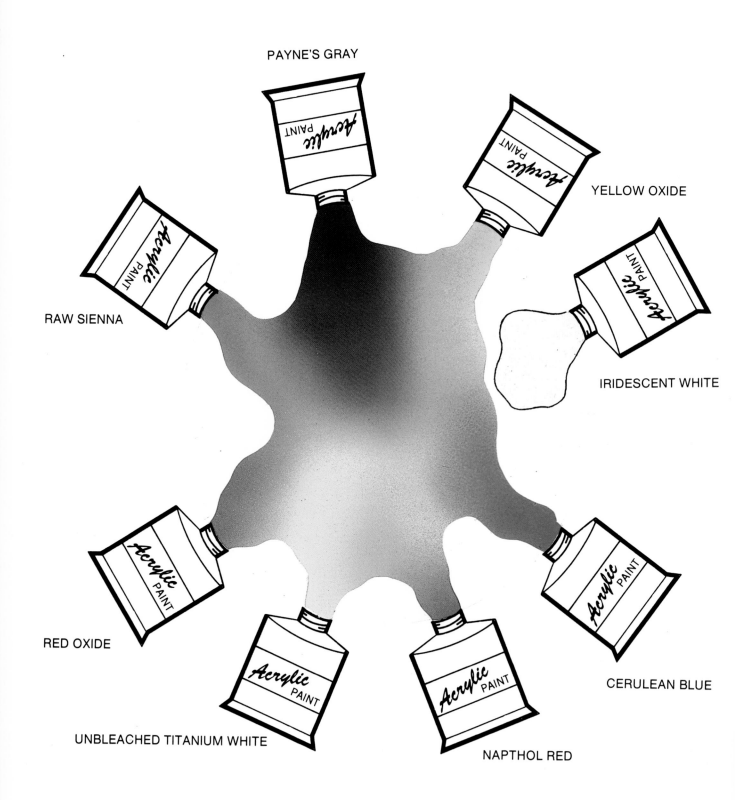

PAYNE'S GRAY

YELLOW OXIDE

RAW SIENNA

IRIDESCENT WHITE

RED OXIDE

CERULEAN BLUE

UNBLEACHED TITANIUM WHITE

NAPTHOL RED

Painting the Rainbow Trout

Colors Used:

Payne's Gray
Yellow Oxide
Cerulean Blue
Raw Sienna

Iridescent White
Unbleached Titanium White
Naphthol Red

The two previous projects we painted with a series of washes. Now we will use a dry brush technique that works well for painting trout and salmon.

Trout have small scales and the head and gill covers lack scales entirely. Contrary to the first two projects, we do not draw the scales on first, then paint. Instead, we complete all the painting steps and before we apply the iridescent white we will draw the scales. They are all the same size so the only problem is a little writer's cramp because of the tremendous number of scales to be drawn.

Before painting I draw the lateral line, with an 8H lead pencil, as a reference point for the pink stripe. We begin our painting with naphthol red and again we use a #3 brush. We again mix a wash, but instead of loading up the brush we use a small amount of the

red wash and blot the brush almost dry. This dry brush technique will be used throughout the painting of the body.

However, the head is smooth so we must return to the wash technique for the head and on the outer edges of the gills. Figure 59 shows the two painting techniques. Notice that with the trout we will not have to paint in the inverted position as we did with the sunfish and crappie.

Figure 60 shows the pink stripe and a second wash on the gill covers. The pink stripe goes all the way to the base of the tail (FIG. 61). We need not complete the pink stripe now, so we can start on the head and back with a mixture of cerulean blue and yellow oxide, using the dry brush technique. Begin brushing from the nose towards the tail (FIG. 62).

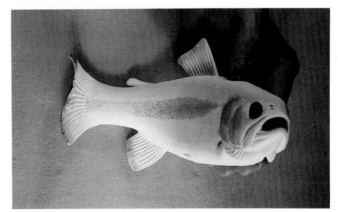

Figure 59

Figure 61

Figure 60

Figure 62

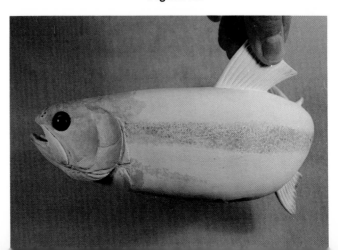

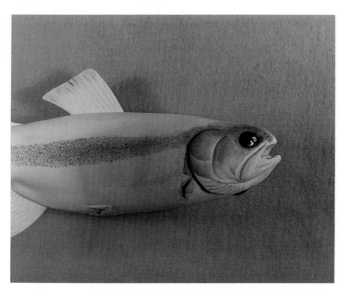

Figure 63

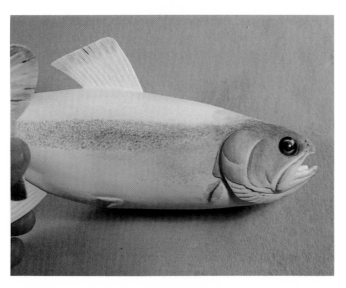

Figure 64

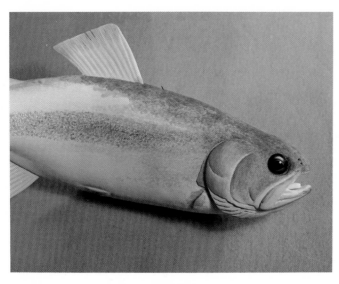

Figure 65

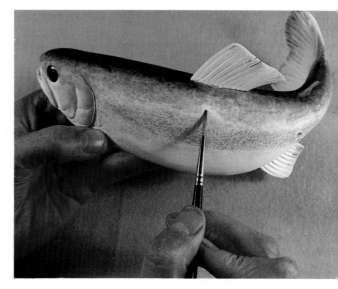

Figure 66

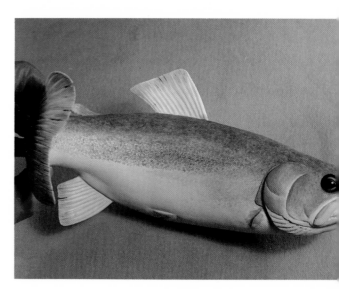

Figure 67

We then apply green, a mixture of yellow oxide and cerulean blue, around the eye and head (FIG. 63). As we do this more pink is worked on the cheek area to make a smooth transition between the two colors (FIG. 64). A touch of yellow oxide will aid this transition.

Also notice in Figure 64 that we dry brush cerulean blue in the area just below the pink stripe. Again we seek a smooth transition between the two colors, as with the head. Where the naphthol red of the pink stripe overlaps the blue it becomes a purple color that eliminates any harsh color differences between the areas.

Now we return to the back of the fish, using the dry brush technique to apply cerulean blue and yellow oxide paint along the back and down the sides (FIG. 65). As we approach the pink stripe we apply yellow oxide between the two colors as they meet (FIG. 66). The colors gradually come closer to blending along the back above the pink stripe (FIG. 67).

210

With cerulean blue we then complete the blue stripe to the tail and paint two coats of red wash on the adipose fin (FIG. 68), after which we apply yellow oxide just below the blue stripe (FIG. 69). The overlapping of color here will produce a shade of green the same as if one were to mix the two for the top of the head and back. Using yellow oxide to blend the colors creates the smooth transition we were seeking. We darken the back by adding more blue than yellow oxide to the mixture (FIG. 70).

Now that the body coloring is coming together, we can paint a wash, using the wet wash technique, of raw sienna to the dorsal and anal fins (FIG. 71) and the tail (FIG. 72). After a second wash of the raw sienna we work some blue and green into the fins

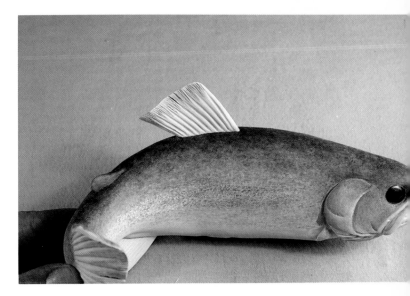

Figure 70

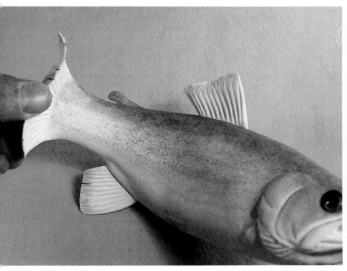

Figure 68

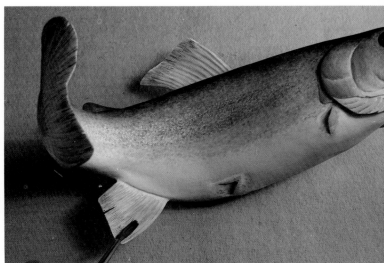

Figure 71

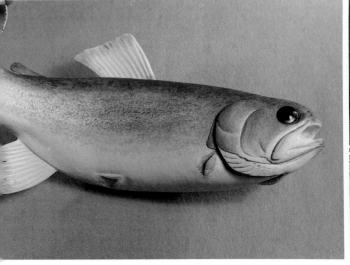

Figure 69

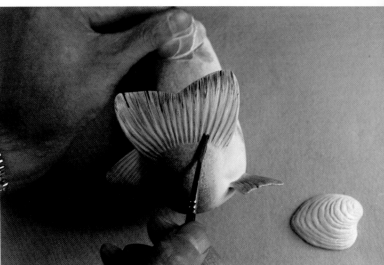

Figure 72

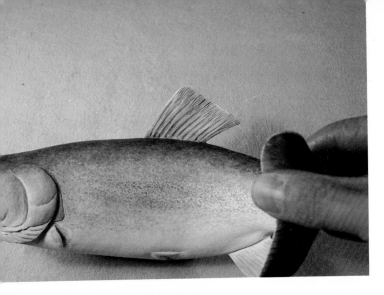

where they attach to the body (FIG. 73). Applying a blue wash to the tips of the tail again gives the rays a transparent look (FIG. 74). Alternating washes of raw sienna with Payne's gray and yellow oxide will darken the tail and dorsal fin to the color we want (FIG. 75, 76).

The mouth is painted with a mixture of unbleached white and naphthol red, again using the wet wash technique (FIG. 77).

Figure 73

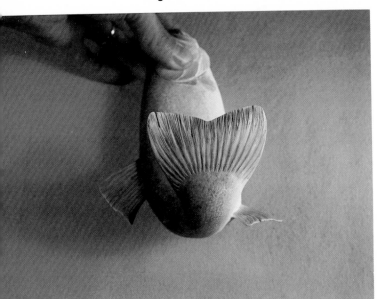

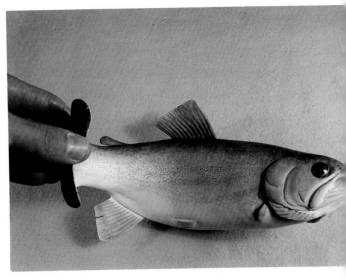

Figure 76

Figure 74

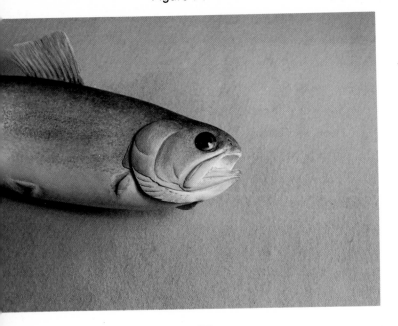

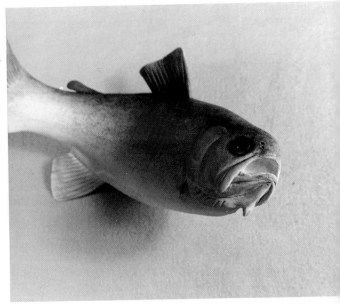

Figure 75

Figure 77

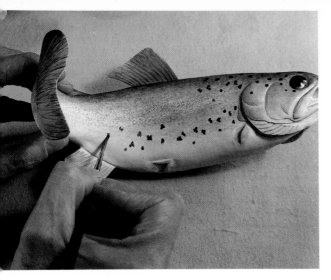

Figure 78

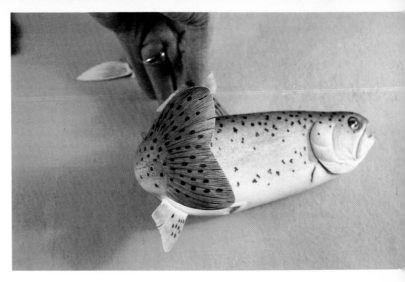

Figure 80

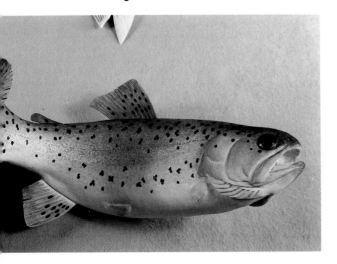

Figure 79

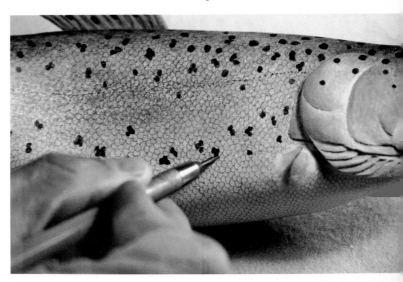

Figure 81

Our reference material is very useful for determining the placement of the rainbow's random spots. These spots are more numerous above the lateral line, practically non-existent directly below the line, but return again in lesser numbers toward the lower side of the fish (FIG. 78), as well as on the dorsal and anal fins (FIG. 79) and the tail (FIG. 80). The whole tail of the rainbow is covered by spots, which distinguishes it from other trout because none have this full pattern. The spots are made with a mixture of Payne's gray and a small amount of raw sienna.

Before finishing and attaching the pectoral and pelvic fins we begin drawing the scales with a 9H pencil (FIG. 81). Obviously, the fish is more convenient to handle without these delicate fins attached. Later, after gluing the fins into place, we will finish drawing the scales to the fin locations. Now, however, we do draw the scales on the body of the trout, and when finished we dab a coat of iridescent white onto each scale to create the shiny, silvery appearance.

The pectoral and pelvic fins are given a wash of raw sienna with some red oxide washed between the rays (FIG. 82). Subsequent washes darken these areas (Fig. 83), with a wash of cerulean blue applied toward the end of the rays to tone down the white

Figure 82

Figure 83

Figure 84

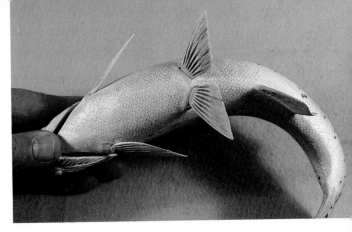

Figure 87

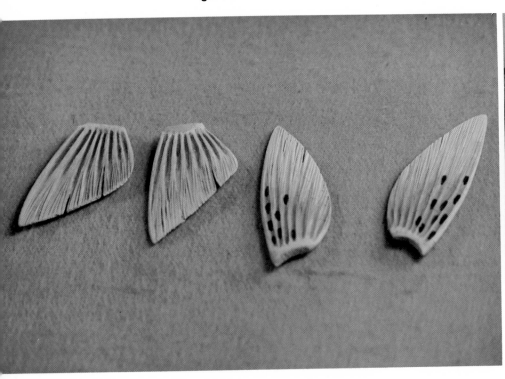

Figure 85

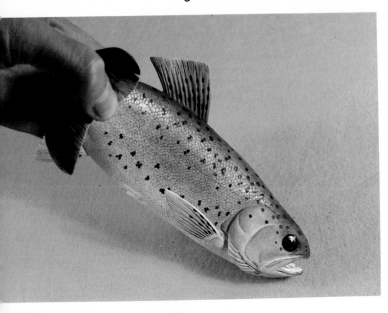

Figure 86

Figure 88

and give the fins a transparent appearance (FIG. 84). The pectoral fins display a series of black spots while the pelvic fins are void of spots (FIG. 85).

The fins are now ready to be glued into place with white glue (FIG. 86, 87). Cover the seams between the fins and the body with Elmer's wood filler (FIG. 88), and after it has dried thoroughly, sand smooth with 240 grit crocus cloth or sandpaper and give them two coats of gesso (FIG. 89).

Again using the 9H pencil we now continue the scales up to the pectoral and pelvic fins (FIG. 90) and dab them with iridescent white (FIG. 91, 92).

The only thing left to do is to give the trout one coat of Deft spray lacquer. After it dries, carefully scrape the lacquer from the eyes with an X-acto knife.

The painting of the grass is quite simple. I use Hooker's green, cadmium yellow and gesso (FIG. 93). Remember, though, that water grass, as well as other plants growing in the colder waters suitable for trout, have a darker green color than other grasses.

214

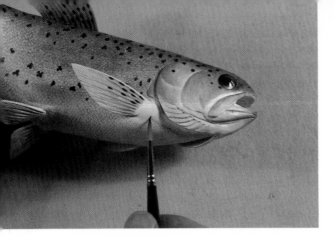

Figure 89

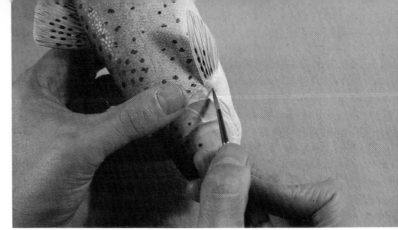

Figure 91

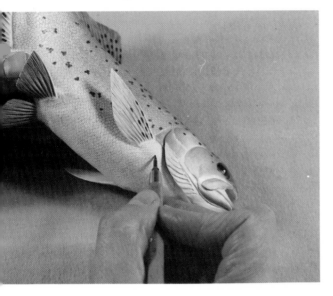

Figure 90

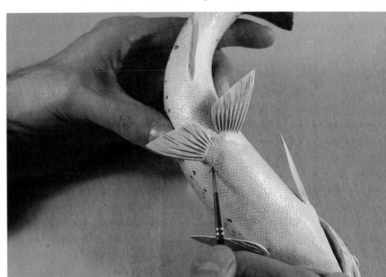

Figure 92

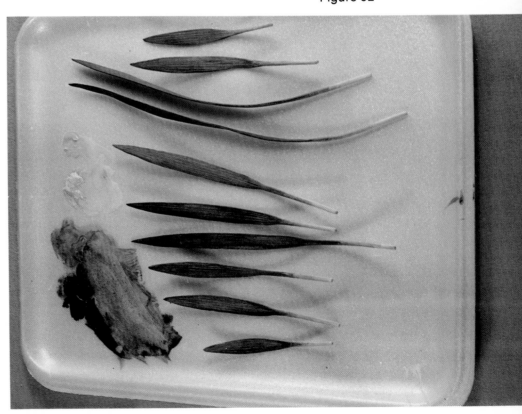

Figure 93

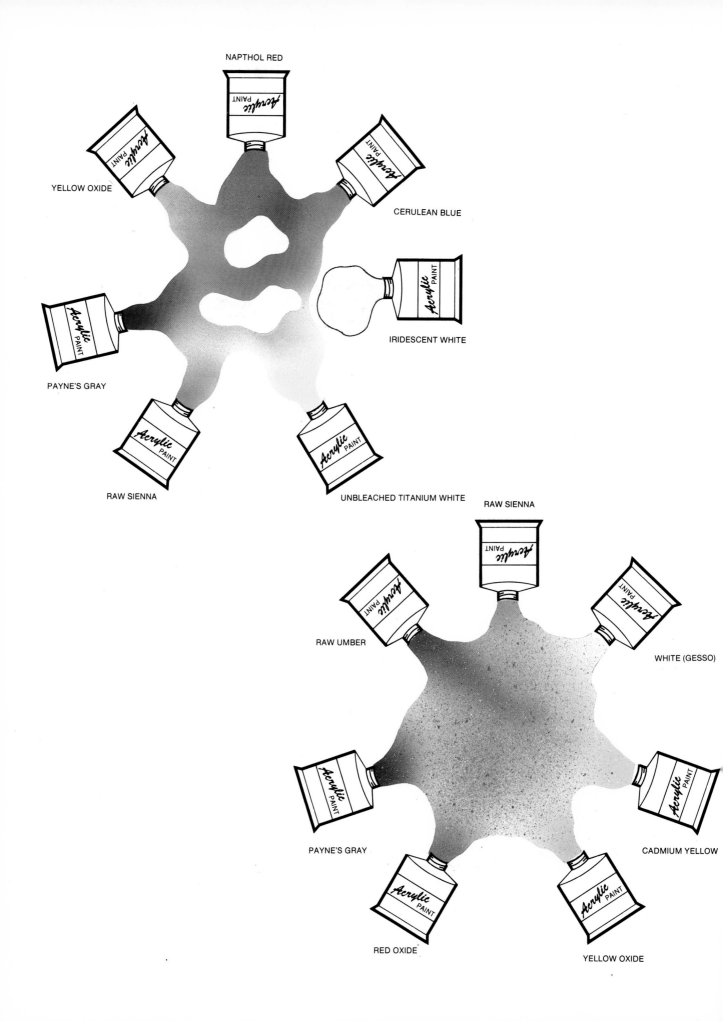

NAPTHOL RED

YELLOW OXIDE

CERULEAN BLUE

IRIDESCENT WHITE

PAYNE'S GRAY

RAW SIENNA

UNBLEACHED TITANIUM WHITE

RAW SIENNA

RAW UMBER

WHITE (GESSO)

PAYNE'S GRAY

CADMIUM YELLOW

RED OXIDE

YELLOW OXIDE

Figure 94

Figure 96

Figure 95

Figure 97

The sand base does not need to be sealed, but is given a coat of gesso and raw sienna (FIG. 94) followed by highlighting between the ridges with a wash of raw umber (FIG. 95). Notice that the area under the driftwood does not require painting. The colors I used are Payne's gray, red oxide, yellow oxide, raw sienna, raw umber, cadmium yellow and gesso. See the Color Chart for the sand base.

To achieve the sand color and texture on the base use an old toothbrush. Generously load the forward end of brush with any color we wish and spatter the paint onto the base by running the tip of our finger quickly over the bristles (FIG. 96). See Illustration C-12. By applying several washes and spatterings of different colors of paint, we gradually build up the paint to the desired color and texture (FIG. 97, 98, 99, 100). When satisfied with the sand base we attach it to the finished walnut base with wood screws (FIG. 101).

Figure 98

217

Figure 99

Figure 100

Figure 101

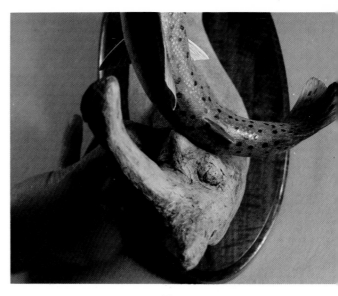

Figure 102

After aligning the driftwood and marking the corresponding holes on the base, we drill the holes and fasten the driftwood to the base with wood screws. We then mount the trout into place (FIG. 102), gluing the pins into the trout and the driftwood with five minute epoxy, and complete the rainbow trout composition by gluing the grass into the holes with white glue Don't be surprised if some minor adjustments are needed with the grass.

The rainbow trout is now finished, ready for conspicuous display on the mantle, bookshelf, desk or coffee table.

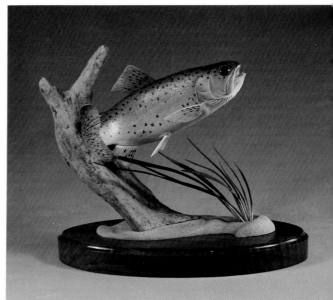

Painting the Channel Catfish

Colors Used:

Payne's Gray
Yellow Oxide
Cerulean Blue
Red Oxide

Raw Umber
Unbleached Titanium White
Raw Sienna

The coloration on a channel catfish will vary as much as a trout. "Cats" from warmer and slower moving waters range in color from olive-gray to a bluish black. A silvery olive green to a whitish-blue can be found on those fish from colder and swifter moving waters. Reference material is of great help but is more difficult to obtain in all parts of the country. Since I am more familiar with the darker varieties, and they give me the opportunity to use more colors from the palette, I prefer painting them.

As I have done with the other projects in this book, I use a styrofoam plate though it is best to keep the tray upright since we will be using larger amounts of water. Recently, I have begun by mixing a basic color of Payne's gray and yellow oxide, then moving from that both ways depending on the tone or shade of that basic color I want. I use a slightly larger sable brush, #4 or #5, to mix the acrylics well, but not too large. If you use a brush that is too big, you may end up with thick globs of paint, which will foul the air brush.

Another important point: keep plenty of clean water handy, preferably in a squeeze bottle, to flush the air brush. This prevents a build-up of paint, especially on the needle. I flush the air brush after every two or three cupfuls of paint. As mentioned before, I also recommend periodic cleaning of the disassembled brush according to its instructions.

A hair dryer reduces painting time, but I find that in the time I spend preparing for the next coat of paint the previous coat has dried, so artificial means of drying are usually not necessary.

We begin by spraying yellow oxide over the areas of the head and the back (FIG. 104) to map out those areas to be made darker later, such as the head. After several coats on these areas, we move on to the fins and tail, spraying them with a coat of raw sienna and red oxide wash, again just mapping these areas while keeping the fish the same shade (FIG. 105). Note also that we spray a base coat of cerulean blue in the area from the belly towards the tail.

Now we turn our attention again to the head and back, applying several coats of the Payne's gray and yellow oxide mixture (FIG. 106, 107). Now back to the fins, where we again spray them with the raw sienna and red oxide (FIG. 108). Working back and

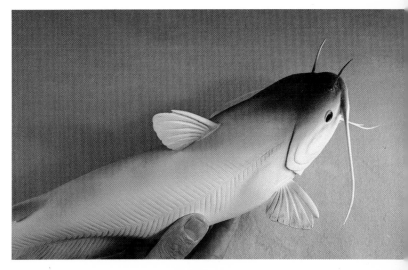

Figure 104

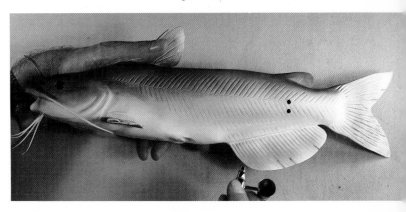

Figure 105

Figure 106

forth between the two colors we keep the color of the fish more even while gradually achieving the color we seek (FIG. 109, 110, 111). Notice that on the tips of the tail, anal fins and dorsal fins we spray a mixture of cerulean blue and a tiny bit of red oxide.

Since we have been painting mostly with three washes which have not included colors we need for the pectoral fins, and since we need raw umber and red oxide/unbleached white for the mouth, as well as the pectoral fins, we have avoided the pectoral fins until now. They also require some very fine, delicate spraying so as not to cause over-spraying on areas which are most difficult to cover.

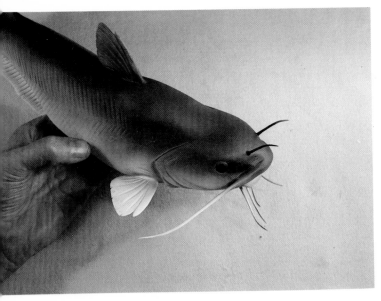

Figure 107

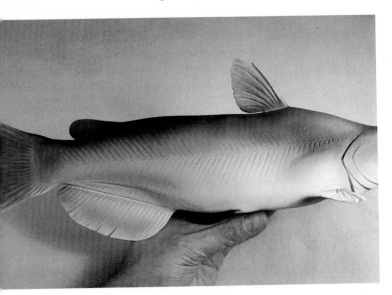

Figure 108

Figure 110

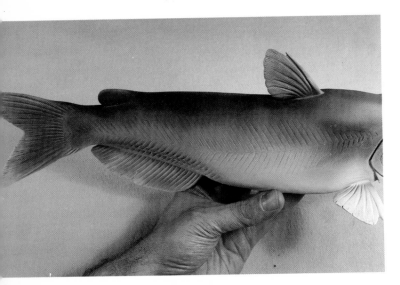

Figure 109

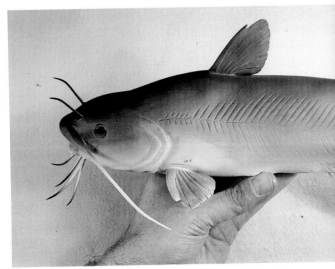

Figure 111

The bottom gill covers are painted by brush with a thin wash of red oxide and unbleached titanium white (FIG. 112). We paint the bottom of the pectoral fins with the same wash, creating the mottled coloration of the spines with a coat of raw umber and Payne's gray (FIG. 113). Another coat or two of a raw umber and raw sienna mixture will even out the mottled color on the fin (FIG. 114, 115).

We brush the tips of the barbels with a darker shade of Payne's gray and raw umber (FIG. 116).

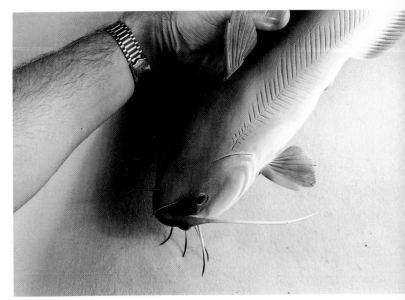

Figure 114

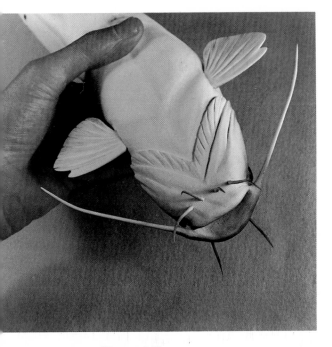

Figure 112

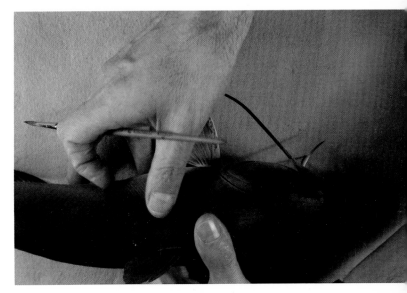

Figure 115

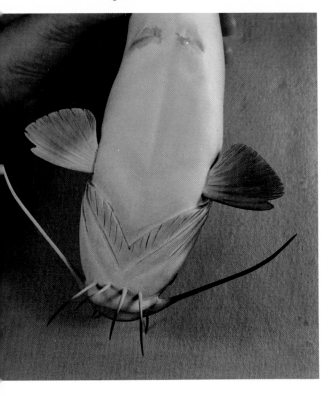

Figure 113

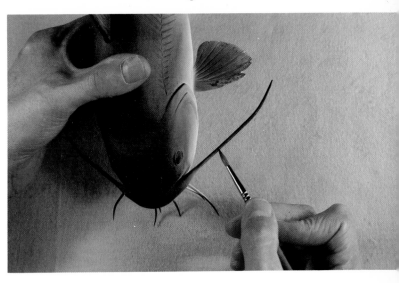

Figure 116

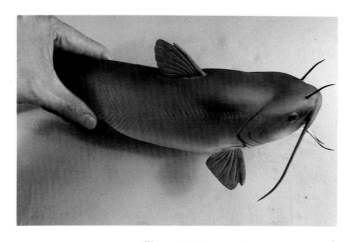

Figure 117

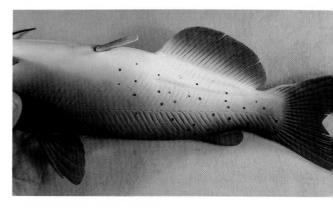

Figure 121

Figure 118

Figure 119

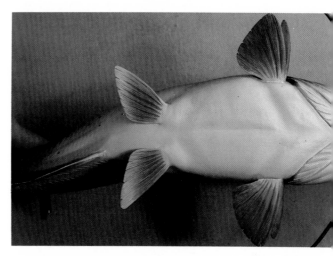

Figure 122

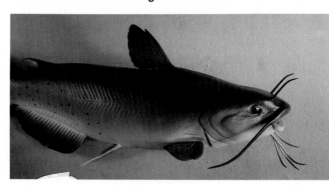

Figure 123

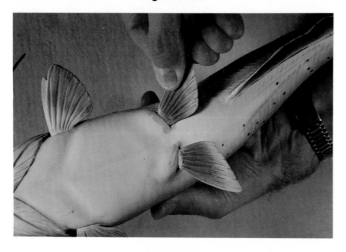

Figure 120

Figure 124

e bases of the lower jaw barbels remain white
ith the tips being dark (FIG. 117). Since we need
e color to be gradually lighter in the direction of
e bases, we very carefully spray the barbels to
void over-spraying onto the body of the fish.

As catfish grow larger they lose the spots but this
ze fish will still have a few from the middle of the
ody back to the tail (FIG. 118). We add these by
pplying Payne's gray with a #3 brush. Note also
at we spray a coat of cerulean blue right at the
ase of the tail, producing a purple color.

The pelvic fins in Figure 119 are painted with
everal coats of a raw sienna and red oxide mixture,
ith cerulean blue applied to the tips of the rays.
ter they have dried, insert and glue them with
mer's carpenter's glue (FIG. 120) at the angle
own in Figure 121. Fill the creases with
arpenter's wood filler, sand smooth and apply two
oats of gesso to the sanded filler (FIG. 122).

The painting of the channel catfish is now
omplete. After spraying the completed fish with
o light coats of acrylic spray (FIG. 123) and gluing
e pins into the body with five minute epoxy, the
hannel catfish is ready to mount as soon as the
poxy has set (FIG. 124).

ainting the Clam Shells:

To seal the two inside-showing shells, I apply two
oats of acrylic spray, sanding after the first coat
ith worn out or used 240 grit sandpaper.

I do not seal the three outside-showing shells, but
pply two coats of gesso. Then I seal them with two
oats of acrylic spray. The reason this procedure is
eversed from the inside showing shells is that when
e outer dark covering of the shells are painted, the
aint dries on top of the sealing gesso. This allows
ou to give them a deteriorated look by scraping and
hipping the dark covering away, revealing the
hite underneath instead of bare wood as would be
e case with the inside-showing shells.

To paint the inside-showing shells I use gesso for
hite, iridescent white, cerulean blue, naphthol red
ght or a tiny bit of cadmium red, and raw sienna. To
chieve a pearl look I mix a small amount of gesso
ith iridescent white. After two coats I will mix with a
mall portion of it a tiny amount of red to make pink,
pplying this combination to a small area near the
uter edge of the shell. The same procedure is
ollowed using blue. I am thus creating the refracted
ght qualities of the shell. Raw sienna and cerulean
lue are used in the area of the shell hinge where it
as been stained. The inside is then sprayed with
our or five coats of acrylic spray to achieve the
hiny pearl look.

For the outside-showing shells I use Payne's
ray, raw sienna, yellow oxide and burnt umber. To
aint some of the outer shells without the crusty
ook first paint a light wash of equal amounts of raw
ienna and yellow oxide. Get the darker tones by
radually darkening the surface with burnt umber
nd Payne's gray. If the shell is sort of mottled,
arker colors can be applied with the dry brush
ethod.

For the crusty, weathered look on the shells, a
thick mixture of Payne's gray and burnt umber is
applied with an X-acto knife blade, much as a
palette knife would be used. I use a hair dryer to
speed the drying of this thick paint. After drying, the
paint can be chipped or scraped off with the same
knife, creating the weathered look we want. If too
much white shows, apply a wash of burnt umber
and raw sienna to tone it down. Since these shells
are found under water, apply one coat of spray
lacquer to give them a wet look.

When the clam shells have dried (FIG. 125), we
are ready to assemble the whole catfish composition,
deciding which shells will adorn the catfish's domain
and how they should be displayed.

Figure 125

When attaching the clam shells to the finished
base remove the lacquer finish at the point of
contact with a small flat gouge. This will assure the
best possible bond of the shells to the base.

Now we mount the finished catfish to the driftwood
in the same way as our other projects, completing
an unusual, beautiful decorative wildlife carving.

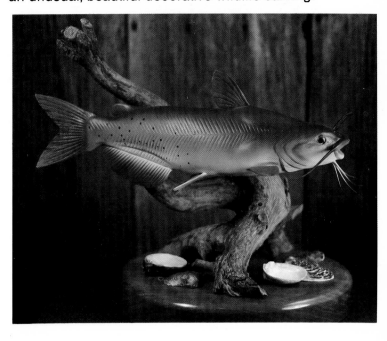

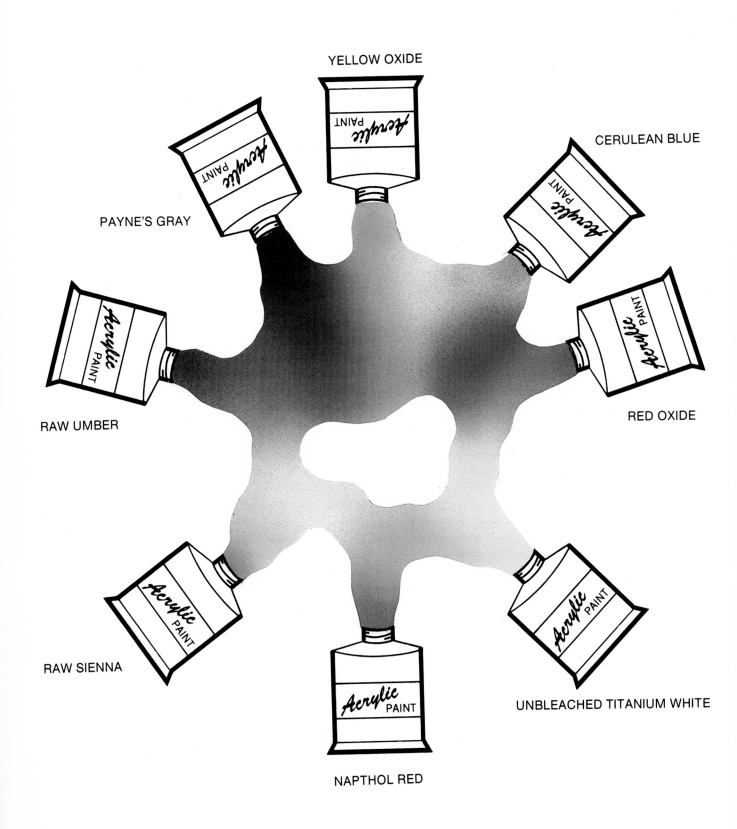

YELLOW OXIDE

CERULEAN BLUE

PAYNE'S GRAY

RAW UMBER

RED OXIDE

RAW SIENNA

UNBLEACHED TITANIUM WHITE

NAPTHOL RED